ABSTRACT ART IN THE LATE TWENTIETH CENTURY

By the middle of the twentieth century, abstraction was the accepted language of art as practiced by painters and articulated by critics, who began to investigate its historical and theoretical dimensions. *Abstract Art in the Late Twentieth Century* includes seminal essays on abstract painting written over four decades by eleven of its most incisive critics. Tracing the post-Greenbergian development of critical issues such as hard-edge painting, deductive and serial structure, monochrome abstraction, the psychological analogy, regionalism, and the "death of painting" in Postmodernism, the essays examine works by Ad Reinhardt, Frank Stella, Brice Marden, Sherrie Levine, and Gerhard Richter, among others. The introduction and commentary by Frances Colpitt situates the essays historically and examines their philosophical sources and influences, from formalism and phenomenology to structuralism and poststructuralism. What emerges is a coherent and optimistic picture of abstract painting, the definitive contribution of modern art.

Frances Colpitt is Associate Professor of Art History and Criticism at the University of Texas at San Antonio. A scholar of American art since 1960, she is the author of *Minimal Art: The Critical Perspective* and has organized many exhibitions, including *Chromaform: Color in Sculpture* and *In Plain Sight: Abstract Painting in Los Angeles*.

CONTEMPORARY ARTISTS AND THEIR CRITICS

GENERAL EDITOR:

Donald L. Kuspit, *State University of New York, Stony Brook*

ADVISORY BOARD:

Matthew Baigell, *Rutgers University, New Brunswick*
Lynn Gamwell, *State University of New York, Binghamton*
Richard Hertz, *Art Center College of Design, Pasadena*
Udo Kulturmann, *Washington University, St. Louis*
Judith Russi Kirshner, *University of Illinois, Chicago*

This series presents a broad range of writings on contemporary art by some of the most astute critics at work today. Combining three methods of art criticism and art history, their essays, published here in anthologized form, are at once scholarly and timely, analytic and evaluative, a record and critique of art events. Books in this series are on the "cutting edge" of thinking about contemporary art. Deliberately pluralistic in approach, the series represents a wide variety of approaches. Collectively, books published in this series will deal with the complexity of contemporary art from a wide perspective, in terms of both point of view and writing.

ABSTRACT ART IN THE LATE TWENTIETH CENTURY

EDITED BY **FRANCES COLPITT**

University of Texas at San Antonio

PUBLISHED BY THE PRESS SYNDICATE OF THE UNIVERSITY OF CAMBRIDGE
The Pitt Building, Trumpington Street, Cambridge, United Kingdom

CAMBRIDGE UNIVERSITY PRESS
The Edinburgh Building, Cambridge CB2 2RU, UK
40 West 20th Street, New York, NY 10011-4211, USA
477 Williamstown Road, Port Melbourne, VIC 3207, Australia
Ruiz de Alarcón 13, 28014 Madrid, Spain
Dock House, The Waterfront, Cape Town 8001, South Africa

http://www.cambridge.org

© Cambridge University Press 2002

First published 2002

Printed in the United Kingdom at the University Press, Cambridge

Typefaces Electra 10/13 pt. and Futura *System* LATEX 2ε [TB]

A catalog record for this book is available from the British Library.

Library of Congress Cataloging in Publication Data
Colpitt, Frances.
Abstract art in the late twentieth century / Frances Colpitt.
 p. cm. – (Contemporary artists and their critics)
Includes bibliographical references and index.
ISBN 0-521-80836-7 – ISBN 0-521-00453-5 (pb.)
1. Art, Abstract. I. Title. II. Series.
N6494.A2 C654 2001
759.06'52 – dc21 2001035676

ISBN 0 521 80836 7 hardback
ISBN 0 521 00453 5 paperback

CONTENTS

ACKNOWLEDGMENTS

I am especially grateful to authors John Coplans, Douglas Crimp, Hal Foster, Jeremy Gilbert-Rolfe, Donald Kuspit, Philip Leider, Lucy Lippard, Grégoire Müller, Sheldon Nodelman, and David Pagel, and to June Harwood, on behalf of Jules Langsner, for their contributions to this volume. Based on our mutual commitment to abstract painting, Saul Ostrow deserves much credit for suggesting the topic and format of the book and reading the initial manuscript. Donald Kuspit, series editor of Contemporary Artists and Their Critics at Cambridge University Press, supported this book (as well as my previous book on minimal art), for which I am eternally grateful. Also at Cambridge, Beatrice Rehl and Stephanie Sakson facilitated the book's publication with dedication and attention to detail. The good fortune of a Faculty Development Leave from the University of Texas at San Antonio provided the opportunity to complete the manuscript. Contributing to my ideas about abstract painting have been long-term conversations with many abstract painters, especially David Novros, Ed Moses, John M. Miller, Edith Baumann-Brogan, Alan Wayne, Scot Heywood, Madeline O'Connor, Aaron Parazette, and James Hayward. As my graduate research assistant, Jennifer Davy offered invaluable assistance with the many details involved in preparing the book for publication. My graduate students in Texas and elsewhere, past and present, have always taken an interest in my work and often helped to develop my concerns. Above all, I appreciate the unwavering dedication of my husband, Don Walton, whose being there makes everything possible.

F.C.

CONTRIBUTORS

John Coplans, who was born in London in 1920, became a painter after service in World War II. A founding editor of *Artforum*, he served in a variety of editorial positions between 1962 and 1977. His last exhibition of paintings was held at the M. H. de Young Museum, San Francisco, in 1963. A recipient of the Frank Jewett Mather Award for Art Criticism in 1974, he is the author of eight books (including one on cybernetics) and numerous articles on art. He was also director of the Art Gallery at the University of California, Irvine; senior curator of the Pasadena Art Museum; and director of the Akron Art Museum. In 1980 he returned to making art using photography as his medium. Since then, solo exhibitions of his art have been held at the San Francisco Museum of Modern Art, the Art Institute of Chicago, the Museum of Modern Art, New York, the Centre Georges Pompidou, and many other venues. In 1997, P. S. 1 Contemporary Art Center, New York, mounted a retrospective of his photographs, which was followed by another at the Scottish National Galleries, Edinburgh. He has received two Guggenheim and several National Endowment for the Arts Fellowships and was decorated in 2001 by the French government with the Order of Officer of Arts and Letters.

Douglas Crimp received his Ph.D. from the City University of New York and is Professor of Art History/Visual and Cultural Studies at the University of Rochester. He is the author of *On the Museum's Ruins* (1993), coeditor of *How Do I Look? Queer Film and Video* (1991) and *October: The First Decade, 1976–1986* (1987), and editor of *AIDS: Cultural Analysis/Cultural Activism* (1988). *Melancholia and Moralism* is forthcoming in 2002. He received a Rockefeller Foundation Humanities Fellowship, Program for the Study of Sexuality, Gender, Health and Human Rights, in 2000 and the Frank Jewett Mather Award for Art Criticism from the College Art Association in 1988.

Hal Foster is Townsend Martin Professor of Art and Archaeology at Princeton University and coeditor of *October* magazine. His new book, *Prosthetic Codes, and Other Modernist Fantasies*, is forthcoming from MIT Press in 2002.

Jeremy Gilbert-Rolfe teaches in the Graduate School of the Art Center, Pasadena, California. Winner of the College Art Association's Frank Jewett Mather Award for Art or Architectural Criticism in 1998, he is the author of *Immanence and Contradiction: Recent Essays on the Artistic Device* (1986), *Beyond Piety: Critical Essays on the Visual Arts, 1986–1993* (1995), and *Beauty and the Contemporary Sublime* (2000).

Donald Kuspit is Professor of Art History and Philosophy at the State University of New York at Stony Brook. His most recent books are *The Rebirth of Painting in the Late Twentieth Century* (2000) and *Psychostrategies of Avant-Garde Art* (2000). He recently gave the Getty Lectures at the University of Southern California.

Jules Langsner was born in New York in 1911 and grew up in Los Angeles, graduating from the University of California at Los Angeles. Langsner was a highly regarded critic and art historian and a regular contributor to *ARTNews*, *Art International*, and *Arts and Architecture*. He taught art history at Chouinard Art Institute and Otis Art Institute. While his writings spanned the work of artists of many persuasions, he is best remembered for his involvement with the abstract classicists and is credited with having coined the term "hard-edge" to define their pursuit. He was married to Southern California artist June Harwood, who has donated his papers to the Archives of American Art. Jules Langsner died in Los Angeles in 1967.

Philip Leider edited *Artforum* magazine from its founding in 1962 until 1971, when he accepted a teaching position at the University of California at Irvine. In 1989, he left to teach at the Bezalel Academy of Art in Jerusalem, where he currently lives, writing for both American and Israeli publications.

Lucy R. Lippard is a writer, activist, and curator living in Galisteo, New Mexico. Her recent books include *Lure of the Local: Senses of Place in a Multicentered Society* (1997), *On the Beaten Track: Tourism, Art, and Place* (1999), and a new edition of *Mixed Blessings: New Art in a Multicultural America* (2000). She has organized more than fifty exhibitions and cofounded numerous artists' organizations, including Printed Matter, the Heresies Collective, Political Art Documentation/Distribution, and Artists Call Against U.S. Intervention in Central America.

Grégoire Müller is a painter and writer who currently lives in Switzerland, where he was born in 1947. Writing first from Paris and then New York, he took an active part in the debate about the new art. Before resuming

the practice of painting, he was editor of *Arts Magazine* (1969–72) and author of *The New Avant-Garde* (1972). His paintings have been exhibited in numerous galleries and museums, including the Zurich Kunsthaus. A book on his paintings, *Grégoire Müller, or a Theory of Painting*, is forthcoming.

Sheldon Nodelman received his Ph.D. in the History of Art from Yale University. Before joining the Visual Arts Department at the University of California, San Diego, he taught at Bryn Mawr College, Princeton University, and Yale University. He has been the recipient of Fulbright and Morse fellowships and has been a Getty Scholar. His most recent published work is *The Rothko Chapel Paintings: Origin, Structure, Meaning* (1997). He is also the author of many articles on twentieth-century art and on Roman art, in particular, Roman portrait sculpture, on which he is a recognized authority. He is currently at work on a book on Marcel Duchamp.

David Pagel is an independent critic and curator who writes for the *Los Angeles Times*. He is reviews editor of *Art Issues*, a contributing editor of *Bomb*, a visiting scholar at Claremont Graduate University, and an undergraduate instructor at the University of California at Los Angeles. Recent exhibitions he has organized include *The Dreams Stuff Is Made Of* (Frankfurt, Germany), *Radar Love* (Bologna, Italy), and *Jim Isermann: Fifteen* (Milwaukee, Wisconsin).

INTRODUCTION

Redefining the role of painting in Western culture, abstraction is the definitive innovation of modern art. If painting is the "standard-bearer" of modernism, abstract painting is its "emblem," according to recent critics.[1] It is the thing, one imagines, that will characterize twentieth-century art for generations to come. Its development was prepared for by the invention of photography, to which pictorial representation was essentially bequeathed, as well as by the potential for self-expression explored by nineteenth-century romantics and symbolists, and the formal innovations of the cubists. Although abstract painting became a reality in the second decade of the twentieth century, its birth was not easy, as its innovators recalled. "I could not immediately come to 'pure abstraction' because at that time I was all alone in the world," Wassily Kandinsky later acknowledged.[2] For Kasimir Malevich, the radicality of his simple, black square painting, *Black Quadrilateral* (1915), "was such an important event in his artistic career that for a whole week (so he himself related) he could neither drink nor eat nor sleep."[3] The birth of abstraction signaled painting's demise to Alexander Rodchenko. His three monochrome canvases of 1921 led him to conclude, "This is the end of painting. These are the primary colors. Every plane is a discrete plane and there will be no more representation."[4]

The fact that painting was conventionally defined as an art of representation meant that early twentieth-century abstract painters and their supporters were perpetually on the defensive, differentiating their goals from those of representational artists. The oppositional nature of historical abstraction is treated in depth in the first section of the commentary in this book. By midcentury, however, abstract painting had achieved legitimacy and self-sufficiency to the extent that it no longer needed justification for deviating from the norm. Marking its acceptance was the watershed exhibition of the

young Frank Stella's black paintings in *Sixteen Americans* at the Museum of Modern Art in New York in 1959. While the blankness of Stella's "pin stripe" paintings was soon criticized as nihilistic and boring,[5] the paintings' claim on the now-established tradition of abstraction was not in dispute. In contrast to what I call historical abstract painting (from roughly 1910 to 1959), contemporary abstraction, ushered in by Stella, is not only no longer threatened by the standard of representation, it ceases to develop historically. It shifts, as a practice and a concept, from the status of a verb (as in "abstracting from") to a noun (the nonrepresentational painting as a thing in and of itself). This nondevelopmental stage encompasses late modern abstraction (represented by Stella, Brice Marden, Robert Ryman, et al.) and what, for lack of a better term, I call postmodern abstraction, initiated by Peter Halley and informed by theory rather than the traditions of painting *or* abstraction.

Taking his cue from G. W. F. Hegel, Arthur Danto claims that, "beyond the pale of history," we arrived at the end of art in the 1960s. "In that post-historical moment . . . what had come to an end was that narrative but not the subject of that narrative."[6] A convincing assessment of contemporary art's nondevelopmental nature (surely, we witness shifts and swings of styles and subjects, and technological innovations spurred on, especially, by the computer, while artists, more than ever before, continue to make art despite its "end"), it also prepares the way for the argument that painting is dead, an argument that is coincident with the third phase. Rehearsed in the chapters (especially "The End of Painting" by Douglas Crimp) and detailed in the commentary in this book, the "death of painting" began to take hold in the mid-1960s when artists such as Donald Judd proposed that moving into three dimensions (but not into sculpture, which was for him synonymous with statuary) was a way out of the limitations of painting.[7] Belief in painting's irrelevance was widely accepted by critics in the 1970s and '80s, when not only three-dimensional installation art but performance and photography (and soon video and computer technology) appeared to be more relevant to contemporary life than the preindustrial craft of painting. Throughout these debates, painters have continued to paint and painting never vanished. The significance of the controversy lies in the very recognition of it: the fact that painting is no longer the "standard-bearer" of contemporary art but may, in light of this, be practiced with a new kind of freedom and resolve.

This volume includes chapters by eleven of abstraction's most incisive critics. All of the selections are object-oriented; that is, they discuss actual works of art rather than merely theoretical constructs, although philosophy and theory – and in particular the work of Hegel, Maurice Merleau-Ponty,

and Jacques Derrida – are central to such discussions. While not attempting to provide a complete history of contemporary abstract art, the essays capture the flavor, popular topics, and methodologies of each of the last decades, rooted, like Hegel's philosophy, in "the concrete factuality of the world."[8]

The first chapter in this book is an early attempt to make historical sense of abstract painting without apology or defensiveness. It was published in the then-remote outpost of modern art, Los Angeles, in 1959. Although the artists discussed in the essay had well-established regional reputations, in contrast to New York, Los Angeles was not considered the cultural nucleus that it is today. That is the topic of the last chapter. Following his debut in 1959, Stella continued to make work of considerable interest to young artists on both coasts. Surveying the artist's ten-year development of issues seminal to abstract painting, Philip Leider provides an in-depth review of Stella's first retrospective in 1970. In "Serial Imagery," John Coplans discusses the history of painting in series from Claude Monet to Kenneth Noland. Lucy Lippard and Grégoire Müller offer thought-provoking analyses of monochromatic painting, with special attention to Ad Reinhardt's black paintings. An excerpt from Sheldon Nodelman's major but little-known book accompanying an exhibition of work by Brice Marden, David Novros, and Mark Rothko represents many concerns of the 1970s.

Douglas Crimp's chapter (written in 1981) introduces the first serious critique of abstract painting's relevance to postmodern society. Contrasting neo-geo painting (by Peter Halley, Sherrie Levine, Philip Taaffe, et al.) to the work of Stella and Ryman, Hal Foster reveals the market-driven nature of much art in the 1980s while Jeremy Gilbert-Rolfe provides a more optimistic poststructural interpretation of abstraction. The book also includes Donald Kuspit's "The Abstract Self-Object," an unusual analysis of modern and postmodern painting from a psychological point of view. Surveying the latest development in abstract painting, David Pagel's chapter discusses the impact of contemporary feminism and formalism.

The commentary places the chapters in their historical contexts and examines their philosophical sources and influences, from formalism and phenomenology to structuralism and poststructuralism. Explored also is the impact of influential art critics such as Clement Greenberg, Michael Fried, David Carrier, and Arthur Danto, the perception of abstract paintings as objects or things (rather than pictures or illusions), the role of the body in perception, and the influence of the political critique in postmodernism. A few issues not raised in the anthologized chapters are dealt with in the commentary. Op art, which was never treated very seriously by critics in the 1960s, experienced a surprising revival in the 1980s (see Chapter 8), as

well as more recently in major exhibitions of Bridget Riley's paintings,[9] and should be acknowledged for its contributions to contemporary abstraction. Derided as perceptual gimmicks, op did not easily lend itself to the pervasive critical method of formalism in the 1960s. Meaning or content, which could be found in form at the time, was difficult to attribute to optical painting. The meaning of monochrome painting was almost as elusive, despite the fact that it has been the focus of many critical essays since midcentury.[10] Finally, the role of the computer, which I only touch on in the commentary, promises to challenge and enhance contemporary abstraction in the manner that photography revolutionized the practice of painting in the nineteenth century.

The phenomenon of abstract painting is intimately linked to the history of twentieth-century art, but this does not mean that, with the passing of the century, abstraction has lost its relevance. Although it is not as widely practiced as it was, especially from the 1920s through the 1960s, abstract painting remains viable, particularly appealing to audiences demanding more from art than either visual entertainment or conceptually based political commentary. As Terry Smith observed in 1971, "painting is not becoming obsolete, only less practiced by artists. The best artists who continue to paint feel in a liberated situation – they no longer have to carry the whole weight of artistic change and are more free to explore the infinite options still open within painting. However, they can no longer claim for painting a special status, nor any special concessions. A painting now has to be good/interesting *as art* before it is of any interest as painting."[11] Freed from the demands of history and tradition as well as mimesis, abstract painting, as this book hopes to show, continues to be a vital component of contemporary visual culture.

NOTES

1. Arthur C. Danto, *After the End of Art: Contemporary Art and the Pale of History* (Princeton: Princeton University Press, 1995), 148; Yve-Alain Bois, "Painting: The Task of Mourning," in *Painting as Model* (Cambridge: Cambridge University Press, 1993), 230.
2. Wassily Kandinsky letter to Hilla Rebay (January 16, 1937), quoted in Peter Selz, *German Expressionist Painting* (Berkeley: University of California Press, 1957), 184.
3. Anna Leproskaia, quoted in Jean-Claude Marcadé, "K. S. Malevich: From *Black Quadrilateral* (1913) to *White on White* (1917); From the Eclipse of Objects to the Liberation of Space," in *The Avant-Garde in Russia, 1910–1930: New Perspectives*, eds. Stephanie Barron and Maurice Tuchman (Los Angeles: Los Angeles County Museum of Art, 1980), 22.

4. Quoted in Benjamin H. D. Buchloh, "The Primary Colors for the Second Time: A Paradigm Repetition of the Neo-Avant-Garde," *October* 37 (Summer 1986): 44.

5. See, e.g., Brian O'Doherty, "Frank Stella and a Crisis of Nothingness," *New York Times*, sec. 2, p. 21; and Max Kozloff, "New York Letter," *Art International* 8, no. 3 (April 1964): 64.

6. Danto, *After the End of Art*, 4–9.

7. Donald Judd, "Specific Objects," in *Complete Writings: 1959–1975* (Halifax: Nova Scotia College of Art and Design, 1975), 181–89.

8. Robert S. Hartman, "Introduction," in G. W. F. Hegel, *Reason in History: A General Introduction to the Philosophy of History*, trans. Robert S. Hartman (Indianapolis: Bobbs-Merrill, 1953), xii–xx.

9. *Bridget Riley: Reconnaissance*, Dia Center for the Arts, New York (September 2000–June 2001) and *Paintings 1982–2000 and Early Works on Paper*, Pace Wildenstein, New York (September–October 2000).

10. See, e.g., Joseph Masheck, "Hard-Core Painting," *Artforum* 16, no. 8 (April 1978): 46–56; and Carter Ratcliff, "Mostly Monochrome," *Art in America*, 69, no. 4 (April 1981): 111–31.

11. Terry Smith, "Propositions," in *Conceptual Art: A Critical Anthology*, eds. Alexander Alberro and Blake Stimson (Cambridge: MIT Press, 1999), 258.

1

JULES LANGSNER

FOUR ABSTRACT CLASSICISTS

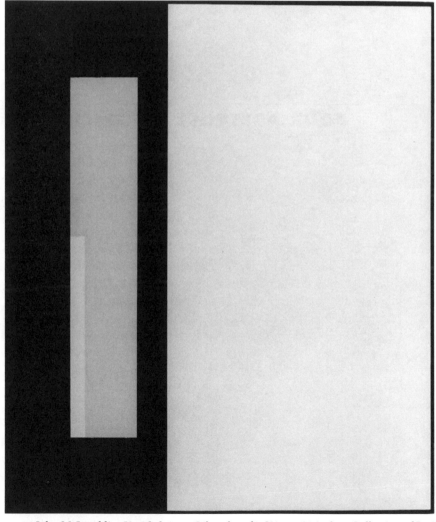

John McLaughlin, *Untitled*, 1953. Oil on board, 38$\frac{1}{2}$ × 32$\frac{1}{2}$ inches. Collection of Joni and Monte Gordon, courtesy of Newspace, Los Angeles.

Everything we see is dispersed and disappears. Nature is always the same, but nothing remains of it, nothing of what we see. Our art should give to nature the thrill of continuance with the appearance of all its changes. It should enable us to feel nature as eternal.

– Paul Cézanne

The four painters banded together in this exhibition – Karl Benjamin, Lorser Feitelson, Frederick Hammersley, and John McLaughlin – are flying in the face of current fashions in art nomenclature by calling themselves Abstract Classicists. Nowadays you can insult some artists by calling them classicists, a state of affairs not entirely surprising if you recall the history of modern art. That history recounts the bitter struggle between traditionalists in positions of authority on the one hand, and defiant tradition-breakers (now victorious) on the other. The traditionalists asserted their right to rule over the art world on the assumption they alone inherited the mantle of Classicism, as if by divine dispensation. To gain recognition the tradition-breakers found it necessary to discredit Classicism as a sterile and oppressive mode of vision for the modern artist.

If there is such a place as a twentieth-century Purgatory, it surely includes a corner reserved for presumptuous classicists. I hasten to assure the reader the Abstract Classicists in this exhibition will not be found in the corner of Purgatory reserved for sterile academicians. The art of the Abstract Classicists belongs to the twentieth century, while at the same time it accords with certain enduring principles of Classicism. Their paintings are without

Jules Langsner, *Four Abstract Classicists* (San Francisco: San Francisco Museum of Art and Los Angeles: Los Angeles County Museum, 1959), 7–12. Reprinted in *Four Abstract Classicists* (San Francisco: Modernism, 1993), 3–6.

exterior resemblance to the Classicism of ancient Greece or of the Renaissance. Nevertheless the paintings are essentially classical in concept. The work of these artists stems from the premise that there is a core of Classicism – distinguished from its several historic manners – which remains valid, viable, infused with creative vitality.

The impulse to Classicism is marked by concern with the element of form in a work of art. The classicist might be described as a form-conscious artist. It is indeed true that form participates (in one degree or another) in most works of art. However, form as a primary force in esthetic experience is stressed in classical art. Form in a classical work is defined, explicit, ponderable, rather than ambiguous or fuzzily suggestive. The spectator clearly apprehends the form as a form, whether or not the form denotes a familiar object or symbol, or is wholly abstract. Consequently response to the work as an esthetic entity cannot be separated from active perception of form.

The classical artist's preoccupation with form transcends passing fancy with any attractions he may find in a particular shape. Form in classical art is articulated in an orderly relation to every other form in the same work. That is to say, forms are structured in accordance with some unifying concept or organizational plan. Moreover the unifying concept in a classical work is not simply an invisible skeleton supporting forms that otherwise might fall apart. The relation of form to form – the construction of the work – constitutes a *raison d'etre* in itself. Our pleasure, our satisfaction, in response to a classical work of art derives in no small degree from awareness of the work's configuration, from the clarity and coherence of its structure.

The classicist, like everyone else, is subject, in day to day life, to a buzz of confusion, to innumerable fleeting impressions and unrelated experiences. When it comes to art, however, the classicist seeks ordered relationships of a kind seldom found in the helter-skelter of raw existence. In this regard Classicism parallels the inquiries of science. The simultaneous emergence of science and classical art from the seedbed of Greece was more than happenstance. Both science and classical art reflect the passionate need of the Greek spirit to bring light and order to the world of man.

Classicism shares with science the premise that the phenomenal world conforms to one or another principle of regularity. The incredible achievements of science testify to the validity of this implicit faith in the coherence of phenomena. The scientist discovers coherences that previously eluded detection. The classicist creates man-made objects to duplicate the idea of coherence. Just as there are innumerable modes of organization in the universe, there are endless ways for the classically minded artist to create impeccable works of art.

Impeccable order in a classical work requires clarity in the relation of form to form, form to color, and form and color to space. To achieve impeccable order the classical artist consciously edits "ideas" rising to the surface from the unconscious. The classicist ponders the choices open to him in the construction of a work of art, and he accepts full responsibility for his decisions. A classical work is deliberated rather than produced spontaneously. Its development is controlled and in no way is the outcome of chance caprice. This is not to say the paintings of these four Abstract Classicists are assembled mechanically according to a preconceived plan. They are not. An Abstract Classicist painting may develop step by step, one form suggesting another, or the "idea" for the picture may precede its placement on canvas.

The process of developing an idea step by step as the painting unfolds is described in a revealing statement by Frederick Hammersley –

I compose a painting by hunch. A "hunch" painting begins by having several different sizes of canvas around. By seeing them every day I will for some unclear reason pick up one. Part of the time I have no idea to begin with. I like the size and shape in front of me and I try to put marks on it to go with it. It seems to be a process of responding or reacting to a particular "liked" canvas.

At first I would paint a shape that I would "see" there. That one colored shape in that canvas would work, or fit. The next shape would come from the feeling of the first plus the canvas. This process would continue until the last shape completed the picture.

The structure making is of prime importance. Until this is right nothing further can be done. After the picture works in line the shapes "become" colors. I answer the hunch as it comes.

John McLaughlin, on the other hand, frequently commences a painting with an advance "idea" in mind. He writes:

Actually, the task of composing a painting is always with me, whether in my studio or elsewhere. So when it's time to really nail something down I have some idea of the immediate approach, test it out and try to perfect it by placing forms cut from construction paper directly on the canvas. By a devious process of trial and error, these forms constantly varying in size, color, numbers, a placement will eventually determine the feasibility of the plan in mind. When and if satisfied with the design, notes of the precise placement of the papers are made and similarly drawn on the canvas, then painted in with possible changes in color only.

In either case – step-by-step creation of forms or trial and error modification of an advance idea – the Abstract Classicist first draws upon intuition and then edits the raw material. Both stages are equally important: without

suggestive ideas, no painting; without editing, no coherence. An Abstract Classicist painting, then, represents a rational crystallization of intuitive experience.

A classical work of art aspires to balance – thought and feeling, intelligence and intuition, reason and emotion. The rational element in classical art runs counter to a widespread contemporary belief in the primary value of emotion and intuition in esthetic experience. Submitting the creative act to regulation (or guidance) by intelligence, it is contended, diminishes (if it does not exterminate) mood, feeling, emotion. Thus one encounters comments to the effect classical art is cold, austere, impersonal, excessively disciplined, devoid of passion, what have you. These are objections difficult to overrule only if one accepts blindly the premise that the mission of art is concerned exclusively with the expression of emotional states of being, and forgetting that intelligence is every bit as human as feeling.

Nor is classical art devoid of feeling. That's a canard no amount of analysis of the esthetic experience can dispel for persons determined to accept as an article of faith the equation – Classicism Equals Cold Art. It is true the classicist is not preoccupied with art as an opportunity to make autobiographical statements. He is not a narcissist in paint, nor does he turn to art for the succor of the confessional. Feeling in classical art is distilled, rather than transferred in its primal state. The classical approach results (in large part) from an awareness of art as a distinctive kind of experience. Classicism recognizes the difference between immediate emotion or sensation and the change effected in experience by its conversion into art.

Classical art objectifies subjective states of being in the sense that Haydn or Mozart transpose feeling states into lucid structures of sound. A classical work shifts the viewer's attention away from the fugitive life of emotion to the enduring life of art. In this connection, Karl Benjamin observes, "There is, of course, a powerful emotion latent in the relationship between man and painting, depending for its release on the openness of the former, the worth of the latter, and some indefinable mutuality in both."

Abstract Classicism parts company from earlier schools of Classicism in that it disposes of allusions to the familiar external world of everyday life. The relative merits of figurative and non-figurative art is [sic] not at issue here. Suffice to say, abstraction, in one or another of its manifestations, is a going concern in all corners of the free world. Thus the presentation of an ideal human form, appropriate to the concerns of classic Greece, is without relevance to Abstract Classicism. Nor is Abstract Classicism concerned with historical genre painting, as in the Classicism of Poussin or David. Abstract

Classicism seeks to create *new* perceptions rather than recreating familiar forms or legends.

The four Abstract Classicists in this exhibition frankly acknowledge they are purists of painting. They are engaged in a serious and determined effort to create works of art that are at once a pure, formal, and harmonious quintessence. A purist in matters of art, unlike a purist in mathematics or science, may expect to have his work discounted as a form of social irresponsibility, or interpreted as a devious psychological retreat from reality. In answer the Abstract Classicist might contend (and I would concur) that the artist may create experiences other than mirror images of ourselves. It is within the power of art to add unique dimensions to life without which our existence would be impoverished indeed.

The Abstract Classicist paintings in this exhibition require a particular way of *seeing* if the viewer is to gain the rewards they offer. It might not be amiss at this point to turn to Poussin, the great seventeenth-century classicist, on the difference between looking and seeing:

There are two ways of looking at objects: one is simply to look at them, the other is to look at them attentively. Simply to look at them is no more than to receive naturally upon the eye the shape and appearance of the object in question. But to look at an object attentively means, over and above the simple and natural impression made upon the eye, to find out carefully the way of knowing the object well. Thus it can be said that to *look* at a thing is a natural function, whereas what I should call *seeing* it is a rational process.

An Abstract Classicist painting presents a distinctive mode of vision. If the spectator is to *see* these works, approach the pictures attentively and not merely *look* at them, he will discover certain salient aspects they share in common.

Abstract Classicist painting is hard-edged painting. Forms are finite, flat, rimmed by a hard clean edge. These forms are not intended to evoke in the spectator any recollections of specific shapes he may have encountered in some other connection. They are autonomous shapes, sufficient unto themselves as shapes. These clean-edged forms are presented in uniform flat colors running border to border. Ordinarily color serves as a descriptive or emotive element in painting. Its relation to the viewer tends to be more visceral than cerebral. But in these paintings color is not an independent force. Color and shape are one and the same entity. Form gains its existence through color and color its being through form. Color and form here are indivisible. To deprive one of the other is to destroy both. To clarify matters,

eliminate semantic confusion, it is helpful to unite the two elements in a single word – *colorform*.

Notice that each colorform is flat. No attempt is made to simulate volume or illustrate recession in perspective, or as Lorser Feitelson states, these works "are free of three-dimensionally described objects, tangible space, perspective, or atmospheric light and dark shading." The flat colorforms gain definition by the ways in which they fit exactly the contours of the adjacent colorforms. The colorforms are complementaries of each other, coupled together as in the Chinese symbol for *yin and yang*.

Thus each colorform behaves as both a positive and a negative force in the painting.

The paintings in the exhibition are composed by making shapes exactly complement each other, and at the same time oscillate back and forth as positive and negative forms. The approach follows a track of ideas suggested by the pictures of Malevitch and the constructivists, and Mondrian and the painters of De Stijl. In the pictures of Malevitch and Mondrian there is a striving to create an art of flat geometric shapes that is not fixed and stabile. It is an art in which static elements are tensed, made to separate from each other, advance forward from the picture surface and back again.

The California Abstract Classicists proceed from this intention of Malevitch and Mondrian. They seek to fluctuate forms that are tightly embraced together. Forms in their paintings are in continuous flux. Forms are not frozen in an instant of time, nor are they constructed as a building – firmly fixed in a stationary position. The paintings take place in space-time. At one moment a form announces its presence, and the next moment it slips away, only to reassert itself again. This alternation between forms in focus and the same forms thrust into periphery is precisely determined. The gears must interlock if the paintings are "to work."

The structural principle guiding these four artists is the same. The ways in which they elaborate the concept varies from painter to painter.

The elongated forms in the Karl Benjamin paintings interlock in a continuous composition that seems to be without beginning or end. Whenever one of these zigzag shapes appears to overlap an adjacent zigzag, it tucks itself back in somewhere else. According to Benjamin, "Each shape or form is almost part of a great sheet with only this little part showing to let

you know the whole exists." Benjamin is a subtle colorist, inclined towards closely orchestrated hues to create effects in concert.

Shapes in the paintings of Lorser Feitelson are "Magical Space Forms" intended to suggest realities beyond themselves, realities Feitelson calls "extra existences." He employs color to intensify the "magical" reversal of form and space. Contrast is more important than closeness of values, and the combination of colors often is startling and unexpected. He is concerned primarily with the duality of space and form, stating, "Space, with its expressive possibilities of mystery and monumental magnificence, and rhythm, with its limitless potentialities for harmonic and emotional experience, are the two principal elements in my recent work."

Frederick Hammersley's forms present a poetic attitude towards shapes as growing things. As he says, "They are not really round, nor often really straight – they just look that way." Hammersley thinks of depth as a by-product of the reaction between the colored shapes. He does not try to suggest depth. When it comes to color, Hammersley is frankly a hedonist. There is a carnival air to the colors he favors, and as he explains, "Color is the reason for painting. Color is pleasure and satisfaction."

The John McLaughlin shapes are consistently perpendicular. They avoid curves, diagonals, or other intimations of form in nature. Deliberately neutral in character, McLaughlin's forms might be described as anonymous. Essentially color serves him as a means of defining forms and regulating a form's relative importance in the composition. The overall impression of a McLaughlin painting almost invariably is that of a cool serenity. Each painting represents the outcome of a process of refinement. He says, "I work long and hard, make and remake until I feel that every barrier to 'being there' has been hurdled."

The paintings of these four artists are the result of intellect and intuition working harmoniously together. The impeccable order in the pictures may suggest to the casual viewer so many demonstrations of a cold and impersonal logic. Nothing could be farther from the circumstances of their creation. True, accident is not allowed to intrude. Shape, scale, and color are carefully determined in relationship to each other. But the creation of a shape and the choice of color to give that shape existence is purely intuitive.

The human mind may create an intelligible order. The process by which it accomplishes that creation remains mysterious and elusive. The paradoxical relation between the intelligible and the mysterious concerns Lorser Feitelson. He says of his work, "The enigma of reality is greatly increased by the duality of interchangeable forms and space in which stark flat areas

of color have an ambiguous existence. To achieve this result I find my work demands full participation of both my sensibilities and my critical faculties."

The indefinable element in Abstract Classicism leads McLaughlin to observe, "I use my powers of selection (and rejection) to the full, but on the other hand I cannot explain why I accept a particular design as against another. Nor, incidentally, do I employ logic as a means of realizing my objectives. I have no workable scheme or formula. If my work could be reasoned out and defined in terms of logic I have failed."

From the fifth century B.C. to the sixth decade of the twentieth century A.D. there have been many permutations of Classicism. The final verdict on the California Abstract Classicists is not in. Each of them – Benjamin, Feitelson, Hammersley, and McLaughlin – continues to explore a frontier of painting. On the basis of this interim report the odds are in their favor.

PHILIP LEIDER

LITERALISM AND ABSTRACTION
Frank Stella's Retrospective at the Modern

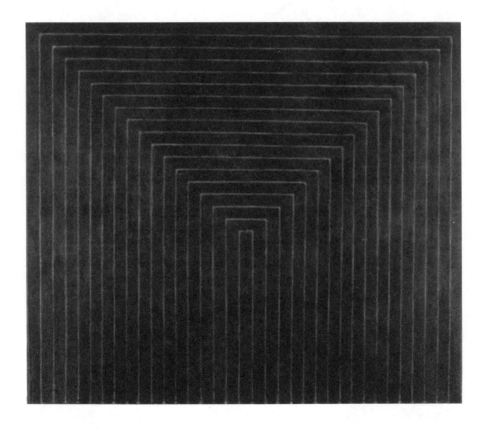

Frank Stella, *Getty Tomb*, 1959. Black enamel on canvas, 84 × 96 inches. Los Angeles County Museum of Art, purchased with Contemporary Art Council Funds. © 2002 Frank Stella / Artists Rights Society (ARS), New York.

The idea in being a painter is to declare an identity. Not just my identity, an identity for me, but an identity big enough for everyone to share in. Isn't that what it's all about?

— Frank Stella, in conversation

Both abstraction and literalism look to Pollock for sanction; it is as if his work was the last achievement of whose status every serious artist is convinced. The way one reads Pollock influences in considerable measure the way one reads Stella, and the way in which one reads Pollock and Stella has a great deal to do, for example, with the kind of art one decides to make; art ignorant of both looks it. The abstractionist view of Pollock was most clearly expressed by Michael Fried, basing himself in part on Clement Greenberg, and that view is now so thoroughly a part of the literature that students run it through by rote; how his art broke painting's dependence on a tactile, sculptural space; how the all-over system transcended the Cubist grid; how it freed line from shape, carried abstract art further from the depiction of *things* than had any art before; how it created "a new kind of space" in which objects are not depicted, shapes are not juxtaposed, physical events do not transpire. In short, the most exquisite triumph of the two-dimensional manner. From this appreciation of Pollock, or from views roughly similar, have come artists like Morris Louis, Kenneth Noland, Jules Olitski, Helen Frankenthaler and, partially at least, Frank Stella.

The literalist view of Pollock emerged somewhat more hazily, less explicitly, more in argument and conversation than in published criticism.[1] Literalist eyes – or what were to become literalist eyes – did not see, or did

Philip Leider, "Literalism and Abstraction: Frank Stella's Retrospective at the Modern," *Artforum* 8, no. 8 (April 1970): 44–51.

not see first and foremost, those patterns as patterns of line freed from their function of bounding shape and thereby creating a new kind of space. They saw them first and foremost as *skeins of paint dripped directly from the can*. Paint, that is, which skipped the step of having a brush dipped into it; paint transferred from can to canvas with no contact with the artist's traditional transforming techniques. *You could visualize the picture being made* – there were just no secrets. It was amazing how much energy was freed by this bluntness, this honesty, this complete obviousness of the process by which the picture was made. Another thing about Pollock was the plain familiarity with which he treated the picture as a *thing*. He left his handprints all over it; he put his cigarette butts out in it. It is as if he were saying that the kind of objects our works of art must be derive their strength from the direct-ness of our attitudes toward them; when you feel them getting too arty for you (when you find yourself taking attitudes toward them that are not right there in the studio with you, that come from some place else, from some transmitted view of art not alive in the studio with you) give them a whack or two, re-establish the plain-ness of your relations with them.

Literalism thus sees in Pollock the best abstract art ever made deriving its strength from the affirmation of the *objectness* of the painting and from the directness of the artist's relations to his materials. In short, the greatness of the abstraction is in large measure a function of the literalness of Pollock's approach. Such a view of Pollock would naturally lead one to seek in quite different places for a way to continue making meaningful abstract art than would a view based on the abstractionist reading of Pollock. The kind of an object a painting was began to emerge forcefully as an issue in painting.

The objectness of painting was explored with great ingenuity and enor-mous sophistication by Jasper Johns during the middle and late fifties, but his literalism is consistently undermined by a Duchampian toying with irony and paradox, an impulse to amuse and be amused above all. How cleverly he seemed to dismiss problems that were draining the life out of abstract art! How easily those flags and targets seemed to diagnose and then cure the lingering illusionism and vestigial representationalism that plagued ab-straction in the fifties. All that had to be done was simple rehearsal of the differences between actual flags and actual paintings.

Needless to say, abstraction was not looking like that. Abstraction was discovering that objectness was the thing to beat, and that the breakthrough to look for was a breakthrough to an inspired two-dimensionalism, and that the way to do it was through *color*, and, as much as possible, through color alone. That the differences were immense can be seen simply by comparing

a Noland circle painting with a Johns target. The one is about color and centeredness and two-dimensional abstraction, with no references whatever to objects or events of any kind in the three-dimensional world. The other is about an object called a target and an object called a painting, and, given the cleverness with which the problems are posed, were an instant success in colleges everywhere.

One college student, Stella, saw in Johns a way to an advanced all-overness. The cleverness, irony and paradox parts he left to others, perhaps figuring that if Still and Pollock could do without them he probably could too. From Johns, Noland could only have taken, if anything at all, the suggestion of the possibilities of a centered image. Stella, however, takes from Johns directly the striping idea: it solved the problem of keeping his pictures flat, and it solved it simply, clearly, and in a way that allowed him to move on to other things.

Stella was crucially interested in keeping his pictures flat because he was crucially interested in making abstract pictures that could survive as post-Pollock art. He was crucially interested in making abstract pictures, and *only* in making abstract pictures, and has never been interested in anything else to this day; the consistency of Stella's antiliteralist ideas throughout his career is remarkable, as the extensive quotations from Stella's both public and private remarks, scattered through the catalog text, make clear.* As other abstractionists like Louis, Noland and Olitski – all older by at least ten years than Stella – pursued this ambition by exploring color, Stella thought the biggest obstacles to a greater abstraction were structural and compositional, and he went to work overcoming these with a cold, smartaleck, humorless methodicalness that showed up, in the paintings he finally exhibited at the Museum of Modern Art in 1960, like a slap in the face.[2]

The pictures were insufferably arrogant. They seemed to reiterate nothing but insultingly simple principles that only his paintings, however, seemed to understand. Thus, if you are going to make an abstract painting, then you cannot make it in the kind of space used for not-abstract painting. And if you are going to make abstract pictures you have to be sure that your colors don't suggest or take on the quality of non-abstract things, like sky or grass or air or shadow (try black, or if that's too poetic, copper or aluminum). And if one is going to make an abstract painting one should be thoughtful about what kind of image one chooses, how it is placed and what kind of shape the entire picture has because otherwise,

* William Rubin, *Frank Stella* (New York: Museum of Modern Art, 1970).

before you know it, you are going back into all the classical problems: objects in a tactile space. Also, a picture isn't abstract just because the artist doesn't know when it's finished. Pollock's message wasn't "Go Wild"; it was 1) keep the field even and without dominant image or incident; 2) be careful about color; 3) keep the space as free from the space needed to depict three-dimensional forms as possible; 4) eliminate gesture, let the method chosen seem to generate the picture. If the *whole* picture is working right, accidents and inconsistent details don't matter any more than handprints and cigarette butts; there can be mistakes, awkward stretcher bars, even drips.

The main criticism of the pictures seems to have been that they had nothing to say.

The great irony that comes in here is this: all the while that Stella is pursuing, with ferocious single-mindedness, the idea of the completely consistent non-referential abstract painting, artists like Carl Andre and Don Judd are being absolutely fascinated with the literal *objectness* of Stella's paintings. Andre, who was very close to Stella in the early sixties, seems to have been the first to draw the conclusion that almost all the literalist artists were to come to: if the best painting was moving inevitably toward three dimensions, then the best hope for a true post-Pollock abstraction may lie in three-dimensional art. The incipient move into three dimensions implied in Stella's paintings is made manifestly clear in Andre's work of the early sixties, most explicitly in a work like the 1959–60 untitled construction. Judd, too, made works which seemed to spell out the three-dimensional implications of Stella's work. Both artists seemed to share what can be called a fundamental presumption of literalism: if one has moved into three dimensions because that seems to be where the best abstract art can take form, then there is no sense in making art in three dimensions that tries to approximate the sensations or appearances of two dimensions. On the contrary, the more three-dimensionality is affirmed, acknowledged, declared, explored, the more powerful the work of art can be. One of the ways in which this is done, for Judd, is in the employment of simple orders. Writing in 1965, Judd remarked, "Stella's shaped paintings involve several important characteristics of three-dimensional work," and he goes on to list them. Among the things he lists is the *order* of the stripes, which he calls "simply order, like that of continuity, *one thing after another*." Stacking is such an order, simple progressions another. Andre depends heavily on orders which, as often as possible, correspond to the way in which materials are used in the literal world, common orders, one thing beside another, like a row of bricks. Almost all the literalist imperatives come from the need to explicitly

acknowledge three-dimensionality: structural clarity, everyday materials, directness of relations with materials.

The differences between Andre and Judd emerged slowly and steadily all through the sixties; Andre was to consistently limit himself to solutions that were respectful of, and consonant with, the problems of sculpture, while Judd's indifference to sculpture and its problems would become more obvious every day. Both artists got better and better. Criticism might have focused on this and life for both men might have been, if not easier, at least a little more dignified. Instead, both got washed into the mud slide called "Minimal art," or ABC art, or Primary Structures, and found themselves part of a "movement" that included work as utterly extraneous to their interests as Larry Bell's glass boxes, Tony Smith's architectural abstractions, Robert Morris's psychology-oriented constructions. (Judd's protesting voice, utterly lost in the ballyhoo, can be picked up in the catalog of "Primary Structures": "I object to several popular ideas. . . . ")

The Minimal art craze set everyone back for years; the job of criticism now would seem to be to patiently undo the damage and carefully begin the work of revealing the development of a literalist art in America which extends quite unbrokenly from about 1959 to the present and which, in one way or another, involves in its network at least part of the work of artists as diverse as Andre, Judd, Flavin, Serra, Heizer, Morris, Smithson, Sonnier, Nauman, Saret and undoubtedly many others including, for example, early Poons and early Ron Davis. It is a development which cannot be contained in categories like minimal, reductive, anti-form, process or anti-illusion, and museums, rushing to organize exhibitions around such "themes" are, as usual, doing more damage than they can imagine.

The abstractionist critics – mainly Clement Greenberg, then Michael Fried, William Rubin and others in greater or lesser degree – had, by the mid-sixties, done monumental work. They had turned the stampede toward a second-rate, imitative gestural painting ("Tenth Street") and re-directed the eyes of the art world to where the quality really was coming from: Louis, Newman, Noland, Olitski, Stella, Kelly, Frankenthaler, David Smith and Caro. (Don Judd's critical writing in many cases made similar judgments, but from an utterly different point of view.) In the development of literalism, however, abstractionist criticism has figured hardly at all: to the extent that the abstractionist critics considered it at all, they condemned it. (No critics of the quality of the best abstractionist critics came forward to champion or explain the literalist development, and this may account for the fact that the literalist artists do a lot more of their own writing than had been customary.)

Abstractionist criticism tended to ignore the literalists except when it had to deal with Stella. Noland and Olitski, for example, worked as if literalism never existed; they were years older and seem to have felt no compulsion to engage with it. But literalism was being made by Stella's friends and contemporaries and it was palpably clear that on one level or another Stella was engaged with it, even, perhaps, against his will, certainly against his explicit convictions about where quality in contemporary art lay. So in dealing with Stella abstractionist criticism had either to condemn him for seeming to be inextricably mixed up with artists like Judd and Andre and Flavin and those others, or it had to somehow disassociate him from them. In the latter case, the line was always that the literalists misunderstood Stella. (In Mr. Rubin's text they seem to be misunderstanding him on every page.)

Stella's statements often seem to back up this interpretation, but they are never really on all fours with it. It always seems, in reading his remarks, that his objections are not so much to a misunderstanding of his work but to the fact that the implications being extracted from his work are not leading to art that he can believe in with the absolute assurance with which he accepts the art of Noland or of Caro; it is as if he feels that better work should somehow have come out of literalism, and that if it had *he* would certainly have a lot fewer problems than he has. He has certainly never made the moves in his own work which *would* disassociate him from his literalist contemporaries (as, for example, Poons has done, and Ron Davis), and this perhaps out of a deep instinct for what it is that makes his work so central to ambitious art. For it is precisely Stella's ambivalence about the literalist implications of his own paintings that is fundamental to what he is all about. It is why every move he makes is followed with such intense interest by other artists; his own love-hate relationship with literalism is an issue which arises in their studios every day. It is the source of his direct relevance to almost all the serious art that is being made today, and it is why his retrospective has a seriousness to it, a timeliness that few others have had. His shows just get looked at with harder eyes and tougher minds, because, for almost everyone, taking Stella's measure is more *important*, somehow, than taking anyone else's.

Judd's reading of the implications of Stella's striped paintings must have been argued over by Stella and his friends hundreds of times in the years between 1960 and 1965, and though Stella, in his commitment to the esthetics of abstraction, has openly repudiated it, he has never done so *completely*, and never without some amount of duplicity. It is Stella's ambivalence and

humor, therefore, that gives the flavor of high comedy to Mr. Rubin's account of the famous "thick-stretcher" controversy:

In New York City, Stella began to increase the size of his box-and-stripe pictures. He stretched the cotton duck over 1 × 3's which he butt-ended together. This method, used for reasons of economy, produced an approximately 3-inch-deep stretcher that set the picture more clearly off from the wall. Stella soon found this deep stretcher to his taste aesthetically and has retained the device. Given the flatness of his painting, there was always the possibility that the plane of the picture might be assimilated to the wall. The deep stretchers, he has remarked, "lifted the pictures off the wall surface so that they didn't fade into it as much. They created a bit of shadow and you knew that the painting was another surface. It seemed to me to actually accentuate the surface quality – to enhance the two-dimensionality of the painting's surface."

In view of Stella's eschewal of pictorial allusions to anything outside the painting itself – or even of illusionist references to the space of that extra-pictorial world – it was inevitable that the deep stretcher would focus attention on the picture as an object. And, indeed, that objective sense of the surface reinforced the anti-illusionist flatness. But in popular criticism the awareness of the object nature of the picture led in time to loose theorizing – on the level of what Meyer Schapiro has called "night-school metaphysics" – about the concreteness or objectness of the paintings. This kind of theorizing later played a role in the "justification" of Minimal art, and Stella feels it has turned into cant. "It's a little bit my own fault. I didn't mean it to be that way. I used to say that, after all, a painting is only an object – not meaning that it's just any object. It is a special kind of object – one that's intended to be a painting. My position was a reaction to the high-flown rhetoric of the fifties, but my reasoning got . . . abbreviated." In this regard, the net effect of the deep stretcher, Stella has observed, is that "it makes the picture more like a painting and less like an object by stressing the surface."

Mr. Rubin is anxious to save Stella for abstraction and disassociate him from what he calls "Minimal art." It thus becomes perfectly logical, for him, that an extra-deep stretcher enhances the two-dimensionality of the picture surface, while it is only in grubby night schools that the addition of depth to height and width makes an object more *three*-dimensional. What then is Stella *really* liking about the effect of that deep stretcher? It is the object quality they give the picture, and if he does not say so it would seem to be again because of his hesitation about the ultimate quality of any literalist innovation, even his own. Mr. Rubin is a little too offhand in remarking that Stella "retained the device," as if it were a matter of no consequence. In fact Stella didn't merely "retain" the deep stretcher – he made it even

deeper. Some more of that "loose theorizing" turned on the observation that the deep stretcher was roughly as deep as the width of the painted bands, thus providing a very literal module for them. Loudly did Stella protest this reading, but in the 1966 series, which used a much wider band, the stretcher, by coincidence, also widened, from three to four inches.

Some of Stella's anti-literalist utterances are extreme, but, to my mind at least, they are never as extreme as they appear to Mr. Rubin. "The sculptors just scanned the organization of painting and made sculpture out of it. It was a bad reading of painting. . . ." The statement seems damning enough, but Stella is a complicated artist and probably an even more complicated man, and Mr. Rubin's haste in snaring the quotation and using it to justify writing off "minimal sculpture" altogether, completely overlooks the ambivalence that has always marked Stella's attitude. "Misreading his enterprise," Mr. Rubin writes:

some sculptors saw his shaped canvases as pointing ineluctably to their three-dimensional art. To that extent, the historical position of minimal sculpture is more of a tangential offshoot of late fifties abstract painting than it is a continuation of the main line of sculptural development that passed through David Smith.

Stella would probably not be so quick with that "misreading his enterprise" business, especially as applied to artists who were, after all, friends and contemporaries. It is Andre who writes the catalog statement for Stella in "Sixteen Americans" (and who still likes to insouciantly identify himself as "student of Stella"), and it is alongside Judd that he defends sixties art in a well-known interview. If fellow artists who know you that well are misreading your enterprise so badly, then either you have pretty dumb friends or maybe they're not misreading it so badly after all. In any event, there is no misreading Mr. Rubin's enterprise: he is anxious to get Frank Stella as far from those "Minimalists" as he can get him.[3]

By the middle sixties almost all of Stella's contemporaries in New York were dealing with literalist issues in one way or another. In three dimensions, literalism was rapidly discovering that earlier blanket strictures against illusionism of any kind was [sic] too restrictive an attitude: materials themselves were making that clear enough. Some materials simply led one into certain kinds of illusionism – mirrors, plexiglass, various kinds of perforated metal, fluorescent light. (By the end of the decade materials would have provided literalism with ways of drawing, with compositional relations, with fantasy, with poetry, and all in ways perfectly consistent with the most deep-rooted literalist convictions.)

Stella's 1966 series – sometimes called the Wolfeboro or Moultonboro series and in the catalog text called the Irregular Polygons – is one which Michael Fried thought ought to have been "unpalatable to literalist sensibility," partly because of the incipient illusionism which Stella permitted in them. But it is interesting to compare the series with what Judd liked about the stripe paintings:

Stella's shaped paintings involve several important characteristics of three-dimensional work. The periphery of a piece and the lines inside correspond. The stripes are nowhere near being discrete parts. The surface is farther from the wall than usual, though it remains parallel to it. Since the surface is exceptionally unified and involves little or no space, the parallel plane is unusually distinct. The order is not rationalistic and underlying, but is simply order, like that of continuity, one thing after another. A painting isn't an image. The shapes, the unity, projection, order and color are specific, aggressive and powerful.

The periphery of the Irregular Polygons and the lines inside correspond; the surface is even farther from the wall than previously; the order of the painting is not rationalistic and underlying but is simply order, like the order of a map, and, like a map, is not an image but a unity of shapes whose projection, order and color are specific, aggressive and powerful. Certainly, the paintings were a little "soft on illusionism," but illusionism, as Ron Davis was shortly to make even clearer, wasn't the issue in 1966 that it was in 1961. The illusionism in the Irregular Polygons didn't bother anybody. The pictures affirmed their objecthood in as straightforward a way as any of his pictures had before.

Without a doubt, the *main* ambitions of the pictures were not related to literalism or to the issue of objecthood any more than were the main ambitions of the stripe pictures. In the Irregular Polygons these ambitions seem to have had more to do with getting to use color in a way not previously available to Stella; the very fact that they *needed* color as they did pointed to a growing conviction that a high post-Pollock abstract art founded on structure alone could not be carried further than Stella had already carried it. ("The sense of singleness . . . has a better future outside of painting," Judd had written the year before.)[4] A second ambition, obvious in the *blitzkrieg* manner of Stella's attack (who ever thought of making paintings with shapes like *that?*), was to raid the shaped canvas and convert it into what would be, for the next while at least, virtual private property. But in the course of accomplishing these ambitions Stella had given a whole lease on life to literalist painting.[5]

By 1966 Stella had been under the gun for five years. In the Irregular Polygons he accomplished a major change of style without having to give an inch of his position in the center of advanced art in New York and without managing to repudiate any of the meanings which literalism attached to his work. The strain shows in the paintings, many of them the most explicitly violent Stella has ever made. Forms interpenetrate as if by naked force; spiked, sharp edges abound; colors often verge on the hysterical. It is astonishing that even as these paintings are being made the vision of a monumental decorative muralism is taking form in the artist's mind.

As the sixties drew to a close, the relationship between literalism and abstraction in American art changed considerably. When the decade opened, both literalism and abstraction shared the ambition to make the most advanced abstract art it was possible to make after Pollock. As the decade came to an end it was clear that within literalism several tendencies had emerged and the issue of whether the goal of art making was still high abstraction was no longer one on which everyone agreed. The move into three dimensions led further than anyone had anticipated; the interest in materials led to orders and applications vastly more complex than anyone had dreamed. Literalism was encompassing acts and arrangements unthinkable seven or eight years before and artists were making choices which had no sanction as certain, say, as Pollock had granted to the work of the early sixties. Sanction for many of the undertakings of these artists was sought – if it was sought at all – in traditions much older than Modernism, and in this many of the literalist artists of the late sixties resemble the emerging Abstract Expressionists of the mid-forties. For both, the sense of a new beginning was overwhelming; for both the idea of *what to do* as artists was up for grabs; for both uncertainty, especially as it pertains to their relationship to the tradition of modern art – and not merely the plastic tradition but the social and economic traditions of museums, dealers, collections and collectors – is the fundamental condition of their creative lives.

Stella's relationship to the literalism of the late sixties is not crucial; no critic need worry about disassociating the Protractor series on which Stella commenced work in 1967 from Morris, Smithson, Heizer or Sonnier, for example. Even his ten-year dialogue with Judd has quieted to matters like the casual salute to the stacked boxes in the design of a painting like *Tahkt-I-Sulayman II*. And, like literalism itself, his relationship with abstraction, by the end of the sixties, is not that critical either. It is as if the demands of a monumental mural decoration could be, and have been, engaged without reference, or without *strident* reference, to the two esthetic attitudes which had hitherto governed the making of high art in his time. Stella's most

recent series, therefore, is in a sense outside the scope of this article, or at least seems to be at this time.

This might be just as well, since the exhibition contains only eight of the 100-odd works Stella has made in this series since 1967. Accurate analysis awaits a large exhibition of these paintings alone, one in which Stella's various moves, both successes and failures, can be sorted out and evaluated. The limitation to eight works in the exhibition is undoubtedly a function of mechanical requirements (space, mostly) and balance (though the series, chronologically, *does* take up a third of Stella's mature career). It also, I suspect, reflects Mr. Rubin's own uncertainties regarding the series. The catalog text *worries* a lot about the pictures—it worries about a certain loss of structural consistency in some of them; it worries about the introduction of certain illusions; it worries about the introduction of a kind of figure-ground relation in some of them.

The new pictures suggest that Pollock's role as a mediator between mural and easel painting did not so much derive from the size and scale of his large pictures, as from their *decorativeness*. At least one direction implicit in Pollock, therefore, was the possibility of accepting and acknowledging the decorative implications of abstraction instead of avoiding or denying them (the usual reaction to the charge of "wallpaper" is to have a fit). The risks were great – an apparent loss of seriousness, a sense of being lightweight – but success could open to abstract art an area of vast possibilities. For Stella, working with large shaped canvases which tended more and more to look as if they were made for specific architectural settings, the vision of a high-level decorative art not only dovetailed with perfect logic with where he had arrived after the Irregular Polygon series, but also represented itself as a continuation of a main implication in Pollock.[6]

But the character of the artist! Of all the artists in America who *might* have decided to risk the possibilities of letting loose the decorative id beneath the abstractionist ego, Stella was surely the least likely. The identity he had declared, the identity he had imposed on American culture, was coiled, tense, arrogant, lean, ungenerous, unremittingly rational, self-denying and unsensuous. From whence was to come the openness, generosity, spontaneity, lyricism which an art of freely accepted decorativeness was to be made?

In the light of the most recent paintings in the exhibition (which, it must be emphasized, is not as good a light as a large-scale exhibition of these works would be) it would seem that the beginning of the series was marked by the strain of a kind of mental and emotional "re-tooling." The earliest paintings in the series held tensely to very simple and prominently declared all-over design structures – which Stella has designated as interlaces, fans

and rainbows – within which an extensive range of colors was employed. The design structures corresponded sometimes rigorously, sometimes less consistently, to the overall shape of the canvas, which was architectural and muralistic and which was by far the most radical aspect of the paintings. In other words, Stella, during this early period, found himself relying on what he had always relied on: a bold picture shape and an aggressive all-over design structure. The amount of freedom given to color is greater than in the past, but it is apparent throughout that he is depending on what he has always depended on to deliver the picture with force and cogency. Most interesting of all, however, is the lingering *harshness*, even some traces of the pictorial violence of the Irregular Polygons. It would appear that Stella would be deep into the series before a genuine lyricism would be freed, and good criticism can look forward to sorting out the steps Stella had to take to achieve it.

Certainly by 1969 and 1970, Stella had thoroughly loosened the overall design structure and seems to have systematically turned more and more of the authority of the paintings over to color. Pictures like *Ile a la Crosse II* and its companions have an expansiveness of decorative grandeur which bursts upon us like the interior of the Guggenheim Museum, triumphs of sheer confidence. In pictures like these, the identity we all share in Stella's art as *our* art, the art of *our* time, is deepened, broadened, and made, of all things, joyous.

NOTES

1. And is still emerging. See Robert Morris's article in this issue. [Robert Morris, "Some Notes on the Phenomenology of Making," *Artforum* 8, no. 8 (April 1970): 62–66.]
2. *ARTnews*, for example, went into shock. In writing up "Sixteen Americans" Stella's name wasn't even *mentioned*. [The dates of the exhibition, *Sixteen Americans*, organized by Dorothy Miller, were December 16 to February 14, 1960.]
3. The case for Stella as an abstractionist artist with a special and profound relation to literalism is movingly made by Michael Fried in his essay, "Shape as Form." That I don't use the word "literalism" as he does in that essay, or in his later essay, "Art and Objecthood," should not obscure the fact that it, as well as the whole frame of reference of this article, comes out of his criticism.
4. All the Judd quotations are from "Specific Objects," *Arts Yearbook*, 1965.
5. Only four of the Irregular Polygons are in the exhibition, which seems to me very unfortunate. Those pictures get better all the time, and a larger viewing of them would have been a revelation.
6. Another view of muralism and its problems is in Sidney Tillim's "Scale and the Future of Modernism," *Artforum*, October, 1967. Stella dealt with this essay explicitly in a lecture given in Chicago in 1968.

JOHN COPLANS

SERIAL IMAGERY

Ad Reinhardt, *Black Painting*, 1962. Oil on canvas, 60 × 60 inches. Photograph by Ellen Page Wilson, courtesy of Pace Wildenstien. © 2002 Estate of Ad Reinhardt / Artists Rights Society (ARS), New York.

HISTORY

A paradox of art is that despite the artist's strange antilogical existence, his thinking often coincides with and even anticipates major discoveries in science or philosophy. The use of Serial Imagery in anything like the forms we know it today began with the work of the major Impressionist innovator, Claude Monet;* and to a remarkable extent the Serial[1] aspect of Monet's art parallels the most advanced mathematical concepts of his time.

* Since the original publication of this essay, Coplans has identified California photographer Carleton E. Watkins as the first artist to explore issues of seriality and has amended subsequent publications of "Serial Imagery" to include this information. In an article published in 1978, Coplans wrote:

In the nineteenth-century photographic milieu the word "series" is used very loosely. Usually, but not always, it denotes any cluster of work linked by a shared theme or subject matter, rendered in a similar technique, and the same size. In addition, for purposes of easy reference a series may be numbered. But the numbering system and any order within the series, such as the sequence the images were taken in or even a correct sequence for viewing, might or might not relate.

In Watkins' photographs, however, *series* takes on a special, innovative meaning. Inherent to his use of seriality is the notion of a beginning and end; the coequality of the parts, which are self-sufficient as images yet part of a set; and their uniformity of size, format, and technique. However, what more than anything else differentiates Watkins' use of seriality is the notion of a macro-structure, which he was, it seems, the first to employ. His macro-structure is defined by relational order and continuity. There is a consistent semi-narrative structure and syntax to the Yosemite photographs, encompassing both vista and panorama – distant and lateral vision – and endowing the pictures with their serial quality. Watkins, then, subsumes the notion of painterly masterpiece into photographic seriality.

John Coplans, "C. E. Watkins at Yosemite," *Art in America* 66, no. 6 (November–December 1978): 100–108.

John Coplans, *Serial Imagery* (Pasadena, Calif.: Pasadena Art Museum and the New York Graphic Society, 1968), 7–20. Revised as "Serial Imagery," *Artforum* 7, no. 2 (October 1968): 34–43. Original reprinted in Edward Leffingwell, *One of a Kind: Contemporary Serial Imagery* (Los Angeles: Municipal Art Gallery, 1988).

In 1872 the first half of the pioneer Dedekind-Cantor mathematical theory of the continuous independent variable apeared with Dedekind's publication of *Stetigkeit und irrationale Zahlen*.[2] The second half of the theory, Cantor's *Beiträge zur Begründung der transfiniten Mengenlehre*,[3] was set forth in 1895. In the period between these two publications Monet produced his first extended series, the seven views of Gare Saint-Lazare (1877), followed by the series of fifteen *Haystacks* and the series of twenty *Poplars*, painted and exhibited in 1891. And in 1894, still a year before Cantor's publication, Monet painted the classic prototype of Serial Imagery: the twenty nearly identical views of Rouen Cathedral. With eloquent insight the French writer and politician, Georges Clemenceau, on viewing the exhibition of the *Cathedral* series in 1895 stated: "With twenty pictures the painter has given us the feeling he could have . . . made fifty, one hundred, one thousand, as many as the seconds in his life. . . . Monet's eye, the eye of a precursor, is ahead of ours, and guides us in the visual evolution which renders more and more subtle our perception of the universe."[4]

In the ensuing decades Bertrand Russell elaborated more firmly on the Dedekind-Cantor theory of serial order, first in Volume 1 of his *Principles of Mathematics* (1903) and then jointly with Alfred North Whitehead in the second and third volumes of *Principa Mathematica* (1912–13). At this time Marcel Duchamp made his only Serial construction, *Three Standard Stoppages* (1913). Always the supreme master of irony, Duchamp intended in this piece to attack logical reality by setting up an arbitrary paradigm of the laws of physics. The greatest irony may be that Duchamp to this day is very likely unaware that his scientific parody in 1913 accorded perfectly with the most advanced mathematical principles of the day.

Another aspect of Serial Imagery manifested itself a few years later, however, this time in poetry. Gertrude Stein's famous poem, "Rose is a rose is a rose is a rose," written in 1922, is a classic Serial structure – and a striking antecedent to Andy Warhol's endless Series of identical Brillo boxes which appeared some forty years later. It is not known whether Stein was aware of Monet's Serial work; but she was familiar enough with Whitehead (an early theoretician of Serial order) to name him one of the three geniuses of the time (along with herself and Pablo Picasso).[5]

Over the next two decades in northern Europe experimentation with Serial forms emerged in the work of several artists and one musician, each working independently of the other. In 1914, the Russian-born German Expressionist painter Alexei Jawlensky, a self-exile in Switzerland at the outbreak of World War I, began without apparent reason his extraordinary

series of landscape *Variations*. Jawlensky was to continue painting various Series up to 1937. In the early twenties Arnold Schoenberg, the German musician, began the sophisticated use of Serial forms in his twelve tone scale musical compositions. At approximately the same time in Holland, Piet Mondrian standardized the components of his pictorial structure. Essential to Serial forms is the property of self-consistency, a discovery on which Schoenberg and Mondrian based all their future work. Mondrian was well aware of Monet's Series. In his self-education as an artist at the turn of the century he painted his way through Monet, Munch, Van Gogh, Matisse and later Analytic Cubism. Between 1902 and 1908 there are constant echoes of Monet in Mondrian's work, especially of the *Poplar* and *Haystack* Series. The idea of stabilizing his structure first appears with some consistency around 1914 in Mondrian's ovoid-shaped *Pier and Ocean* Series of charcoal drawings. Prior to leaving Berlin for America in 1931, Josef Albers began his series of *Treble Clefs*, using a repetitive image based on the sign placed at the beginning of the musical staff. Albers did not finish this Series until after he had settled in the United States; it was to play a major role in his subsequent evolution.

Although on the surface there is no link, beyond a unitary geographical location, to this extraordinary emergence of Serial concern in several artists and a musician from Germany, these events are not as coincidental as they appear. The principal connection between Jawlensky, Schoenberg and Albers was their friendship with Kandinsky. Jawlensky and Schoenberg were both members of *Der Blaue Reiter*; Schoenberg exhibited a number of paintings in the 1911 exhibition along with Kandinsky. Kandinsky prior to World War I was the dominant avant-garde artist in Germany and his initial impulse towards abstraction was occasioned by his encountering a Monet *Haystack* at an exhibition of Impressionist painting in Moscow around the year 1895. Unable to recognize the motif in the painting, and puzzled, he consulted a catalogue for the title. The splendor of Monet's painting, however, obscured its represented object and convinced Kandinsky that the *object* was no longer an indispensable element of painting. Kandinsky maintained an interest in Monet's art thereafter; in 1901 in Munich he founded the Phalanx group and exhibited Monet's work.[6] Grohmann mentions the similarities between Kandinsky's painting technique in 1903 and the phase of Monet predating the *Haystacks*.[7]

In addition, Kandinsky was a continuous and close friend of Jawlensky in the years prior to World War I and thereafter when Kandinsky was teaching at the Bauhaus. There can be little doubt Kandinsky noted the constant seriality of his friend's work after 1914.

Albers was a student and later a teacher at the Bauhaus and knew Kandinsky well. It is worth noting that Jawlensky called his first Serial works *Variations*, a title common to music and one used several times by Schoenberg for his compositions. Albers similarly named one of his later Series *Variants*. If no didactic connection can be traced between the evolution of these various artists, including Schoenberg, there is at least one thing they hold in common: their impulse towards abstraction. Music, of course, is in any event an abstract art and Schoenberg's fascination with Kandinsky's circle is understandable. Nevertheless, in view of the vitality of the intellectual climate of Germany up to the point of its destruction by Hitler, and given Kandinsky's impulse towards abstraction, it seems inevitable that the significance of Monet's Serial paintings would have been noted by these men and incorporated in their art.

As a consequence of the rise of Nazism and the outbreak of World War II both Albers and Mondrian were to find their separate ways to the United States, Albers in 1933 (to teach at Black Mountain College in North Carolina) and Mondrian in 1940 via England to New York, where he died in 1944. Although the foundation of Albers' art was laid in Europe, it matured in the United States. A major precursor in the use of Serial Imagery, Albers remains the most important contemporary link with the style's crucial origins.

Whatever admiration for the quality of their accomplishment as artists existed in America, neither Albers nor Mondrian were to have a direct influence on the establishment of the New American Painting,[8] for a variety of reasons. Unlike Hans Hofmann, who also emigrated from Germany in the early thirties, Albers never became identified with the emergent generation of New York post–World War II painters. Hofmann's approach to painting and his gregarious instincts as an artist allowed him to assimilate more readily into the American scene; thus he is now acknowledged as a founding contributor to the New American Painting. Though Albers was never ignored as a painter, within the American art ambience he has invariably been considered more European than American, despite the fact that his art flowered in this country. His famous, endless Series, *Homage to the Square*, which he still continues to paint with incredible verve at the age of eighty, was conceived and begun in 1948 at approximately the same time the New American Painting had established its identity – or at least its quality. For the most part Albers has by choice, it seems, been an isolated figure, standing aloof, obsessively pursuing his own path. Yet one of the ways in which new art authenticates itself and demonstrates its inherent radical quality is the manner in which it enforces a re-evaluation

of past art. And just as the New American Painting has forced a rehabili-
tation of Claude Monet and brought his art back into the prominence it
so justly deserves, another, younger generation of American painters now
compels a reevaluation of Albers' art; it is to be hoped that with recognition
of Albers' key contribution to the evolution of Serial Imagery, his position
and seminal contribution to American Painting will be more realistically
assessed.[9]

A special condition of the American scene (significant to the generation
of the New American Painters) was an attitude which rejected any distinct
stylistic affiliation to a particular painter or movement. While it is true both
Gorky and Pollock owe an enormous debt to Picasso, they worked their
respective ways *through* Picasso, and finally rejected falling into his orbit;
indeed, they proceeded to first raise and then paint a series of *objections* to
Picasso's art. This process was eventually to unleash their own unique vision.
Moreover, if the stylistic variety inherent to the New American Painting is
closely observed, it can be seen that every major American painter who broke
through in that epoch employed a similar procedure vis-à-vis the dominant
twentieth century European art. It must be emphasized that the American
painters were looking to the overall range of European art within the first half
of the century. In this manner they maintained diversity of outlook without
eclecticism. The influence of Mondrian, or for that matter, of Malevich,
Kandinsky, Picasso – or any specific style or movement such as Surrealism
or German Expressionism – was therefore oblique. It is precisely this sense
of objection, or reaction, to any highly influential artist's work that accounts
for the vigor of American painting and invalidates any attempt to ascribe
direct influences of a fixed lineage to stylistic developments within recent
American art.

Another aspect in the New American Painting prevented the absorption
and use of Serial structure. Essential to the morphology of Serial Imagery
is the abandonment of the conspicuous uniqueness of each painting. The
New American Painters, on the contrary, were extreme individualists who
asserted, as central part of their esthetic, the unique identity of each indi-
vidual painting. Small changes in the overall size of a canvas – even an
inch or two – as well as differences in degree of color saturation, changes in
hue or texture or density of paint, were used to avoid standardization and to
enhance singularity. Many paintings by Newman, for example, are similar
to one another – yet at the same time each painting is vastly different from
any other. Each asserts a different solution and expresses a different mood.
One painting may be somber, even dark; another, highly keyed. The colors
are rarely repeated.

Although it is true Newman, Gottlieb, Motherwell, De Kooning and Kline all painted in series at one time or another, to paint in series is not necessarily to be Serial. Newman's series of *Fourteen Stations of the Cross* are all painted in black and white – but they are linked by a narrative theme. Motherwell's many *Spanish Elegies*, De Kooning's *Women*, Kline's black and white paintings and his multi-colored paintings, along with Newman's paintings are classical instances of theme and variation. Gottlieb, in a number of his later *Blast* paintings, becomes more systematic; but again, these paintings are insufficiently rigorous in the handling of syntax to qualify as Serial.

Initiated by Albers, the adoption of Serial Imagery by American artists began tentatively in the late fifties and spread rapidly in the sixties. No single event determined this change of climate. The American development of Serial Imagery is quantitatively weighted in favor of abstract art, but not exclusively so; Andy Warhol, for example, has contributed richly to the use of Serial Imagery with a literal subject. Concurrent with the first Serial activity in the United States an isolated European figure curiously emerged: the French painter Yves Klein, who later elicited the respect of a number of American painters. Klein's approach to Seriality, however, failed to influence the European scene. Moreover, the development of his work was prematurely cut off by his untimely death in 1962 at the age of thirty-four.

Apart from Albers who had been working in Series since 1931, the first American painter to adopt the Serial format was Ad Reinhardt, in the mid-fifties.[10] (Reinhardt, by virtue of the length of his painting life which began prior to World War II, belongs to the generation of New American Painters; he was a close friend and associate of painters of that group and an original contributor to this phase of American painting.) In the early sixties the use of Serial Imagery proliferated, and Albers and Reinhardt were joined by Morris Louis, Frank Stella, Kenneth Noland, Ellsworth Kelly, Andy Warhol and the sculptor Larry Bell, to name only a few.[11] A number of younger sculptors on the American scene use or have used series, but either the Serial syntax is not a *central* concern to their art, or their structure is basically modular, that is, of a micro-order. Although the work of such sculptors as Donald Judd has been described as Serial, this is incorrect. Judd, for example, replicates parts by having identical units manufactured; they are then positioned to form one sculpture, one unit. Judd's images have a modular structure, and his range of similar sculptures relate [*sic*] more to sculptors' traditional use of editions than to true Serial forms.

DEFINITION

As nature becomes more abstract, a relation is more clearly felt. The new painting has clearly shown this. And that is why it has come to the point of expressing nothing but relations.

– Piet Mondrian

Abstract art or non-pictorial art is as old as this century, and though more specialized than previous art, is clearer and more complete, and like all modern thought and knowledge, more demanding in its grasp of relations.

– Ad Reinhardt

Serial Imagery is a type of repeated form or structure shared equally by each work in a group of related works made by one artist.[12] To paint in series, however, is not necessarily to be Serial. Neither the number of works nor the similarity of theme in a given series determines whether a painting or sculpture is Serial. Rather, Seriality is identified by a particular inter-relationship, rigorously consistent, of structure and syntax: Serial structures are produced by a single indivisible process that links the internal structure of a work to that of other works within a differentiated whole. While a Series may have any number of works, it must, as a pre-condition of Seriality, have at least two. Thus a uniquely conceived painting or sculpture *cannot* be Serial.

There are no boundaries implicit to Serial Imagery; its structures can be likened to continuums or constellations. Though often painted in sets, that is, in a limited number that satisfy a given condition, Serial Images are nevertheless capable of infinite expansion. There is no limit to the quantity of works in a Series other than what is determined by the artist.[13] Once established, a Series may be kept open and added to periodically in the future. The question of the number of works in any given Series is relative to the artist's intentions and working procedures, and may involve a variety of approaches (as will be later discussed). Serial Imagery furthermore ignores the rational sequence of time. Series can be cut off at any point (cf. Kenneth Noland, Morris Louis, Frank Stella, Ellsworth Kelly); re-entered later (Stella); or continued and extended indefinitely (Josef Albers).

Central to Serial Imagery is the concept of *macro-structure* – that which is apprehended in terms of relational order and of continuity, but not in terms of distance, number or magnitude. The following example will make this relationship clearer. If the number one is combined with a comma and given the status of a self-contained unit (representing a single painting), and repeated thus,

1,1,1,1,1,1,1,1,1,1,1,

all the units are interchangeable. The units are presented lineally and with-out hierarchy of order; each unit is similar and each is of equal importance. In the same manner the macro-structure of a Series is self-evident irrespec-tive of the number of works in the Series.

Equally essential to Serial form is the *consistency* of the postulates, that is, that no two contradictory propositions can be deduced from any collocation of units. Hence, if the units are positioned irregularly,

1,1,1, 1, 1, 1,1, 1, 1,1,

the rhythms may vary but the macro-structure in each subgroup is identical to that of the whole.[14] Thus the macro-structure is not dependent on interval or distance; each unit remains interchangeable and has the same rank as the others, without disturbing the continuity of the macro-structure. This interchangeability of the units and their lack of hierarchical order is more clearly revealed if the units are arranged symmetrically, as follows:

1, 1, 1, 1, 1, 1, 1, 1,
1, 1, 1, 1, 1, 1, 1, 1,
1, 1, 1, 1, 1, 1, 1, 1,
1, 1, 1, 1, 1, 1, 1, 1,
1, 1, 1, 1, 1, 1, 1, 1,
1, 1, 1, 1, 1, 1, 1, 1,
1, 1, 1, 1, 1, 1, 1, 1,
1, 1, 1, 1, 1, 1, 1, 1,

Such an arrangement, which can be read up and down, diagonally, or back and forth in any direction, demonstrates (if only by analogy) the inherent capacity of Serial structures to interact and to reinforce, by juxtaposition, each other's presence and qualities. Meaning is enhanced and the artist's intentions can be more fully decoded when the individual Serial work is seen within the context of its set. In earlier or non-Serial art, the notion of a masterpiece – of one painting into which is compressed a supreme artistic achievement – is implicit. However, with Serial Imagery the masterpiece concept is abandoned. Consequently each work within a Series is of equal value; it is part of a whole; its qualities are significantly more emphatic when seen in context than when seen in isolation.

The foregoing is not to say that a Serial painting or sculpture lacks auton-omy. Each single work in a Series must be complete in itself and therefore *may* be shown in isolation. Furthermore, in some Series the appearance of the paintings, if they are exhibited as a set, will be affected by the se-quence in which they are hung. This is especially so in the work of Albers (though the degree and type of change that takes place varies from artist to

artist). Albers is so precise in his handling of color – itself a highly *imprecise* material – that the emphasis and tonality of his paintings are subject to considerable variation according to their juxtaposition.

In mathematics there seem to be at least four possible Serial forms. Referring to the Dedekind-Cantor theory of variables, Edward V. Huntington states:

> ...**With regard to the existence of first and last elements, all Series may be divided into four groups: 1) those that have neither a first nor a last element; 2) those that have a first element, but no last; 3) those that have a last element, but no first; and 4) those that have both a first and a last.**[15]

The implications of definitions 1) and 4) may be illustrated with Gertrude Stein's strikingly Serial poem: "Rose is a rose is a rose."[16] As Miss Stein relates in her autobiography,[17] she made a monogram of the poem, which she used on her notepaper:

In this form the poem has a first and a last member, whether it is written in a line or designed as an emblem, and would fall under definition 4) above. yet in discussing the poem Miss Stein either deliberately or inadvertently misquotes herself and renders the poem "...a rose is a rose is a rose is a rose."[18] If "is" is added to either end of this revised form, and the poem recast as an emblem, the parameters of the structure are sufficiently altered to make the difference critical; the poem then conforms to definition 1) and in its duration becomes similar in structure to a continuum — that is, non-linear. (It is also perfectly symmetrical in the disposition of its parts, having seven members in each quadrant.)[19]

All contemporary usage of Serial Imagery, whether in painting or sculpture, is without either first or last members. Obviously, at one point there had to be a beginning – the first painting or sculpture made – but its identity becomes subsumed within the whole, within the macro-structure. The same principle applies to the last member. At any given point in time one work in a Series stands last in order of execution, but its sequential identity is irrelevant and in fact is lost immediately on the work's completion. The basic structure of Serial Imagery, then, can be likened to a pack of cards, in which every card is the Ace of Spades; all cards are of equal value and all imprinted with the same emblem, which may or may not vary in size, color or position.

Setting the question of Albers aside for the time being, it can be said that the first use of Serial Imagery in recent painting is shared by two artists, Ad Reinhardt and Yves Klein. Klein's Serial painting (begun about 1957) is marked by the systematic use of one canvas size and one grainy textured color. Among Klein's Serial works the similarity of color together with the low textural level of organically clustered paint grain, while it slowed down scan, was insufficient to defeat an inherent tendency towards inert uniformity. Reinhardt's use of Serial Imagery, on the other hand, though also basically entropic as an enterprise, is more important for a number of reasons. Reinhardt's Serial usage predates that of Klein, and unlike the overtly systematic look of Albers' art, Reinhardt's Serial forms imply *the use of a structure whose order is inherent but concealed*. In various paintings (as far back as 1955) Reinhardt employed as a structural principle a series of symmetrically positioned forms that repeated the framing edge. At times he united four square canvases to form a larger square. This modular division of the overall format was further reiterated by the horizontal and vertical squares symmetrically placed within each segment. His early systematic use of symmetry served to purge his painting of an outdated rhetoric, which he campaigned against equally in his systematically reiterated writings.

Reinhardt clearly is a key figure in the evolution of Serial Imagery in the United States, as Klein was not. If, apart from the inherent entropic tendency of his painting, any deficiency could be isolated it would be his manner of paint application, which never sufficiently deactivated the internal time-flow of the structure. His method of facture, consisting of a layer-upon-layer application of flat paint over a preexistent image, left traces of a "local" time-track. In his last works, however, the black overlay of paint fused more into a one-to-one relationship with his structure. As the paintings got blacker they became more and more neutral. The formal importance of Reinhardt's painting therefore resides in its quality of indetermination, its

neutral emptiness. This indeterminate quality would not be remarkable in itself if it were not allied to an emphasis on symmetry and macro-structure: that which raises no claim to stand for the work in its own right, but which controls the development of the individual painting within a Series. What Reinhardt set into motion was the idea of a network of choices and limitations, which were preformed but not logically apparent on the surface of the picture or within the whole Series. Until now it has always been assumed that Reinhardt was only repeating one painting rather than painting a Series. On the other hand Reinhardt's work also proved that once the hierarchical links are solved and ironed out it becomes increasingly difficult to achieve contrast, that is, to give each painting a positive identity without reasserting rank or becoming overbearingly redundant. Nevertheless, his painting was a forceful step in the Serial direction and of great importance to a later generation.

It was Stella who made the first moves to exploit Serial depositions of a higher order. In the manner of Reinhardt, Stella (in his first Series, in 1959) also employed black, but with a linear element tracking across the picture plane. These lines were formed by leaving ragged edges of unpainted ground between the abutting areas of black. Stella reversed Reinhardt's process of paint application; instead of making an image and then painting over it, allowing it to bleed through, Stella obliterated most of the ground and left the unpainted parts to form the image. In this way he obtained a greater fusion of image and facture, without leaving a time-trace. By varying the linear image he asserted the individual identity of each painting within the overall system.

It is important to note that the organization of Stella's paintings begins at the center, and spreads outward by his use of various kinds of symmetry. Rather than echoing the rectilinear shape of the canvas within the field, as Reinhardt had done, Stella asserted the thickness of the stretcher bar as a modular element that controlled interval-width between the lines in the internal structure of the painting. However, instead of imposing the framing edge as the unifying structural principle, Stella took the basic module and extended it outside the framing edge by 1) making the stretcher bar equal in thickness to the internal module, and 2) repeating the ground color with the unpainted portion of canvas that covered the stretcher bar. It is only coincidental to his system that the internal modulations and the stretcher thicknesses are the same. In this manner Stella was able to employ a wide variety of images that have no one-to-one relationship with the horizontal and vertical elements of the framing edge; the vectors of his internal imagery are consequently disparate and energetic. (This structural process involves

an absolutely different syntax from that arising from Synthetic Cubism, which systematically reiterates and plays against the internal boundaries of the framing edge.)

It is useful to return to Gertrude Stein's poem "Rose is a rose is a rose is a rose" in order to amplify Stella's moves. To Miss Stein nouns were of great importance. In systematically repeating the noun "rose" she took advantage of its innate capacity to evoke multi-levels of meaning and image. The subject of her poem might very likely have been Francis Rose, a minor Surrealist painter with whom she was extremely friendly. As the poem was read it might have conjured up a succession of images something like this: Rose (Francis) is a rose (flower) is a rose (color) is a rose (perfume) is a rose (gem) is a rose (compass card), etc. In Reinhardt's Serial Imagery the threshold of difference between each painting is so low as to finally deny difference, though it is true each painting occupies a different space. Stella, on the other hand, created a unique identity for each painting by using a simple, bilaterally symmetrical network of images, which, in effect, were variants of the same image. In this way he preserved an absence of hierarchy; each image was equal in rank. Each image at the same time asserted its own identity with its own evocative potential, so to speak, in the manner of Miss Stein's rose. Moreover, Stella's paintings can be positioned in random order; the time-flow is non-sequential.

Although Piet Mondrian's art employs systematic elements of equal value that are interchangeable, they contain an obvious linear time sequence and a first and last number. This is apparent because his facture becomes more refined in time and each painting is self-consciously dated on the front. In this sense Albers' art is nearer to Stella's; the duration between Albers' paintings is compressed, and the time-flow more nearly reversible. Music, poetry and dance, by the very nature of their form can only flow forward in time. It is impossible to play music, to read poetry or to dance backwards. In one form or another Claude Monet, Alexei Jawlensky, Marcel Duchamp, Mondrian, Albers, Klein and Reinhardt have all proved in their Serial investigations that it was possible to make time relative and to reverse its flow. But it was Stella, who was soon to be joined by Noland, Louis, Andy Warhol, Larry Bell, and somewhat later, Kelly, who began a sophisticated dialogue involving the non-sequential possibilities of Serial forms that rapidly led to a new plateau of achievement.

Inherent to the earlier use of Serial Imagery is a lack of extension or progression; whatever the quality of Mondrian's and Albers' achievement, their art reaches a plateau and stays there. Obviously they become more adept in time at using their system, but their art nevertheless remains

circumscribed by a non-expanding esthetic. They refine rather than explore the system further. Part of Stella's remarkable achievement was his discovery that the inherent non-atavistic tendency of Serial art – the inability of the artist to regress to a more primitive spatial notion so long as his system was maintained – could be accelerated and made to leap forward rapidly. Stella began exploring the nature of Serial Imagery vertically as well as horizontally by altering the parameters within each successive Series. Every Series of Stella's is distinctly different from every other Series. The parameters of each Series are not only varied but often reinforced in complexity. For instance, within one Series Stella may repeat the same shape in different colors while, at the same time, progressively altering the initial shape. Stella discovered that the permutations – the typical, possible distributions, which are strategically central to Serial order – can be varied at will. That there are no limiting rules to this strategy is reminiscent of Wittgenstein's remark: "Language is a 'game' the rules of which we have to make up as we go along."[20]

Stella's moves towards a discrete quantification of the parameters was first marked by a realization (in the *Black* Series) of well-defined and clearly distinguished *units*, articulating themselves by means of reciprocal effect, each one limiting and defining the nature of its fellows. Thus a situation of cross-incidence and cross-reference, of reciprocal relativity and multi-polarity became his most essential means. And in order to judge the fruitfulness of each new step within a particular Series it became necessary for Stella to anticipate the entire route ahead.

Noland and Louis, who soon joined Stella in the Serial enterprise, have a more romantic outlook; such pre-plotting is clearly antithetical to their esthetic. To be sure, Serial Imagery, though systematic, does permit unknown variables. As Anton Erhenzweig has observed, the artist obviously "cannot anticipate *all* the possible moves that are open according to the rules which [he is] still making up," but he "*can* handle 'open' structures with blurred frontiers which will be drawn with proper precision only in the unknowable future" (my italics).[21] Both Louis and Noland are much older artists than Stella, and their painting habits were formed by the esthetic of an earlier generation. It is to their credit that once they entered the Serial dialogue they performed brilliantly, though often with perceptible hesitancy because of their disinclination to plot and anticipate their primary moves. After Noland's first extraordinary Series of *Targets* (which were done in 1960–62 and are among the finest explorations of Serial Imagery), his hesitation and wavering became apparent; yet in the later *Chevron* Series and others that were to follow he reasserted his Serial direction with great clarity and extraordinary verve.

Stella's earliest investigations involved shape; in contrast, Noland's earliest concern was color. As the ensuing dialogue developed Stella and Noland were to exchange interest, Noland later exploiting shape as well as color and Stella adding color to his explorations. Louis' central focus was on color throughout. These artists, as well as Bell (in sculpture) were to discover that Serial Imagery directly attacks all conscious means of ordering the micro-structure; the internal order can become random, providing the parameters of the macro-structure are systematically maintained. Louis discovered this in his pouring technique, and was then able to paint without envisioning the complete field. Provided Louis could delineate in advance where he was to pour the color, and could maintain the same family of color and similar intervals within each distinct Series, it was not necessary for him to view the whole potential field; each area of the painting could be added to part by part.

Given the overriding control asserted through the macro-structure and the drive to create an individual identity for each discrete unit, a corollary of the Serial process would then be the development of an infra-structure that surfaces and magnifies buried qualities. Stella, for example, in his second Series, as a final necessity brought about by the logic of the internal configuration, began to notch out the shapes of his canvas; this idea was made possible by the reciprocity of the parts to the macro-structure, which in its topology lies outside the boundaries, or apart from the boundaries, of the framing edge. Stella's intention it would seem was not to create objects or to objectify his canvas as much as to make the individual work's presence within a Series *resonate*, to give each unit more visual energy, thereby reversing the entropic process; in other words, to give each painting a supra-identity.[22] John Cage has used a similar procedure in musical performances: in order to give clarity and brilliance to the sound emitted by a particular instrument, he removes it from the ensemble and places it within or at some point on the perimeter of the audience, where it waits its turn to be heard in the prescribed sequence of play.

It must be remembered that in Serial Imagery the exhibition space becomes a component. Only when paintings of a Series are exhibited together in a gallery space do the parameters built into the paintings and their reciprocal quality begin to operate. By permitting the paintings to bite into the wall space, and the wall space to bite into the shaped canvas, Stella added another reciprocal parameter to his system; he emphasized the space by forcing it and the painting to become attached. Moreover, when his shaped paintings are strung on the walls, the walls act like sound boxes echoing the interior shape and amplifying the exterior shape. The intervals

between paintings, as the intervals in music, become positive elements. The more eccentric the overall shape of the canvas the greater the contrast between interior and exterior forms (as, for example, in Stella's 1966 Series of highly idiosyncratic shaped canvases with contrapuntally shaped colors). Stella not only orchestrates the color and the shape so they simultaneously assert and deny one another; but when these paintings are strung along a wall the intervening spaces intensify the differences between canvases. (Noland's attenuated diamond shapes also set up a series of highly repetitive and assertive external diagonal rhythms when exhibited adjacent to one another.)[23] In addition to resonating the individual unit within the Series and extending its identity, Stella's art tests both the structural parameters of Serial Imagery and the extent to which they can be stretched.

Too little in recent criticism has been written on the nature of color as it is experienced in the work of Stella, Noland and Louis, other than to note its *optical* quality. All our experience of color, of course, is optical; yet Albers for one – perhaps more than any artist over the last twenty years – has set out to render our perception of color more precise, specifically by focusing on a limited range of particular colors. He has in a sense blatantly revealed the purity of color as an optical phenomenon; he has magnified the tensions color is capable of inciting in the eye, and he has made the viewer sensitive to color as a purely perceptual experience. His single-minded, haunting enterprise has been to lock color and structure into an absolute, one-to-one relationship. Color to Albers has never been a decorative element. No artist in recent times has rendered more precisely than he, or permuted so intensely, the possible range of color experience, without denying its subjective or psychological overtones. It should be added that while Albers has always insisted his approach to color is intuitional, that fact has for the most part been ignored.

Central to Serial Imagery, as has been previously stated, is the controlling influence of the macro-structure, within which (provided the parameters are systematically observed) a high degree of randomness in the use of infra-forms is possible. Applying this principle to the use of color in Serial forms, it is necessary for an artist only to maintain the same family of colors in order to proceed with an extraordinary degree of freedom – a freedom, moreover, that has not previously been possible. The moment Louis, to take one example, began a systematic use of Serial Imagery the whole nature of his color enterprise changed. In his Series of *Stripe* paintings the effect of pouring the different but adjacent stripes of color onto the unsized ground was to give these vertical elements a lateral displacement in time and space. In other words, by pouring only once rather than several times to form

each single stripe within a typical cluster, Louis left no record of the flow of time. An additional effect of pouring one stripe adjacent to another and letting the stain spread from one to another was to induce a homogenized surface. The stain acted somewhat in the manner of mortar, which fills in to give brickwork a monolithic appearance despite visual evidence of the brickwork's modular origins. This method enabled Louis not only to achieve what Albers had practiced for years, but to bring added complexity and randomness to the process.

On the other hand, turning to the *Target* paintings by Noland, it is evident that the most crucial parameter of Noland's macro-structure is the *center* of the painting rather than the framing edge. Noland's color structure depends on the most rigid and absolute use of symmetry. In most of the clear-edged *Target* paintings it is of no consequence whether the top is marked; the paintings may be hung any side up without altering the appearance of the image. Noland's use of a jig of some kind to brush in the forms ensures the rigidity of his symmetry and its lack of perceivable variations. Presumably by choice, Noland varies the interval and distance between the concentric rings of colors. However, once he has set up his system he could probably position the color more randomly if he wished.

The result of this system of control by a macro-structure in the work of Louis, Noland and Stella is that for the first time color can be fully orchestrated. The intervals, cadence and textures of the colors begin to assert themselves in a form similar to music, with the individual colors vibrating and resonating. In Louis' *Stripe* paintings the colors virtually form visual chords. And unlike music, color need not be read forward (linearly) but can be scanned from any point in any direction, allowing the rhythms as perceived by the eye to vary to an extraordinary extent. As a result color in these paintings takes on a role it has never been permitted to assume in all the long history of art.

Within the development of Serial Imagery Andy Warhol's art proves to be highly idiosyncratic. Warhol was to take the inherent entropic tendency of the earlier phase of Seriality and (like Beckett and Genet, two outstanding figures in recent literature whose life style Warhol in various ways so remarkably echoes) turn it into a positive factor. Perhaps no single image in the second half of the twentieth century is so daring in concept and so beautiful in appearance as Warhol's helium-filled Series of floating aluminum pillows, which change position and relationship to one another with the slightest breath of air. In their form they represent the most perfect visual analogy of a continuum the human mind has conceived: identical, manufactured objects remorselessly stamped out by a machine, which when

filled with gas and clustered within a space, become more organic in their relationship than the interweaving strands of a Pollock painting.

Larry Bell is the only sculptor of consequence to emerge in the sixties who deploys Serial Imagery. Originally a painter, Bell sculpture has a presence that betokens still another aspect of Serial forms. It has been shown that Serial Imagery is concerned not with the notion of masterpiece, but of process. Process implies progression or advance within a steady rhythm – in other words, continuity and productivity. Process is not a closed system arising out of a unique esthetic; it is not concealed in highly charged psychological factors. Process is a system that can be decoded and adapted to any personal use. Once a process is understood, an artist can enter into the dialogue at any point. It is choice of "realm" that is important and not uniqueness of "subjects." Hence Bell's crucial act was that he decoded the Serial system and made his own entry into the process, while working out of Los Angeles and without ever having been to New York or knowing any of the other artists concerned. More than any art in the past, the dialogue of Seriality is taking place in public; it is a gallery and not a studio art.

From the critical viewpoint, the employment of Serial Imagery raises a number of issues. Serial forms reveal very easily the complexity of the artist's decisions and the nature of his enterprise as a whole. Once several artists use a similar system or process they substantiate each other, both to the audience and to themselves. Each artist, of course, is engaged in an endeavor to make the best art of his time; but the dialogue is so public and the system so flexible that the rate of each artist's reponse is greatly accelerated. Furthermore, the more eccentric any work within a given Series is, the more easy it would seem for the critic to judge it; however, due to the extreme mutuality and interdependence of each painting in a Series, judgments as to the quality of any one painting are difficult, if not pointless. How is one to decide which Mondrian is *the* masterpiece? It is impossible to discuss at any meaningful level the relative importance of any one of his paintings over another. Judgments of this nature have to be foregone. In Mondrian's mature work it is necessary to deal instead with the nature of his informing *structure*: how is it more clear in his later art and less clear in his earlier art? Indeed, except for Mondrian's last works there is *no* inherent system of progression in his art. Moreover, one cannot say which Monet *Cathedral*, which Serial Reinhardt, which *Black* Stella, which Noland *Target*, which Warhol *Campbell Soup Can*, which Serial Kelly or which of the later Bell boxes is best. Such a judgment is meaningless; at best it does no more than exercise a dubious connoisseurship.[24] The crucial factor is, again, the choice of realm, the way each painting fits within the chosen structure: that

is, whether the postulates of each painting are consistent with the others in such a way that no two contradictory propositions can be deduced within a Series. Thus criticism must address itself to the largest entity. The task of the critic is not to say which work is good or bad or best; his task is to ask what is there and what is the nature of the experience. Only then, if he wishes, can the critic venture an opinion of its value. In fact, simply to describe this experience is to in some way evaluate it.

Central to the work of all the Serial artists is the endeavor that has marked art since earliest times: the attempt to describe with the structure of art our perception of the space we inhabit. This undertaking informs all art, whether music, poetry, painting or sculpture; each generation of artists refines, explores, augments or completely restructures our intellectual, psychological and perceptual awareness of the human spatial domain. In modern art there are two main streams of this evolution, one via Monet, the other via Cézanne and the Cubists.[25] Both dealt with simultaneity in different ways. Monet's Serial enterprise (as has already been pointed out) structured simultaneity by the use of a macro-structure, and can be spatially likened to a continuum. The Cubists, on the other hand, dealt with notions of simultaneity within the framework of one painting. Their structure and its topology can be likened to a Moebius Strip, which has no top or bottom, no inside or outside; all are interchangeable within a common framework. It took Cubism to assert Cézanne's notions, but Monet's were fully formed at the outset and were reiterated time after time in his art from 1891 onwards. Monet was painting Serially through the years of Cubism. Yet it was not until nearly eighty years after the *Cathedral* Series that we see Monet's discoveries begin to be realized by other artists. Josef Albers, who was born three years before Monet's first advanced Serial venture began, is the living link between Monet and the new painters. It is to be hoped Albers' art will now be more clearly recognized for its potency.

There are sufficient indications in the emergence of Serial Imagery over the past decade in the United States that the rhythms attendant upon the Serial style ritually celebrate, if only obliquely or subliminally, overtones of American life. In various ways Serial Imagery reveals a local color that identifies the ambience of its origin. Serial Imagery is particularly fitted to reflect its contemporary environment, because of the open and unplanned nature of its internal dialogue, its highly systematic yet flexible process of production, its high degree of specialization, and its narrow, deep focus upon a single issue. Its redundancy is a positive act that continuously affirms the power and continuity of the creative process. Taken together, the approaches of the artists mentioned above in no small measure evoke

the underlying control-systems central to an advanced, "free enterprise," technological society. Esthetically, of course, the paintings are no better or worse for our recognition of this quality.

NOTES

1. Serial Imagery, Seriality, Serial structure or form, etc. is used interchangeably throughout this text, and refers to forms linked by a macro-structure. The use of the word series, on the other hand, refers to a more simple grouping of forms in any kind of a set.
2. See Edward V. Huntington, *The Continuum (and Other Types of Serial Order)*, second edition, Harvard University Press (Cambridge, 1921), p. 1.
3. *Ibid.*
4. Georges Clemenceau, *Claude Monet: The Water Lilies*, trans. George Boaz, Doubleday (Garden City, 1930), pp. 129–130.
5. Gertrude Stein, *The Autobiography of Alice B. Toklas*, The Literary Guild (New York, 1933), pp. 5–6.
6. Apparently no record of the particular works exist, nor the number shown.
7. Will Grohmann, *Wassily Kandinsky*, Abrams (New York), p. 51.
8. "New American Painting" is used throughout this text to represent the broad spectrum of American painters who emerged in the late forties or early fifties, including Baziotes, De Kooning, Francis, Kline, Hofmann, Pollock, Newman, Rothko, Still, Gorky, Reinhardt, Motherwell, etc. Unlike "Action Painting" or "Abstract Expressionism" – which are interchangeable labels, often used selectively to denote the wing of American painters who used a highly expressive, loosely applied and hard-worked overlay of paint with either a figurative or non-figurative image (e.g., De Kooning, Hofmann or Kline) – the term "New American Painting" is inclusive, and is the least redolent of stylistic subdivisions.
9. Indicative of this need for reassessment is that despite Albers' distinction as an artist and his long and important role as a teacher in the United States, unaccountably no major institution in New York has given him a retrospective – the absence of which became most conspicuous on the recent occasion of his eightieth birthday. It is instructive that Albers' painting *Homage to the Square* (painted several decades *after* he came to the United States) is hung in the Museum of Modern Art's collection in a separate room reserved for Mondrian and Mondrian's American disciples instead of the area devoted to major post–World War II American painting. A further indication of the degree of *apartheid* which Albers has suffered is that until roughly ten years ago – until he reached the age of seventy – he barely sold a painting in the United States. It is only with a change of climate induced by the art of a younger generation that his art has received any due appreciation.
10. Paralleling the development of Serial Imagery has been a similar though different enterprise in music. In music, after Schoenberg, the influence of Webern and Berg is important. Serial compositions in music began to spread in 1951 (especially in the work of Boulez and Stockhausen). Late Stravinsky (1956) is

also Serial in form. Milton Babbit, who bases music on set theory, is part of a more pervasive wave that has emerged in the United States in the sixties. For information on Serial compositions and their form in music see George Perle, *Serial Compositions and Atonality*, University of California Press, 1962.

11. The late Paul Feeley, Darby Bannard, Ron Davis, Tony Delap, Walter De Maria are among those artists in the United States who have, at one time or another, experimented with Serial form. Serial Imagery, however, does not seem to be a central concern of their art, nor has its use, it seems (as with Kelly) played a central role in changing the syntax of their work.

12. See Footnote 1.

13. The number of paintings, for instance, in Albers' Series *Homage to the Square* is not known; it is an endless Series to which he continuously adds. In comparison, all of Stella's *Black* Series are known; it is a closed Series delimited by a set number. Until Stella had exhausted for himself the possible variations within this Series, however, the numerical boundary was not fixed. Noland's *Target* Series was similarly not preconditioned by a known quantity in advance. On the other hand, Stella's Series of eccentric geometric paintings of 1966 were preplanned, the quantities having been fixed at the outset and then adhered to.

14. Interestingly enough, the logic of syntax common to western languages does not permit the cataloguing of simultaneously important entities in a non-hierarchical order. In western usage ideas or objects are invariably enumerated in ordinal sequence: 1), 2), 3), etc. The Chinese, on the other hand, prefix equally important items 1), 1), 1), etc.

15. Huntington, *Continuum*, p. 12. This definition, incidentally, is quite contrary to that set forth by Mel Bochner in his article, "The Serial Attitude," *Artforum*, December, 1967, pp. 28 – 33. Bochner's definition reads: "*Series* – a set of sequentially ordered elements, each relating to the preceding in a specifiable way by the logical condition of a finite progression, i.e., there is a first and last member, every member except the first has a single immediate predecessor from which it is derived and every member except the last a single immediate successor." From the illustrations accompanying the article, and from this definition, it is obvious Mr. Bochner confuses modular forms with Serial structures. He evidently is unaware of the Dedekind-Cantor theory, which is central to the mathematical concept of Serial forms.

16. The poem as set forth here was originally one line of a longer and more complex poem, "Sacred Emily," from Gertrude Stein, *Geography and Plays*, Four Seas Press (Boston, 1922), pp. 178–188.

17. Stein, *The Autobiography of Alice B. Toklas*, Literary Guild (New York, 1933), p. 169.

18. *Ibid.*

19. In fact Miss Stein does consciously play with the form of this poem, giving it three different beginnings and, hence, three different structures. She introduces it with "rose," "a rose," and "is a rose" all in the same passage. *Ibid.*, p. 169.

20. Ludwig Wittgenstein, *Philosophical Investigation*, Blackwell (Oxford, 1963), par. 83.

21. Anton Ehrenzweig, *The Hidden Order of Art*, University of California (Berkeley, 1967), p. 42.

22. Ellsworth Kelly had also much earlier struck upon this idea, but his was more a process of dismounting the canvas from the wall by making parts step out onto the floor and into the observer's space. In his case it was to lead to the development of a number of remarkable sculptures.
23. Noland's use of shape, however, is very minimal, especially in the exercise of contrapuntal effects. He attaches his canvases to the wall space and leaves it at that. Shape has become a different issue in his latest horizontal striped paintings.
24. Ezra Pound's comment is highly appropriate: "I reject the term connoisseurship, for 'connoisseurship' is so associated in our minds with a desire for acquisition. The person possessed of connoisseurship is so apt to want to buy the rare at one price and sell it at another. I do not believe that a person with this spirit has ever *seen* a work of art." Ezra Pound, "The Serious Artist," *Literary Essays of Ezra Pound*, Faber and Faber (London, 1954), p. 55.
25. Mondrian and Albers draw upon both traditions.

LUCY R. LIPPARD

THE SILENT ART

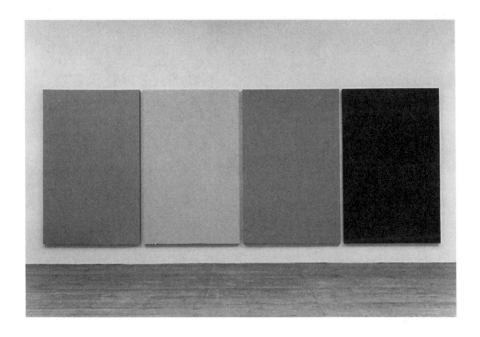

Brice Marden, *The Seasons*, 1974–75. Oil and wax on canvas, four panels, 96 × 60 inches each. The Menil Collection, Houston; photograph by Hickey-Robertson, Houston.

The art for art's sake, or formalist strain, of non-objective painting has an apparently suicidal tendency to narrow itself down, to zero in on specific problems to the exclusion of all others. Each time this happens, and it has happened periodically since 1912, it looks as though the much heralded End of Art has finally arrived. The doom-sayers delight in predicting an imminent decease for any rejective trend. While dada, assemblage and pop art have come in for their share of ridicule and rage, the most venomous volleys have been reserved for those works or styles that seem "empty" rather than "ordinary" or "sloppy." The message of the Emperor's New Clothes has made a deep impression on the American art public. "Empty" art is more wounding to the mass ego than "sloppy" art because the latter, no matter how drastic, is part of the esthetic that attempts to reconcile art and life, and thus can always be understood in terms of life. There is nothing lifelike about monotonal paintings. They cannot be dismissed as anecdote or joke; their detachment and presence raise questions about what there is to be seen in an "empty" surface.

The ultimate in monotone, monochrome painting is the black or white canvas. As the two extremes, the so-called no-colors, white and black are associated with pure and impure, open and closed. The white painting is a "blank" canvas, where all is potential; the black painting has obviously been painted, but painted out, hidden, destroyed. Both are eminently adaptable to the three types of monotone art: the evocative, romantic or mystical; the formally rejective and wholly non-associative; and the gesture of defiance, absolution or comment. Within the past fifteen years a small but diverse group

Lucy R. Lippard, "The Silent Art," *Art in America* 55, no. 1 (January–February 1967): 58–63. Revised version in Lucy R. Lippard, *Changing* (New York: E. P. Dutton, 1971).

of artists has independently concentrated on monotone and monochrome painting. Until recently they appeared as isolated figures, usually discussed, or dismissed, as aberrations in the historical scheme. However, for some five years now it has become apparent that monotone is one of the diminishing possibilities open to a painting that might be called color painting or light painting, even when it eliminates all color variations or even all color. Monotonal painting can also reinstate an almost imperceptible surface inflection that provokes a new kind of surface emphasis unrelated to the emotive qualities of expressionism. One of the curious and interesting facts about monotonal art is the extraordinary variety possible within its ostensible restrictions. Each minute variation of brushstroke, sprayed layer, or value change takes on a highly charged importance in the context of the whole. Even the flat white or black canvas insists upon the canvas itself or upon the paint that covers it. The artists discussed here share only the fact of their monotonal or near monotonal surfaces. Their intentions, attitudes and methods are dissimilar, and only the broadest analogies can be drawn, usually within age or stylistic groupings.

Instances of single-color, single-surface paintings during the past fifty years are few. The first and best-known monochrome painter was of course Kasimir Malevich. His *White on White* series, executed as suprematist studies around 1918, was paralleled by Alexander Rodchenko's black-on-black canvas, also sent to Moscow's Tenth State Exhibition in that year, apparently as a reply to Malevich's white works. Rodchenko's manifesto at that time consisted, coincidentally, of a list of quotations: a device used thirty years later by Ad Reinhardt: "As a basis for my work I put nothing"; "colors drop out, everything is mixed in black." Malevich, who was something of a mystic, equated white with extra-art associations: "I have broken the blue boundary of color limits and come out into white. . . . I have beaten the lining of the colored sky. . . . The free white sea, infinity lies before you." Actually, the square in the Museum of Modern Art's *White on White* is diagonally placed to activate the surface by compositional means. This concern with dynamism separates Malevich from later monotone developments, although a series of absolutely symmetrical drawings from 1913 predicted the non-relational premise of Ad Reinhardt and the younger artists of the sixties. He also emphasized, like today's painters, the art of painting as painting alone, a medium sharing none of its particular properties (two-dimensionality, rectangularity, painted surface) with other media: "The nearer one gets to the phenomenon of painting, the more the sources lose their system and are broken, setting up another order according to the laws of painting."

In retrospect, it is clear that Malevich and Rodchenko were not making monotonal paintings, but they undoubtedly looked more extreme then than they do today. The education of the spectator's eye must be taken into consideration. The history of abstract art has been punctuated not only by an increasing intellectual acceptance of extreme solutions but also by an increasing optical acceptance. In 1918, and in fact until the late fifties, a monochrome canvas in which the values were fairly close looked monotonal or blank to many people. Now our eyes are accustomed to the gloom of Rothko's and Reinhardt's black and blacker canvases, and our perceptual faculties have been heightened in the process. Work that once looked radically uncolorful or invisible now seems nuanced and visible. Similarly, several of the monotonal canvases mentioned here have more than one color in them and are not, therefore, monochromatic; but they appear monochromatic until all the senses have been adjusted to the area within which these subtle colorations operate. The ultimate in a no-color object that is still a painting might be a square (the only undistorted, unevocative shape) with a sprayed white surface (not white formica or any other absolutely smooth ready-made material, for if a surface is not painted, it becomes "sculptural" no matter how the edges are treated). Would this be an empty canvas? Probably not, if it were done right, for as the rejection becomes more extreme, every mark, every absence of mark takes on added significance. As Clement Greenberg has pointed out, an untouched "stretched or tacked up canvas already exists as a picture – though not necessarily a successful one."

Reinhardt, Barnett Newman, Mark Rothko and, to a lesser extent, Clyfford Still are the major American precedents for the current monotonal art. All four, in virtually opposing manners and degrees, stress the experience of the painting above all surface incidents; and all, since around 1951, have more or less consistently dealt with nearly monochromatic or nearly monotonal art. In its denial of compositional balancing of forms, monotonal art is, in fact, an offshoot of the all-over principle of much New York School painting in the late forties. But monotone is all-over painting par excellence, offering no accents, no calligraphy, no inflection. Around 1950 Newman, a strong influence on the younger generation now concerned with monotone painting, made several only slightly modulated, single-color, single-surface canvases, such as the tall vertical *Day One* and an all-white painting of 1951–52. His *Stations of the Cross* series (1958–66) concludes with a precise, pure, white-on-white work that was unavoidably interpreted as representing transfiguration. Newman's titles indicate that he welcomes such symbolic or associative interpretation; most of the younger artists, on the contrary, are vehemently opposed to any interpretation and deny the religious or

mystical content often read into their work as a result of Newman's better-known attitude, and as a result of the breadth and calm inherent in the monotonal theme itself.

The romantic or evocative type of monotone, with which Newman can thus be associated despite his formal innovations, is the most common. It ranges from Wolf Kahn's wholly naturalistic, Turneresque, gray-white canvases; Sam Francis' white paintings; Edward Corbett's early white and black works; Rollin Crampton's gray, turbulent paintings such as *Ahab's Sea*; to Alexander Liberman's totally abstract black washes and Agnes Martin's delicately modulated canvases (essentially drawings) with titles like *Leaf in the Wind*. Martin's light pencil grids on white or pale monochromatic surfaces relate little to the mainstream of rejective art and are unique in their poetic approach to a strictly ordered and controlled execution. Yayoi Kusama had a white exhibition at the Brata Gallery in New York in October 1959, in which her paintings approximated the size of the gallery's walls; the initial impression was one of no-show, but on close scrutiny, a fine mesh of circular patterns was revealed.

Kusama's development since then points to the relationship of such a show to the type of monotone painting that is employed as comment or program rather than as "pure" painting. The dadas, for example, advocated the *tabula rasa* as a fresh start in life, the destruction of everything traditional. Even Mondrian wrote that "the destructive element is too little emphasized in Modern Art." Many observers interpreted Robert Rauschenberg's flat white paintings, shown at the Stable Gallery in New York in 1953, as empty stages open to chance events and all comers. Though Rauschenberg himself has been quoted as saying he "only wanted to make a painting," the white works, and the contemporary black ones, were dismissed as gestures by most of the art world. Allan Kaprow dissented, noting that "in the context of Abstract Expressionist noise and gesture, they suddenly brought one face to face with a numbing, devastating silence." It is probably significant that these now atypical paintings were executed after Rauschenberg studied with Josef Albers at Black Mountain College; they can also be related to John Cage's presence there, though Cage has stated that his own plunge into the void (his silent musical composition) came after Rauschenberg's white paintings. Cage's "the subject is unavoidable: it fills an empty canvas" suggests a point of view analogous to Stéphane Mallarmé's when he proposed to reject symbolic interpretation of poetry and to leave nothing but the white page, which would be "evocative of all because it contained nothing."

The nature of postwar art in Europe has led monotonal painting there in quite a different direction from the increasingly formal orientation of

the American concept. The epitome of gesture artists, and one of the most interesting figures to emerge from Paris in the last decade, was the late Yves Klein – "Yves *le monochrome*," as he called himself. He began experimenting with the concept in 1946, exhibited his first monochromes in 1955 and showed his best-known works, from the *époque bleue*, in May 1957. Klein has little in common with most of the artists discussed here. His work, his statements and his general extravagance were more allied to the Duchampian paradox, and he is an acknowledged founder of the Duchamp-inspired *nouveaux réalistes*. Both he and Malevich called their abstract monochromes "color realism." In 1947, before Cage, Klein had projected a "monotone-silence-symphony" consisting of "one broad, continuous sound followed by an equally broad and extended silence, endowed with a limitless dimension."

Klein sought detachment in the philosophy of the Far East, where he once lived, though his was a theatrical, Westernized orientalism concerned with a "trace of sentimentality," "cosmic phenomena," "pictorial sensitivity" and "The Immaterial," which have proved unsympathetic to most American artists. Nothing could be more opposed to the cool absolute of recent American monotone than Klein's richly sensuous blue and gold canvases or the works of his "cosmogenic period," when he used fire, water and smoke as media. Many of his works were simply gestures in the direction of novelty rather than inaugurations of a new art. The empty gallery he "exhibited" in Paris in 1958 carried Duchamp's 1919 flask of *50 cc of Paris Air* to a logical conclusion, although this negative act is not so radical after all. An idea is radical only in the physical fact of its realization; until then it belongs to the realm of imagination, or literature.

The type of monotone painting that most concerns us in the mid-sixties is the rejective, formally oriented strain. The painters involved share few stylistic traits but are mutually occupied with a further progression of painting, despite the contention of some critics and artists that painting is obsolete. Any discussion of modernist monotone painting must emphasize the central role of Ad Reinhardt, whose square, black, symmetrically and almost invisibly trisected paintings are, according to him, "the last paintings that anyone can paint." Reinhardt is virtually the first artist since Malevich to develop extensively the classical possibilities of the single surface. He began his glowing all-red or all-blue works in 1951–52, and for the next eight years took them increasingly nearer to a total absence of color. "There is something wrong, irresponsible and mindless about color," he has said, "something impossible to control. Control and rationality are part of any morality."

By denying color in his black paintings from 1960 on (though some of them still retain traces of the extremely close-valued red, blue and green with which they began), Reinhardt has simply taken his steadfastly art-for-art's sake esthetic to its logical end. "The one work for a fine artist now," he says, "the one thing in painting to do, is to repeat the one-size canvas – the single-scheme, one color monochrome, one linear-division in each direction, one symmetry, one texture, one formal device, one free-hand-brushing, one rhythm . . . painting everything into one over-all uniformity and non-regularity."

After two decades of art that screamed for attention (from the abstract expressionists through the hard- or soft-edged colorists), Reinhardt's work is finally becoming visible to more than a handful of admirers. The public eye is becoming more accustomed to forced contemplation. Recent events have also proved that the fuzzy-edged, often pretty color used by the "color painters" or "stain painters" has less attraction for the younger generation than Reinhardt's rigorous abstention. He has always stood for the absolute: purity, not purification; the expressionless, not the less expressionist.

Some reaction against color in painting and in structures seems in retrospect only logical. It is one way of avoiding all reference to outside phenomena and denying the kind of decorative painting that requires only a glance to absorb. Many younger artists use color, but use it in a highly evasive or neutral manner. Blacks, whites, grays, browns, pale atmospheric tones, or insipid tints derived from pop art are largely preferred to stronger color. (Paul Brach, for example, recently changed his blue circle on blue ground to an equally near-monotonal gray circle on gray ground in a series of ten canvases going from almost white to almost black.) This off-color development also has to do with an increased interest in light, and no reference to light in painting can be made without mentioning Mark Rothko, whose dark paintings from the late fifties and his reputedly still darker murals projected for a university chapel approach monotone by rejecting drawing, detail and impasto for color-light. Glowing shallow depths and an emphasis on a diffused, differentiated rather than a steady light relate Rothko's works to the atmospheric branch of current monotone painting rather than to the almost tangible gloom of Reinhardt's structured blacks.

Monotone painting can be said to exist in time as well as in space, for it demands much more time and concentration than most viewers are accustomed or, in most cases, are willing to give. Among the most extreme examples are the recent white paintings of Robert Irwin. After an interval of time the patient viewer begins to perceive in Irwin's "blank" surfaces

tiny dots of color which form a haloed, roughly circular form. The square canvases are ever so slightly bowed so that the surface slips away into the surrounding space, and they stress the atmospheric central area rather than the traditional properties of the rectangular support. But the atmospheric effect is no more permanent than the initial whiteness; the color dots in the center are more and more obvious and, when seen up close, become as uninteresting as Signac's pallid color bricks. Irwin does not – with good reason – allow his paintings to be reproduced. Instead, he insists on a directly "hypnotic involvement" between painting and viewer. By re-introducing energy and illusionism and by de-emphasizing the picture support, he deliberately breaks the rules of the formalist academy. But since distance from the canvas is necessary for maximum enjoyment, and since the viewer's optical experience is finally one of amorphous light-energy, Irwin's effects might be better achieved by the use of actual light.

Robert Mangold's work also induces near monotonal atmospheric effects, but it foregoes the impression of glimmering depths that make one query the necessity of Irwin's work being painted instead of projected upon by some outside light source. Mangold's faint gradations, consisting of two pale, closely valued colors[,] are sprayed on smooth masonite; the formats are shaped, though only at one corner or edge, sliced or curved to destroy any concrete object effect. At the same time such a particular shape emphasizes the surface, further avoiding its destruction by light. Mangold's colors are hard to pin down. They fade and intensify into and away from monotone as they are watched. His earlier *Walls* were monochromatic but radically silhouetted and relieflike. When he rejected the apparently inevitable move into free-standing structures, Mangold's entire attention returned to the surface. The lightly atmospheric *Areas* reach a successful equilibrium between the shape of support and the strong assertion of flat, elusively colored plane, presenting the notion of a partially contained space which "continues" unseen, but which also operates within a structural and eminently *seen* framework.

William Pettet works with highly controlled sprayed surfaces that first appear monochromatic, then reveal evenly flecked undercoats of other hues. His grainy "green" paintings touch on a sensuous aspect of intense color disregarded by most of the younger painters, but he avoids the elegance of Klein's royal blues and the vagueness of other European monochromists. Pettet's canvases bear highly generalized affinities to natural phenomena and are similar to, but far more rigorous and single-surfaced than, Jules Olitski's multicolored and illusionistic extravaganzas. Pettet now intends to do a series of paintings sprayed on plastic so that the translucence of his

light-filled color will have more scope; the plastic surface may take these works into a quasi-sculptural area.

The shaped canvas, even if two-dimensional, is usually an imperfect vehicle for monotone painting. Rather than altering the rectangle and continuing to stress the surface, as Mangold does, most adherents of the shaped canvas (such as Peter Tangen, Ron Davis and David Novros) depart more radically toward a relief or sculptural concept. They do not go beyond painting so much as they ignore painting and establish a "third-stream" idiom. While obviously irrelevant to the quality of the work, the whole point of a large monotone surface is denied by the use of exaggerated shapes, which de-emphasize surface in favor of contour. When the expanse of an uninflected single surface gives way to the silhouette, the wall becomes the ground, or field, and the canvas itself becomes an image, a three-dimensional version of the hard-edge painted image. Similarly, works like Ellsworth Kelly's monotone (but differently colored) canvases hung together as one, become a three-color painting, not a monotonal unity. Paul Mogenson's spaced modular panels – of the same height and same iridescent blue but of different widths – also approach sculpture rather than retaining the single surface of true monotone.

An absolutely monotonal and monochromatic art is by nature concerned with the establishment and retention of the picture plane. Three New York artists, Ralph Humphrey, Robert Ryman and Brice Marden, have been working with surfaces that do not relinquish the controlled but improvisational possibilities of the paint itself. They have stripped the impasto of its gestural, emotional connotations. Their canvases emphasize the fact of painting as painting, surface as surface, paint as paint, in an inactive, unequivocal manner. Humphrey has had three monotone exhibitions at the Tibor de Nagy Gallery in New York (1959, 1960 and 1961), in which a dark, heavily worked surface avoided virtuoso expressionism as well as a mechanical or delicately mannered effect. Humphrey's 1965 exhibition was no longer monotonal, but added a contrasting framing band, which also indicated the non-emptiness of a "blank" center. Marden's palette is related to Humphrey's, consisting of neutral, rich grays and browns. A flat but rather waxy surface with random, underplayed process-markings covers the canvas except for a narrow band at the bottom, where drips and smears and the effects of execution are allowed to accumulate. He seems to exclude emotion entirely, whereas Humphrey claims neither an expressionist nor an anti-expressionist point of view.

Ryman's concern, on the other hand, is entirely with paint; he has gradually rejected color since 1958, and his square, irregular, but all-over white

paintings of that period have since become regular, monotonal white paintings in a logical sequence of exclusion. In 1965 he made a series of totally flat, square white canvases (some in oil, some in acrylic, some in enamel), which were still subject to variation, in that even the enamel had a quality of its own, no matter how flatly it was applied. In 1966, Ryman evolved a system of monotone based on an almost imperceptible, impassive, horizontal stroke (made with a thirteen-inch brush) on a "solid" white surface, the only irregularity being a faintly uneven outer edge.

It should be clear by now that monotonal painting has no nihilistic intent. Only in individual cases, none of which is mentioned here, is it intentionally boring or hostile to the viewer. Nevertheless, it demands that the viewer be entirely involved in the work of art, and in a period where easy culture, instant culture, has become so accessible, such a difficult proposition is likely to be construed as nihilist. The experience of looking at and perceiving an "empty" or "colorless" surface usually progresses through boredom. The spectator may find the work dull, then impossibly dull; then, surprisingly, he breaks out on the other side of boredom into an area that can be called contemplation or simply esthetic enjoyment, and the work becomes increasingly interesting. An exhibition of all-black paintings ranging from Rodchenko to Humphrey to Corbett to Reinhardt, or an exhibition of all-white paintings, from Malevich to Klein, Kusama, Newman, Francis, Corbett, Martin, Irwin, Ryman and Rauschenberg, would be a lesson to those who consider such art "empty." As the eye of the beholder catches up with the eye of the creator, "empty," like "ugly," will become an obsolete esthetic criterion.

GRÉGOIRE MÜLLER

AFTER THE ULTIMATE

Robert Ryman, *Untitled*, 1965. White enamel on linen canvas, stretched and stapled onto wooden stretcher, $10\frac{1}{8} \times 10\frac{1}{8}$ inches. Photograph by Ben Blackwell, courtesy of Pace Wildenstein. San Francisco Museum of Modern Art, extended loan of the artist. © 1965 Robert Ryman.

The *Twelve Rules for a New Academy* mark the result of more than twenty years of work, during the course of which Ad Reinhardt passed through different styles. Post-Cubism, Constructivism, "Rococo-Semi-Surrealism" and "All-Over Baroque-Geometric-Expressionism" have been the principal phases of a long evolution. As Lucy Lippard noted in her introduction for the Ad Reinhardt exhibition in 1966 at the Jewish Museum, he held to a principle of rejection: all that did not accord with his ideal of "pure painting," was abandoned along the way, in order to arrive at retaining only the quasi-monochrome surface of his last works. If one really adheres to the manner which Ad Reinhardt indicates to see his works, one remarks that he was not far from truly "making the last paintings which anyone can make"; after him it was necessary to find other forms of art.

The black monochromes, barred in a doubly symmetric way with two black bands, can serve as a reference point for a phenomenology of pictorial perception. The minimal geometry of Reinhardt blocks the eye "inside" the painting. Once within the painting the eye goes and comes following the directionless-laws of the work, without succeeding in finding an exit. The bands of a Reinhardt act as edges which prevent us from falling into all that he does not wish pure painting to be. ("Art is not what is not art. . . . Abstract art has its own integrity, not someone else's 'integration' with something else. . . . Any combining, mixing, adding, diluting, exploiting, vulgarizing or popularizing abstract art deprives art of its essence.") Within the limits of the painting, all that Reinhardt could have otherwise done would have

Grégoire Müller, "After the Ultimate," *Arts Magazine* 44, no. 5 (March 1970): 28–31.

permitted the eye – and the spirit – of the spectator to "go out" toward something else.

To reject the minimum of geometry at which he arrived in order to achieve the pure monochrome would have been to permit the eye to slide flatly toward the limits of the canvas without recording sensations other than that of a continuous intensity. In this case, when the eye arrives at the border limits of the canvas, it circumscribes this intensity within the space and recreates the sculpture or the object (as in the case of the monochromes of Yves Klein which, as opposed to those of Reinhardt, are "symbolic objects").

To substitute the strict delimitations between the monochrometic nuances with informal variations would have been to create for the eye an aperture "in depth" within a romantico-sentimental space for dream or meditation; this would have involved, once again, leading the spectator out of the reality in front of which he is placed – the reality of the painted surface.

Moreover, to accentuate the geometry of the composition inevitably creates in the mind of the spectator an anecdotal hierarchy of forms: geometry playing on our capacity to evaluate rationally, establishing relations of + or − from which we organize our discourse just as the mathematician composes his equation. (Cf. Malevich: "Art is the ability to construct . . . on the basis of weight, speed and the direction of movement.") None of these solutions, no more than that of the uniform Pollockian texture which has a romantic psychological connotation, was possible in the rigorous optic of Reinhardt; with each other experience the spectator would have found himself faced with something other than pure painting, faced with an "elsewhere." That this elsewhere be interesting, stimulating, enriching, of quality, good or bad . . . it little matters – in that it is a domain that painting cannot entirely control.

"Control and rationality are part of any morality," and particularly of the morality of Reinhardt whose entire work reposes upon a will to certitude, upon a fundamental repulsion for all the deviations on which the mind embarks when it attempts to apprehend something . . . deviations which lead it toward this "elsewhere" where all is possible and permitted without control. In Reinhardt, however, there persists only the subtlety of colored nuances, these profound reds and blues that the artistic travail of the brush lets transparently be evoked – something more vague, more sentimental, that he would have wished his painting be. . . . If color and painted material still remain evocative to a certain extent, the light is perfectly controlled and "factual" contrary to what has often been written regarding this. In a painting, light habitually has a double connotation: psychological

(light more or less affects our sentiments), and spatial (light reveals depth; opacity closes the space). It is this double implication, extremely rich, which has merited that light be always associated with painting . . . in the sense that Reinhardt does not intend it to be. In his work, all light other than the simple phenomenon of luminous variable intensity is only a critical adduction exterior to pure painting.

In giving himself a goal to make a painting which is only painting, which is not "referential" to the life of the artist, to aesthetic problems or to anything other than itself, Reinhardt attempted to resolve the Hegelian contradiction between thought and reality: the interior representation that the spectator has of the work being supposed to correspond exactly to the reality of the work, in a rapport that Reinhardt would have wished to be totally univocal. It is in this sense that his work is ultimate and calls for, after itself, something else.

The logical consequence of Reinhardtian theories, as some have already remarked, can find itself more easily in sculpture – specifically with Minimal Art which affirms itself as pure, non-referential volume. But the manner in which Minimal volume occupies space – often aggressively – recreates an ambiguous situation. Only the plaques of Carl Andre attain and depass in purity and "moral" rigor the goal proposed by Reinhardt; placed in the most neutral arrangement possible on the ground, they do not even recall the psychologic notion of construction, of erection, which is the specific characteristic of all sculpture. (One could draw a parallel even between the two evolutions: each work keeping the "souvenir" of an "artistic" creation – this opposed to the "Conceptual" creation of a good part of art today. In order to arrive at his present results, Andre has worked on from Brancusi and has also passed through Constructive stages. . . .)

It is interesting to consider in what state painting has been left by the challenge that Reinhardt formulated by means of his work and writings. It is not a question of considering whether in the capacity of artist he has left an influence or whether he has left a heritage characterized by a style, but rather of making use of a work that we term "ultimate" to situate the work of some young artists. This point of reference distinguishes itself on two levels: formally, Reinhardt has purified painting until it be no more than a colored surface; morally, he has reduced to the minimum the liberty which the artist habitually takes – of utilizing art to speak of himself, in order to express his opinion on whatever non-artistic subject, or to lead the spectator into flattering delusions.

A great part of contemporary abstract painting is non-compositional; with artists such as Diao, Hacklin, Marden, Prentice or Ryman, the only

clearly defined form is that of the support. These artists have rejected the possibility of establishing relations from one form to another form, from one range of color to another, all the while voluntarily directing our attention to the quality of the surface. For them the colored uniform surface of the canvas presents itself as a "fact," an entity referring to nothing else but itself. This factual quality is close to the spirit of Minimal Art, and one realizes that one of the pitfalls that these painters avoid by different means is that of making of the canvas a "specific object" or a sculpture. It is thus that the dense and opaque surfaces of the paintings with wax of Brice Marden always remain "open" at the base of the canvas: if the eye can slide on these surfaces one instant as if on something endowed with an essentially tactile quality, it is very quickly halted at the bottom of the canvas; there "painting" appears, trickling, irregularly covering the rest of the canvas. David Diao manages to block the eye on the surface by creating more or less perceptible "accidents," but without recreating a true pictoral composition, in that each of these accidents owes its presence to a practical cause: the traces of the wooden stretchers of the frame and traces of bricks placed on the ground under the working canvas as props are retained by accumulations of paint on the canvas surface. . . .

To retain the eye on a monochromatic surface is a result easily obtained for those painters who, along the line of Robert Irwin, create the illusion of a space in depth by a subtle working of light. The perfect example of this play of nuances and ambiguities lies in certain recent monochromatic canvases (dominantly white) of Hacklin, who lets us float in an aesthetic and sophisticated world as opposed to the rigor or factuality of Reinhardt. Very close to his approach is the work of David Prentice, who introduces a supplementary ambiguity which breaks, in a way, this illusionary space: the geometry of vertical panel divisions between the different elements of a single canvas cancels out the space-in-depth of the variations of nuances and tends to create a "surface-object," in its turn canceled out by the variations of nuance . . . an unstable coming and going, agreeably gratifying in its gratu-itous aesthetic. A superficial glance at Ryman's work could well make one think that one is in a neighboring domain, whereas oppositely, he has man-aged to totally repudiate luminous or spatial effects in his monochrome cream-white paintings. The color evokes nothing and remains uniform, purely surface. In order to avoid being regarded as an object, the painting of Ryman is flat against the wall with very little support; at the same time the unity of the surface is broken by the juxtaposition of different spreads of paint in a perfectly neutral composition (comparable to the non-composition of Andre). This manner of juxtaposing equal rectangular surfaces leads us

directly to a process of composition frequently employed by artists who deal with the monochrome: gridding. One finds it in the drawings of Brice Marden as well as in numerous canvases of Agnes Martin; while she maintains a rather large grid she depasses the visual effect and attains a result which is not far from the absolute of Reinhardt.

The grills of horizontal, vertical, and oblique lines of Sol LeWitt create a surface which, by their absolute uniformity, must almost inevitably be executed directly on the wall in order to be able to be seen and perceived as "surface" and not as a simple quality of a canvas. LeWitt's systematic and mechanic method of constructing the surface categorically denies all possibility of interpreting the work; the lines cross each other in a manner that no longer has anything to do with the personality of the artist, nor with aesthetics, if one only considers his best works.

In turning around the problems raised by the work and the writings of Reinhardt we perceive that we arrive at an art which, without having anything to do with Anti-Art, might be considered as Non-Art . . . or that one is marking time at limits by proposing parallel solutions. By force of eliminating all that is not painting to arrive at pure painting one ends up at non-painting . . . in a paradox which might not have displeased he who affirmed that more is less. Daniel Buren who always pastes the same bill-posters with bands of neutral color and medium width, or Weiner who leaves no more than barely preceptible traces, represent extreme answers to the writings of Reinhardt: "No texture. . . . No brushwork or calligraphy. . . . No sketching or drawing. . . . No forms. . . . No design. . . . No colors. . . . No light. . . . No space. . . . No time. . . . No size or scale. . . . No movement. . . . No object, no subject, no matter." In fact, from an evolutive point of view, the history of painting stopped ten years ago . . . almost without one's realizing it.

All quotations in this chapter are taken from the writing of Ad Reinhardt.

SHELDON NODELMAN

MARDEN, NOVROS, ROTHKO
Painting in the Age of Actuality

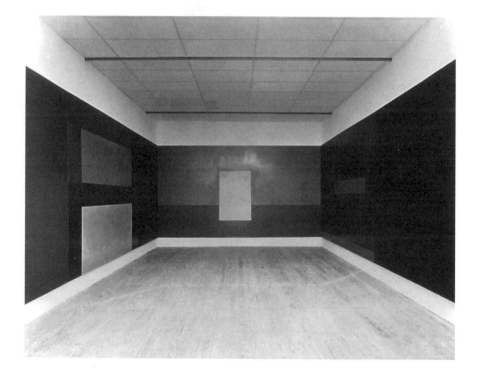

David Novros, *Painting I*, 1974–75. Oil on canvas, three panels, center: 120 × 215 3/4 inches, sides: 120 × 289 inches. The Modern Art Museum of Fort Worth, Museum Purchase, the Benjamin J. Tillar Memorial Trust.

In the prevalent art discourse of the last decade the position of painting has become increasingly problematic.[1] Hardly a generation ago it was still through the pictorial medium – at the hands of the Abstract Expressionists – that a radical alteration was accomplished both in the visible formal organization of the work of art and in the ethos which motivated and justified it, an alteration which appeared at the time – and, in retrospect, still appears to some considerable degree – to have constituted the first major departure from the earlier tradition of modernism dating back to the first years of the 20th century. The present widely-credited "crisis" was itself precipitated in the years just before and after 1960 largely in the work of a painter, Frank Stella, who, drawing upon tendencies directly evident in the works of certain of the first-generation Abstract Expressionists (Rothko, Newman, Still, and in an important, though partial, aspect, Pollock) and other tendencies evoked partially in continuation, partially in response to these (Johns, Rauschenberg), undertook what has seemed a yet more drastic reorganization of the internal economy of the work of art and of the ground rules for its interaction with the spectator. Nevertheless it is precisely painting which has been perceived as put into question through this transformation.

Stella abruptly terminated the millennial history of internally focused composition in painting and reconstituted it as addressed rigorously outward to the world of the spectator, while fusing pictorial surface and physical support into a simple, unified picture/object. In so doing, he seemed definitively to sweep away one of the foremost – if not indeed paramount – traditional properties of painting, that of purveyor *par excellence* of illusion.

Sheldon Nodelman, *Marden, Novros, Rothko: Painting in the Age of Actuality* (Houston: Rice University, 1978), 8–86. Excerpted.

Internally focused composition, by directing the attention of the viewer to the interactions purportedly taking place *within* the object, necessarily diverts that attention from the real interactions ongoing between it and himself and hence would seem necessarily to generate – or at least has traditionally never failed to generate – that kind of response within the spectator which we call "having an illusion." (This of course applies, *mutatis mutandis*, to "abstract" as much as to "figurative" compositions.)

Stella's innovations (soon widely diffused throughout the art of the early and middle '60s) may be seen as the culmination of the long development within Western art, dating back at least as far as the late Renaissance and tremendously accelerated since the mid-19th century, toward the progressive thinning-out of that texture of cues within the overall compositional structure whose interaction has seduced the viewer into the imaginative experience of objects, spaces, and qualities – in short, of a world which is only virtually, rather than actually, present before him. As the specificity of these cues, and the density of their interlacing, have waned, an ever-larger and more overt role has been asserted "from beneath" by the material realities of pictorial construction, which necessarily underlie and sustain such references to the nonpresent (or "ideally" present) in the same manner as phonological events underlie the referential meanings of speech, and from which the spectator's attention has hitherto been diverted. (How "simple," how immediately present, and how neutral relative to the superstructure of reference such events may truly be is another and more complex question.)

Increasingly thus, the material properties of those very forms which have served to engender the referential structure of the picture were thrust forward through the thinning fabric of that structure toward the observer's attention. Among these might be, e.g., the scale, weight, texture, and chromatic properties of paint strokes, each identifiable as a distinct human gesture undertaken with reference to – and hence itself calling attention to – an underlying plane which is itself the surface of an object of determinate size, shape, and finally, thickness. In the work of the Abstract-Expressionist generation such properties were rhetorically emphasized through magnifications of scale and through heightened contrast of the formal constituents with one another and with the sustaining ground, to the point where the capacities of the surviving internally focused compositional references to sustain a comprehensive effect of virtuality were fatally compromised. During the '60s, the "future of illusion" – unless ironically qualified and denatured as in much so-called "Pop" art – might appear bleak indeed. In fact, the celebration of the sensorially present, the stripping away of layer after

newly uncovered layer of yet remaining virtual properties in the quest for irreducible truths of experience – often located in psychophysical transactions beneath the ordinary threshold of conscious awareness – has become a major theme of avant-garde art in the last decade.[2] Here the art object is designed less to engender an associative and imaginative superstructure beyond its physical givenness than to provoke inquiry into the infrastructure of perception and inference beneath that givenness, and hence underlying the world of our ordinary experience; or in a parallel fashion, to exhibit the primary properties of its materiality by dissolving that givenness into the interfacing of varying specific qualities, receptive in varying ways, to varying "outside" forces playing or having played through it in time.

The adequacy of the inherent capabilities of painting to this process of phenomenological analysis has been put acutely in doubt. Painting after all is – or at least, as conventionally understood, appears to be – an operation conducted with reference to a posited two-dimensional field. Its repertory of marks implicitly affirms this field and is collectively comprehensible only in relation to it. Such a field can only be an ideal, i.e., a virtual one. The least number of dimensions necessary for real existence in space is, of course, three: like the page upon which you read these words, a painting is a three-dimensional object, merely a very flat one, whose real thickness – thus whose tangible presence – minimized already by the format of its physical structure, is further negated in traditional pictorial practice by the conspiracy of the superimposed constituent forms to conduct themselves as if sharing a mutually and simultaneously available domain in which the constraints imposed upon entities existent in real space do not apply. (I refer here, obviously, not to the secondary illusionist effects which these forms may be so manipulated as to produce, but rather to the primary code according to which the forms themselves are ordered in their initial presentation to the eye.) Events in real space do not simply proffer themselves to us; rather they withdraw indefinitely from us into ever-new and unforeseeable aspects. Never present in an ideal simultaneity, they disclose themselves only in succession; they must be pursued and this pursuit is waged across time, relentlessly drawing the observer ahead so that he must leave behind the reality fragment he has gained in the quest for the next. The nature of real space thus seems to defy our striving after visual intelligibility in the same fashion as the real time in which speech acts are deployed defies the logical transparency of language. Painting, like language, stakes all upon a perhaps quixotic but inescapable denial of this condition. It claims for itself a special dispensation from the laws which otherwise ineluctably govern our experience, proclaiming a transcendent space in which phenomena

are made completely and simultaneously accessible to the mind, with values which are guaranteed not to shift in the course of being apprehended. The ideal continuity of the two-dimensional plane, its claim to an invariant distance from the eye and hence invariant circumstances within which the variabilities of the superimposed forms may display themselves, free of the danger that their intended nature be misapprehended owing to unpredictable alterations in the condition of their presentation – this ideal continuity predicates an ideal space of pure intelligibility, and therefore one from which the dimension of time is necessarily purged. This printed page affords a ready instance: were it so crumpled as to assert its three-dimensional existence more frankly, the facticity of real space would deny the printed characters their aspired-to uniformities of perceived shape and secure recurrence – in a word, their legibility. It is this aspiration toward an ideal condition of display, fundamental to the pictorial enterprise *per se*, which in a particularly radicalized way has conditioned the development of format, scale, and manner of address in Western painting since the later Middle Ages.

This is not to say that the conduct of the formal superstructure of traditional Western painting did or could wholly ignore the three-dimensional existence of its material infrastructure. Rather, it attempted – usually tacitly but sometimes overtly – to exploit the latter in various ways by co-opting it into its own meaning-system. The usual rectilinear boundaries of the would-be two-dimensional plane, themselves generated out of the same cross-axial grid whence the plane itself derives its existence, posed perilous limit-conditions for the play of the surface forms, threatening to deprive them, by the implicit contrast with an overtly three-dimensional world beyond, of the credibility of their claims to self-sufficiency and hence to valid referentiality. They also collectively constituted the *shape* of the pictorial field, hence infusing the latter with concerns (e.g., balance, centering) subtly derived from the conditions prevailing in the world of real space, traversed by real physical and vital forces. These demands were accommodated traditionally in ways which might mitigate an observer's awareness of them *as demands*, so that the conduct of the overt formal constituents might so far as possible seem justified on wholly internal and self-sufficient grounds; thus awareness of the awkward fact of this infrastructure's existence, implicitly contradicting all the assumptions upon which the overt conduct of the superstructure was based, could be sublimated. At the same time, however, the temptation to court danger by invoking more or less explicitly the presence of real determinants was not lacking; one could thus dramatize the self-conscious virtuosity with which this virtual image was constructed, and

one could attempt to articulate in many complex ways the interaction of the two basically incompatible modes of apprehending the picture/object in such a way as to vivify the virtual scheme's claim to presentness with an infusion of the object's unquestionable assertion of it. This could be done not only with regard to the interplay between the superimposed forms and their physical support, but also to that between the material and virtual properties of those forms themselves. In more recent times, accompanying the progress of an increasingly reductive pictorial dialectic, these possibilities of self-reflexive gamesmanship, with all the eventful transformations which they offer, have assumed the rank of a central concern, indeed become the major subject matter of pictorial activity itself.

In its more ambitious manifestations the "minimalist" painting of the early and middle '60s was a drastic attempt to integrate these apparently incompatible and mutually necessary ingredients of pictorial action into a rigorously consistent whole. However, the basic dilemma remained. Stella and his peers, by proclaiming in a hitherto unexampled way the activity of painting in real space, had simultaneously revealed the picture as an object within that space, thus exposing it as a relatively timid and constrained object. This constraint resulted precisely from its commitment to a pictorial mode of functioning. To the extent that it sought to develop the potentialities inherent in its status as an object by articulating itself more fully in three dimensions (giving rise to a "sculptural" painting corresponding to the "pictorial" sculpture of another era), it imperiled the delicate web of convention, the tacit suspension of disbelief, upon which pictorial virtuality depended. Thereby it risked compromising its inherent pictorial possibilities, and abdicating the special sorts of demands which these could make upon the viewer. An uncomfortable sort of zero-sum game thus ensued. Most serious new painting of the last decade has sought to accommodate, if not always to confront, that issue, usually with uneasy – if sometimes formally brilliant – compromises; much other painting has chosen to ignore it.

Though the decisive formal innovations which generated the art of the '60s were indeed initially formulated in the pictorial medium, the advantage in their development appeared clearly to lie with the new sculpture which quickly emerged in response to them, and which could address the epistemological and psychological problems inherent in forms articulated in "real" space in what seemed a more adequate way. The question then emerged as to whether the fundamental mode of experience upon which painting depends remains a viable one in the late 20th century. The emergence of sculpture toward the beginning of the last decade into a position of

leadership among the arts, a position it had scarcely enjoyed since classical antiquity, suggests one answer to this question.

*

On the face of it, the future of painting, in an age determined to deconstruct the virtual as far as may be and to erect an art of actuality, may appear bleak indeed. Can the specifically pictorial mode of experience with its ineluctable commitment to virtuality address our most pressing existential and hence aesthetic concerns? The answer must seem initially that it cannot. The validity of that answer hangs, however, upon the cogency of the assumptions upon which it is based. In the present exhibition, the Institute for the Arts of Rice University has sought to present a group of works which undertake in varying ways to question these assumptions – not by art-world polemic but through the exploration of hitherto dormant potentialities in the pictorial medium itself, and of levels of functioning implicit in its very nature which therefore have not hitherto been made fully explicit issues of formal organization.

A proper understanding of the point of the exhibition depends on reference to a context which can be represented here only incompletely and, as it were, by proxy. That context is the chapel adjacent to the campus of St. Thomas University in Houston, a few miles from the Rice Museum, which was designed by Mark Rothko under the sponsorship of John and Dominique de Menil. An extended discussion of the Rothko Chapel would be neither feasible nor appropriate here (I hope to treat the Chapel itself and its place in 20th-century art more fully in a forthcoming monograph),* but nevertheless it must recurrently be referred to inasmuch as it forms the indispensable background for the works exhibited. This chapel was envisaged from the outset as the architectural frame for an integrally conceived installation, which in its present form comprises fourteen large panels by the artist disposed sometimes singly and in other cases in contiguous groupings upon the eight walls of its octagonal interior. These panels are not intended to be seen in isolation but as mutually interactive components of a single, comprehensive work of art. Given the viewing conditions which their installation prescribes they cannot indeed be seen in isolation, nor can they be surveyed globally from a single viewing position. In design the individual panels are so adjusted as to respond not only one to another but at the same time to the changing viewpoint of the moving spectator. The

* Sheldon Nodelman, *The Rothko Chapel Paintings: Origins, Structure, Meaning* (Houston: Menil Collection and Austin: University of Texas Press, 1997).

whole is predicated upon an intimate interplay between pictorial surfaces and the three-dimensional space in which they are displayed, and the issues of formal structure which they address emerge fully only in virtue of this interplay.

The Chapel itself is indeed represented here in the form of four large panels, never before exhibited, which were prepared by Rothko as part of an earlier, now supplanted design for its installation. Though they illustrate a phase anterior to his final decision for the Chapel, there is every reason to believe that they reflect the same basic concerns as do their counterparts in the ultimate scheme and should be interpreted according to the same criteria. Regrettably, the very great height of these panels prevented their installation in the same space in the Rice Museum as the two other constituent works in the exhibition, and required their appearing separately in the University's Sewall Gallery some distance away. This is particularly unfortunate inasmuch as the installations by two notable painters of a younger generation, Brice Marden and David Novros, both of whom have acknowledged the influence of Rothko's painting upon the course of their own work, were in some measure inspired by the experience of the Chapel and seek, in ways intrinsic to their own, very different pictorial enterprises, to confront the issues which it presents. Thus the spaces in which the Marden and Novros paintings are displayed were designed by the artists and constructed uniquely for this purpose; we may say that in this case the installation is a planned and integral component of the work of art rather than a factitious condition in which it must be apprehended as well as possible. . . .

. . . Already from the inception of the mature phase of his paintings in the last years of the 1940s, Rothko's compositions, while much involved in effects of "abstract" spatial illusion, nevertheless are so arranged as to display the material actuality of the pictorial object and of the depicted forms which it bears with an unaccustomed directness; indeed it is plain that this assertion of their immediate presence was intended to qualify and interpenetrate the virtual readings which were being generated through them. This was indeed a prominent and distinguishing characteristic of first-generation Abstract Expressionism. The greatly expanded scale of much Abstract-Expressionist painting, for a time the occasion of much controversy, and the abrupt dismissal of the centuries-old tradition of the frame were themselves largely motivated by the desire to invest the picture with a vivid, dominating physical presence and to implant it directly in the spectator's space.

At the same time the compositional apparatus was itself often magnified in scale and its real presence declared in the maximized contrasts between its parts and in the bold collisions between these parts and the framing edges

of the underlying object, whose limits they seemed no longer automatically to respect. The material substantiality of the painted surface itself was frequently insisted upon with broadly gestural paint-handling, thickly built-up surfaces amounting sometimes to a kind of low relief, and occasionally by the inclusion of alien substances or objects. Rothko himself abstained from such compositional melodramatics as he did from any excessive agitation or thickening of the surface pigment. His paintings achieved their particular kind of physical solicitation of the viewer in part from the scale and proportion of the panels themselves, from that of the stacked, interior zones of contrasted color which they contained (especially from the horizontal edges of these as they cut across the panel surfaces almost, though never quite, to their edges), but also from the subtly adjusted play between purely chromatic energies and those illusorily tactile ones resulting from modeling through contrasted values, as both of these absorbed, interpreted, and in turn transformed the material tactility of the pictorial object itself.

In the symmetry and frontality of his compositions, which opened out in confrontational address to the beholder, and in their overscaling and drastic simplification, which reduced to an unprecedented minimum (without wholly eliminating) the illusionist mimetics of internally focused design, his paintings (with those of Barnett Newman) were perhaps the most innovative of the 1950s and directly prefigured the developments of the decade to come.

The four panels exhibited here, dating to 1965–66, are characterized by a layout and facture which may be thought of as intermediate between the artist's familiar manner, pursued with little significant alteration from the late '40s forward, and the newer one which partially replaced it in the course of the '60s, illustrated most notably in the panels which form the present Chapel installation and in the subsequent works immediately preceding the artist's death. The number of the contained elements within the field of the canvas is now reduced from the previous two, three, or more to but one, thus magnifying the scale of its contrast with its ground and heightening the rival claims of each to identify with the underlying object itself; and all trace of a brushy, atmospheric paint-handling, evocative of volumetric effects, is suppressed in favor of an even "impersonal" facture, while the drawing has become similarly precise and "hard-edged." (In themselves these alterations might be thought of as no more than an accommodation to the prevailing mode of the '60s; Newman, too, modified his style in a similar direction during the new decade.) The traditional opposition between figure and ground, in terms both of linear description and of value contrast remains and is indeed apparently heightened, and hence the effects of an illusionist

spatial modeling and at least vestiges of an internally focused compositional dynamic are preserved.

An ultimate phase of compositional reduction was still to come; it would be represented by the monochrome canvases of the Chapel installation and by the last works in which the hierarchy of container and contained yields to the horizontal bisection of the canvas into near-equally weighted zones, which are restrained from intersecting the edges of the support itself only by a narrow and visually recessive framing band. The full extent of the novelty of the four Houston panels, however, is less than immediately apparent. It emerges only across a series of interactions surpassing the physical boundaries of the panels themselves, which were adjusted in conformity with their intended location. Necessarily, these interactions are only incompletely visible in the altered circumstances of their present installation. Their full effect can only be restored through an act of imaginative reconstruction. . . .

＊

The present exhibition is completed by two installations of paintings disposed in architectural space, the work of Brice Marden and of David Novros. In each case the problematics accepted by the artist – that of the disposition of painting in a three-dimensional space and the possible uses of the reciprocal pressures and conditionings which result in the service of a new pictorial economy – is akin to that pursued by Rothko in the Chapel project and is in fact to some degree inspired by it. Each has taken up aspects of those problematics consonant with the inner direction of his own work, and has addressed them in a way new for each but developing from and extending potentialities already existing in their approach to painting. The three components of the present exhibition thus may be seen as a sort of *parergon* to the Chapel itself, one illustrating a stage in its conception, the others pursuing complementary themes and developing others which it had only partially and only implicitly stated.

The Marden installation consists of a shallow rectangular alcove 45 feet across by 17 ½ feet deep, one of whose long sides is open to the principal axis of the gallery space. Within it are disposed eight panels belonging to two distinct groups. Four large upright panels, each 8 feet high by 5 feet wide, are deployed, narrowly spaced, upon the long wall which faces the viewer as he turns into the alcove from the gallery axis. These constitute a group titled *Seasons*. Facing each other upon the two short walls are two pairs of smaller panels, each 29 ¾ inches high by 22 ¼ inches wide, which the artist describes as studies for the larger version. The custom of exhibiting

"studies" together with a "finished" work – conceived for didactic and critical purposes in museological and art-historical circles – has by now, of course, become a relatively common initiative of artists themselves as the distinction between these two categories has dwindled, and with the emergence of an increasingly didactic and serially organized art whose true subject matter has come to be the conceptual framework of its own making.

However, it is evident at once that the Marden installation is not of this sort. It is apparent that the four panels of *Seasons* form a visual unit which is designed to be seen in its present disposition and whose artistic functioning would be utterly disrupted were the present arrangement to be altered. If the four smaller panels were intended to be meaningfully displayed in their character as a "study," they would necessarily have had to [have] been arranged in the order for which they had been originally conceived – presumably the same order as that of the large panels – rather than, as here, broken into two antithetical pairs which cannot effectively be seen together. The present installation makes clear that the two groups – whatever their original genetic relationship – are not intended to be seen side by side as two separate, if mutually enriching, essays upon a common theme; the disparity in the conditions of their visual presentation effectively negates the possibility of such a comparison. Indeed they are so presented that they cannot be seen separately at all, but in fact constitute a single interdependent system, in effect one work of art consisting of eight panels, each modifying our experience of the others within the box of space which they share. Inasmuch as that space, and the disposition of the paintings within it, were as much the artist's decision as was the character of the panels themselves, we are justified in considering all these variables as elements of a single, comprehensive work of art.[3]

The panels themselves are exercises in a format which is by now familiar in Marden's work, vertically oriented rectangles presenting a flat, monochrome field of color devoid – or virtually devoid – of figuration. The qualification refers to a minute interruption – but an important one for the effect of the painting – in the otherwise complete and uniform coverage of the panel surfaces: just above the lower edge of the panel the paint surface thins out, shreds, and leaves at times the tiniest glimpse of underlying canvas. This slight break in continuity is sufficient to prevent an automatic identification of the painted surface with the subjacent physical object, and emphasizes the overall vertical directionality which is faintly perceptible in the texture of the paint surface itself. Thus that surface de-fines itself as a separate entity; a sheet which has been drawn down over the underlying object, almost but not quite obscuring it from view. The

surface as a whole therefore acquires a gestural directionality which – recording the successive applications of layers of paint, its subjection as physical matter to the influence of gravity, and the imposition of the artist's will, acting from outside, upon it – echoes the gestural rhetoric of Abstract Expressionism, most nearly, perhaps, the "minimal" gesturalism of Barnett Newman. The painted surfaces themselves – the result of the layering of coats of pigment in an oil-and-beeswax medium – are singularly opaque and "dead," resisting the penetration of the eye, while the colors, equally characteristically, are curiously "off," choked and inarticulate. All these factors – the sense of the superimposition of a unitary screen of pigment, itself devoid of internal articulation, over a barely glimpsed subjacent object, and the opacity and inertness of that screen itself – combine to frustrate the gaze of the observer, to repel any atmospheric associations and to deny any form of imaginative entry, directing the apparent action of the panels wholly to the exterior. From three sides, thus, the observer's space is crisscrossed by axes of address projecting the somber chromatic weight of the panels and subjecting the spectator to their competing and irreconcilable tensions.

That space itself, anything but "neutral," is strongly articulated despite its apparent simplicity. In fact, as we will see, it constitutes itself as a kind of "theater" into whose transactional system the spectator is inducted, and where he is exposed to a gamut of problematical solicitations which are not "merely" sensorial but psychological and social as well. Its obvious "front," i.e., the long wall which faces the spectator as he enters, turning off his course down the main gallery axis, is designated as such not only by its facing position, and by the dominating size and chromatic emphasis of the four panels which it bears, but also by the fact that the latter are clearly centered within it, while the two pairs of much smaller "sketch" panels, which face one another on the short flanking walls, are *not* so centered, but are noticeably displaced in the direction of the main, rear wall. Drawn as if by magnetic attraction, they help thus to affirm the principal group's centrality and dominance, and their own status as dependent, ancillary, and framing elements. The thrust of the observer's attention toward the "polyptych" is further augmented by the stronger color which distinguishes each of the two inner panels of the flanking pairs from the outer, drawing the spectator's eye inward, and by the fact that the proportions of the so-called "sketches" are substantially closer to square than the panels of the "polyptych," which not only renders them more passive, less assertive shapes, but lends relatively greater stress to the horizontal direction, thereby augmenting the effect of perspectival convergence.

The "polyptych" itself consists of four upright panels whose marked verticality contrasts strongly with the horizontal spread of the wall upon which they are emplaced and endows them with an emphatic anthropomorphic quality, reminiscent of that of the Rothko panels. Their corporeal volume as objects standing separately in space, is emphasized by the three-inch separation between the panels. This is an interval too narrow to release the spectator from the demand to resolve them all into a single visual unit, i.e., to hold them simultaneously in focus, but is wide enough to confer a perceptible plastic independence upon each, a quality reinforced by their strong cast shadows. . . .

. . . The positioning of the thin edge of virtual spatiality at the bottom of the pictorial object is itself significant. Its extraordinary narrowness and the consequent small scale of the variations which it presents, as against the size of the canvas as a whole, impose a very high degree of virtualization and a consequent suggestion of vast spatial expanse – reminiscent of the effect of the surface irregularities within the black rectangles of the Rothko panels – and accentuate the temptation to seek imaginative entry into it. At the same time, the panel in its material nature as an upright, frontal object, addresses the spectator's sense of bodily reality, rendering him acutely conscious of his actual spatial position and scale in relation to it, and thereby stressing the awkwardness of the crouched position – or, alternatively, the Alice-like shrinkage – that would be necessary to "climb into," as it were, the aperture offered. Thus, as in the Rothko panels, he is addressed simultaneously and overlappingly by incompatible solicitations, actual and virtual, each of which accentuates the effect of the other. The tension thus induced helps, of course, to draw the spectator's attention to the consequences of his movements, not only in the horizontal but also in the vertical plane, for the functioning of the virtual system. Here the overlapping solicitations are exploited to engender an effect almost exactly the reverse of that which the Rothkos had sought; instead of sensations of expansion and levitation, ones of compression, scale-diminution, and leaden weight. The imaginative sensation of being squeezed into a size appropriate to the proffered "aperture," and the channeling of the viewer's atention to a level close to the (real) ground plane, corresponding to the lower part of his body from the knees downward and hence evocative of his experience of physical weight and its exigencies, converge neatly with the qualities of the painted surface itself to enhance the panels' overall effect of choked opacity, pressured denseness, and inertia.

Moreover, the implication that the paint surface is interposed between us and a virtual space behind – viz., that it is standing free in space – by calling attention to its own corporeality, intensifies its relationship to our

body, which, crucially, possesses not only a front but also – as the paint sur-
face is now necessarily inferred to do – a back. Front and back represent two
profoundly opposed psychological, cognitive and existential orientations
in the human subject. As the front is that to which our attention is turned,
the back comes to stand for all that to which it is refused, i.e., the re-
pressed contents of awareness. Half of the three-dimensional continuum
of ambient space is at any time rejected by us, blocked effectively from
consciousness in this way. Frontal as they are, pictures have normally
addressed only our fronts, and helped to perpetuate the suppression of much
of our three-dimensional awareness. Marden's device has the virtue of per-
mitting to painting a more comprehensive range of action upon us in space,
without sacrifice of its inherently pictorial mode of functioning. That he is
indeed conscious of the anthropomorphic address of his paintings and of
their implicitly bifrontal character is strongly suggested by his having titled
a group of paintings as the "Back Series" and having prepared an exhibi-
tion announcement showing the nude back of the painter himself [Ed.:
painter's wife] as [s]he looks inward towards the fronts of the paintings; and
by his choice for the cover of his 1975 Guggenheim Museum retrospective
catalogue, of a photograph of himself standing frontally to one side of a paint-
ing no less frontally addressed. In the case of the Rice installation, the provo-
cation of the spectator's consciousness of the unseen, unattended-to realm
behind him contains a subtle threat, if he turns to regard it, he abandons
the microcosm of calculated aesthetic relationships in which he was lately
so fully absorbed to confront what appears in contrast as the chaos of the
"outside" world beyond the installation's limits. This reminder of the fragility
of the virtual experience exhibits its nature as a choice on the spectator's
part, and, while enhancing its preciousness, interfuses it with disquieting
doubts. . . .

*

David Novros has chosen to develop his conception of the relationship be-
tween pictorial and vital [virtual?] space in a very different fashion. He has
constructed three "rooms," two of which are three-sided enclosures, upon
whose walls are affixed huge multi-unit polychrome panels in such a way
as to approximate the effect of murals, and which will not fail to remind the
classically trained observer of Romano-Campanian wall frescoes. These,
however, are not frescoes, a medium in which Novros has been intensely
interested and which he has worked in at [every?] opportunity, but paintings
on canvas, and their luminosity and reflectivity – the antithesis of fresco – is

important to their effect. More important, their surface is not the plane of the wall as such, as is characteristic of mural painting; rather they are stretched canvases which project as slabs noticeably in front of the wall surface. This point is emphasized in the remaining "room," where a large one-wall painting of similar design is shown, which, because of its isolation, is far more plainly contrasted with its architectural surround, and by affirming its physical discreteness stresses its own – and, by implication, its fellows' – kinship with traditional easel painting. In fact, that peculiar tension between contained figuration and the delimited form of the containing object basic to the formal structure of easel painting – but which in mural painting operates on very different terms – is obviously a major concern in these panels. So, as well, is that tension on a more inclusive level, between the containing object and *its* container, in this case the architectural construct which houses it and the space which this construct defines.

Here too, as in the intended disposition of the Rothko panels and in that of the Marden installation, the distension of the work's action in real space and the disturbing realities of peripheral vision are exploited to undermine the claim of the pictorial artifact to uncontested authority over the observer's attention and belief, and to involve him in physical displacements which reactivate his kinaesthetic awareness. Like Marden, Novros has chosen a three-sided enclosure as the appropriate arena for the action of the painted components. However, he does not employ the openness of an omitted fourth side, behind the viewer, as a kind of Damoclean threat to the fragile integrity of the art situation: rather, any such potential threat is defused by the device of a screening wall which partially closes the space. Itself bare of painting, this wall serves to emphasize by contrast the physicality of the three abutting painted slabs and equally their contingency, hence their attention-arresting character of having been set up. At the same time it serves to strengthen awareness of the independent presence of the walls themselves, underlying and framing the painted slabs, and supports their rival claim to define the extent and nature of the contained space. Thus the tripartite slab construct functions as a piece of environmental sculpture, effectively set off against its environment. Marden's panels relate to their enclosure almost entirely in its spatial extension, and treat the delimiting walls merely as surfaces against which they isolate themselves plastically and chromatically; no attempt is made to invoke those surfaces as active architectonic elements inhabited by forces kindred to, and hence competing with, those of the panels. Novros, in his concern for the painting-as-object's interaction with, and reciprocal virtualization of, the physical integument of the environing architecture as well as the space which it defines, develops

a theme characteristic of much "minimal" sculpture, and some painting as well, of the '60s and early '70s; Rothko too had touched upon this theme, not explicitly in the paintings exhibited here, but rather in the pair of identical three-panel paintings which face each other on the side walls of the Chapel, whose pictorial function is permeated and transformed by their strongly sculptural interplay with one another, and with the architectonics of the walls upon which they are installed. . . .

*

If the argument which I have put forward in this essay has any validity, it suggests a need to reexamine certain widely held assumptions which have not only conditioned much 20th century critical thought but have – especially in recent decades – exerted a profound influence upon artistic production itself. Though these issues deserve a much ampler treatment than the very cursory one possible here, their importance to the contemporary situation of the arts compels at least some mention of them. One of these is the prevalent taxonomy of the arts in terms of the modes of sensory perception and of the physical media which are understood to correspond most appropriately to them. In this view, particular material qualities are ascribed an inherent appropriateness to convey certain kinds of knowledge, to image the world in specific and irreplaceable ways which themselves correspond to certain possibilities of human existence. Although traces of it may be found earlier, the attempt to elaborate a systematic hierarchy of the arts based upon such differentiae, to delimit their proper fields of action, and to ascertain what types of content and what principles of organization are suitable to each, dates to the earlier half of the 18th century: Lessings's *Laocoön* and Herder's essay on sculpture are cases in point. This enterprise, codified in the grandiose structure of Hegel's *Ästhetik*, echoed through the 19th century, and at the beginning of the 20th was articulated into a highly rationalized instrument of "scientific" analysis in the works of Alois Riegl, whence (though in blunted and fragmented form) it has been diffused throughout the entire fabric of modern art-historical and art-critical thought. (Its most recent formulation has been the slogan that "the medium is the message.") This idea would not have attained the influence which it did had it not possessed great and obvious merit. Insofar as works of art are embodied in things and events within the "physical" world they must indeed be apprehended through the senses, and the senses indeed differ profoundly in the kinds of information which they convey and the regions of experience to which they seem naturally relevant. Thus it would appear

reasonable to distinguish painting, sculpture, and architecture (to say noth-
ing of poetry, music, dance, and film) according to the way in which they
play upon the various sensorial fields to which they are addressed. In the
art-world discourse of the last decades, however, these analytical distinctions
came to ascribe a normative and prescriptive value in the attempt to find a
replacement for the since-faded external functions and justifications of the
art work in internally-derived, ultimately self-referential motivations. Hence
the prominent role of "faithfulness to the nature of materials" and "respect
for the integrity of the medium" in modern critical theory. The mystique of
"flatness" which preempted so large a share of the discourse about paintings
in America from the '40s through the '60s is an egregious example of this
sort. Within it an ever-growing recognition and celebration of the inherent
properties of the physical medium itself came to be envisioned not only as
an ethical obligation and touchstone of value, but as part of an ineluctable
historical progress.

Abstracted and absolutized in this fashion, the doctrine of the differen-
tiation of the arts in terms of primary modes of sensory address becomes
no longer an analytical aid but an obstacle to effective critical thought.
For no sense exists in isolation. It is not by a particular sense nor even by
the sensorium as a whole that works of art – or indeed things in general
in this world – are apprehended, and to which works of art are addressed.
Rather this apprehension and this address are by and to the mind, that of
the living human being, of whose world-generating cognitive outreach the
various senses are partial aspects, reifications of particular functions. In-
evitably these various functions are experienced simultaneously, mutually
qualifying one another, and ascribed shifting roles in a complex system of
substitutions and exchanges. Nor, inasmuch as these are but prolongations
or specifications of the mind, can sensation and cognition finally be divided.
Insofar as it is a concrete existent in this world, any art work implicitly con-
tains the entire range of possible sensory/cognitive solicitations; specific
formal organization seeks to impose a particular patterning and functional
hierarchy in their presentation. Hence it is vain to attempt to allocate or
prescribe exclusive modes of operation to hypostatized categories of, e.g.,
"painting" or "sculpture"; rather any particular artifact will play upon and
emphasize certain possibilities of pictorial/sculptural (or other) function-
ing. (The proper role of an analysis involving the discrimination of sensorial
modes is in the identification and assessment of this complex transactional
process.) To condemn as "impure" certain of these possibilities merely with
regard to the hypostatized genre-categories to which their material supports
are purported to belong without reference to their effective function as *works*

of art, i.e., as addressed to an integral consciousness as an act of meaning, is arbitrary in the extreme. I have tried to show in what has preceded how relative the inherited distinction between "painting" and "sculpture" indeed is; even within the traditional limits of physical format, modifications of formal organization can induce far-reaching alterations in the mode of address through appeal to cognitive functions alone. (For the sake of brevity I omit any discussion of the further alterations possible through the manipulation of the perceived/cognized *context*.)

The possibilities of meaning inherent in the art work are thus subject to continuous reinvention; they cannot be prescribed in advance. The implications of this for any scheme of historical determinism are clear. Such schemes are binding only insofar as they are assented to, i.e., insofar as they serve to straitjacket thought and feeling, and hence to foreclose choices. In recent years a heightened historical consciousness and an increased sensitivity to contextual values has inspired in artists a keen sense of the positional meaning of their work within a system of ongoing discourse. However, insofar as such a system is envisioned as fixed, i.e., insofar as its possibilities are accepted as delimited in advance, the number of positional meanings is finite. In such a case the available options for significant action are gradually exhausted and the participants find themselves locked into progressively tighter boxes. I believe such a mechanism has in fact been operating within the American and international art worlds in recent years to constrict the range of real artistic (and therefore personal) freedom. The constraints, however, though very painful, are artificial and self-imposed. If what have been understood to be the rules of the game are in fact seen to be capable of – and indeed, in adequacy to changing exigencies, to demand continuous reinvention, the present no longer appears to be determined by the past. Its presentness – its immediate access to the sources whence meaning is unfolded – is restored to it. Signs of such a process of reinvention and rediscovery of possibility are, I believe, beginning to emerge around us. I have tried to point out what I take to be some such significant portents in what has preceded.

NOTES

1. I would like to thank my friend, the sculptor John Ingram, for his patience in enduring hours of protracted discussion of the issues dealt with in this essay, and for his many valuable suggestions.
2. A fuller treatment of this and related questions may be found in my article "Sixties Art: Some Philosophical Perspectives" in *Perspecta: The Yale Architectural Journal* 11 (1967), pp. 73–90.

3. Subsequent to the closing of the Rice exhibition and the dismantling of this installation, Marden has repainted the four panels of the central polyptych so as to bring them to a state of formal resolution as an independent entity. The new and quite different work which has resulted has necessarily severed its functional relationship with the "sketch" panels and with the spatial dispositions of the Rice installation. The work as described above thus no longer exists.

DOUGLAS CRIMP
THE END OF PAINTING

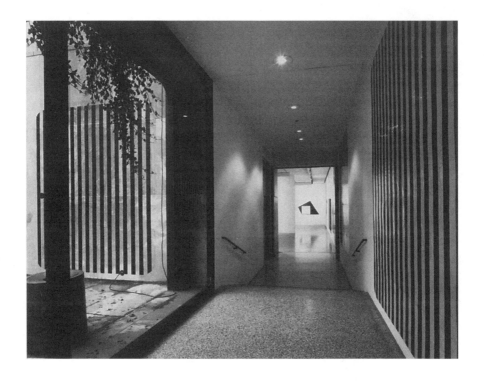

Daniel Buren, Installation view of the exhibition "Eight Contemporary Artists," the Museum of Modern Art, New York, October 7, 1974, to January 5, 1975. Photograph © 2002 The Museum of Modern Art, New York.

Painting has not always existed; we can determine when it began. And if its development and its moments of greatness can be drummed into our heads, can we not then also imagine its periods of decline and even its end, like any other idea?

Louis Aragon, "La peinture au defi"

The work of art is so frightened of the world at large, it so needs isolation in order to exist, that any conceivable means of protection will suffice. It frames itself, withdraws under glass, barricades itself behind a bullet-proof surface, surrounds itself with a protective cordon, with instruments showing the room humidity, for even the slightest cold would be fatal. Ideally the work of art finds itself not just screened from the world, but shut up in a vault, permanently and totally sheltered from the eye. And yet aren't such extreme measures, bordering on the absurd, already with us, everyday, everywhere, when the artwork is exhibited in those vaults called galleries, museums? Isn't it the very point of departure, the end, and the essential function of the work of art that it should be so exhibited?

Daniel Buren, Reboundings

On one of those rare occasions during the 1970s when Barbara Rose abandoned the pages of *Vogue* magazine in order to say something really serious about the art of our time, she did so to vent her anger at an exhibition called *Eight Contemporary Artists*, held at the Museum of Modern Art in the fall of 1974.[1] Although she found the work in the show "bland and tepid" and therefore something "normally one would overlook," she felt compelled to speak out because this show was organized by our most prestigious institution of

Douglas Crimp, "The End of Painting," in *On the Museum's Ruins* (Cambridge: MIT Press, 1993), 84–105. Reprinted from *October* 16 (1981).

modern art, and, for that reason alone, it became significant. But the work was bland and tepid to Rose only from an aesthetic standpoint; it was more potent as politics:

For some time I have felt that the radicalism of Minimal and Conceptual art is fundamentally political, that its implicit aim is to discredit thoroughly the forms and institutions of dominant bourgeois culture.... Whatever the outcome of such a strategy, one thing is certain: when an institution as prestigious as the Museum of Modern Art invites sabotage, it becomes party, not to the promulgation of experimental art, but to the passive acceptance of disenchanted, demoralized artists' aggression against art greater than their own.[2]

The particular saboteur who seems most to have captured Rose's attention in this case is Daniel Buren, whose work for MOMA consisted of his familiar striped panels, cut to conform to the windows facing the garden, and affixed to the corridor wall facing those windows, and again to the garden wall, with leftover fragments displaced to a billboard and a gallery entrance in SoHo. Impressed though she is by the cogency of Buren's arguments about the ideology imposed by the museum, Rose is nevertheless perplexed that Buren would want his work to appear in one, which seems to her like having his cake and eating it too. For illumination on this question, she turns to an interview with William Rubin, director of MOMA's Department of Painting and Sculpture. In the interview, published in a 1974 issue of *Artforum*, Rubin explains that museums are essentially compromise institutions invented by bourgeois democracies to reconcile the larger public with art conceived within the compass of elite private patronage. This situation, Rubin suggests, might be coming to an end, making the museum irrelevant to the practices of contemporary art.

Perhaps, looking back 10, 15, 30 years from now, it will appear that the modernist tradition really did come to an end within the last few years, as some critics suggest. If so, historians a century from now – whatever name they will give to the period we now call modernism – will see it beginning shortly after the middle of the 19th century and ending in the 1960s. I'm not ruling this out; it may be the case, but I don't think so. Perhaps the dividing line will be seen as between those works which essentially continue an easel painting concept and that grew up associated with bourgeois democratic life and was involved with the development of private collections as well as the museum concept – between this and, let us say, Earthworks, Conceptual works and related endeavors, which want another environment (or should want it) and, perhaps, another public.[3]

Rose assumes that Buren is one of those artists whose work wants (or should want) another environment. After all, his text "Function of the Museum,"

which she quotes, is a polemic against the confinement of artworks in the museum.[4] But if Buren's work had not appeared in the museum, if it had not taken the museum as its point of departure and as its referent, the very issues Rose ponders in her essay would not have arisen. It is fundamental to Buren's work that it function in complicity with those very institutions it seeks to make visible as the necessary condition of the artwork's intelligibility. This is the reason that his work not only appears in museums and galleries but also poses as painting. It is only thereby possible for his work to ask, What makes it possible to see a painting? What makes it possible to see a painting *as a painting*? And, under such conditions of its presentation, to what end painting?

But Buren's work runs a great risk by posing as painting, the risk of invisibility. Since everything to which Buren's work points as being cultural, historical, is so easily taken to be natural, many people look at Buren's painting the way they look at all paintings, vainly asking them to render up their meanings *about themselves*. And since they categorically refuse to do so, since they have, by design, no internal meaning, they simply disappear. Thus, Rose, for example, sees Buren's work at the Museum of Modern Art only as "vaguely resembling Stella's stripe paintings."[5] But if Rose is myopic on matters of painting, blind to those questions about painting that Buren's work poses, this is because she, like most people, still *believes* in painting.

✳

One must really be engaged in order to be a painter. Once obsessed by it, one eventually gets to the point where one thinks that humanity could be changed by painting. But when that passion deserts you, there is nothing else left to do. Then it is better to stop altogether. Because basically painting is pure idiocy.

Gerhard Richter, in conversation with Irmeline Lebeer

As testimony to her faith in painting, Rose organized her own exhibition of contemporary art five years after the MOMA show. *American Painting: The Eighties* (the title is oracular: her show was mounted in the fall of 1979) expressly intended to demonstrate that throughout that grim period of the 1960s and the 1970s, when art seemed to her so bent on self-destruction, intent as it was on those extra-art concerns gathered together under the rubric *politics* – that throughout that period there had been "a generation of holdouts" against "disintegrating morality, social demoralization, and lack of conviction in the authority of tradition."[6] These noble survivors, painters all, were "maintaining a conviction in quality and values, a belief in art as a mode of transcendence, a worldly incarnation of the ideal."

As it happens, Rose's evidence of this keeping of the faith was extremely unconvincing, and her exhibition became an easy target for hostile critics. Biased as her selection was toward hackneyed recapitulations of late modernist abstraction, the show had the unmistakable look of Tenth Street art, twenty years later. Given the thousands of artists currently practicing the art of painting, Rose's selection was indeed parochial; certainly there is a lot of painting around that *looks* more original. Furthermore, favoring such a narrow range of painting at a time when pluralism was the critical byword, Rose virtually invited an unfavorable response. And so, as was to be expected, she was taken to task by various art journalists for whomever of their favorites she failed to include. Hilton Kramer's review asked, Where are the figurative painters? John Perreault's asked, Where are the pattern painters? And Roberta Smith's asked, Where is Jennifer Bartlett? But the crucial point is that no one asked, Why *painting*? To what end painting, now, at the threshold of the 1980s? And to that extent, Rose's show was a resounding success. It proved that faith in painting had indeed been fully restored. For, however much easel painting may have been in question in 1974 when Rubin was interviewed by *Artforum* and his museum exhibited *Eight Contemporary Artists*, by 1979 the question clearly had been withdrawn.

The rhetoric that accompanies this resurrection of painting is almost entirely reactionary: it reacts specifically against all those art practices of the 1960s and the 1970s that abandoned painting and worked to reveal the ideological supports of painting, as well as the ideology that painting, in turn, supports. And so, whereas almost no one agreed with the choices Rose made to demonstrate painting's renascence, almost everyone agreed with the substance, if not the details, of her rhetoric. Rose's catalogue text for *American Painting: The Eighties* is a dazzling collection of received ideas about the art of painting, and I want to suggest that painting knows only such ideas today. Here are a number of excerpts from Rose's essay, which I think we may take as provisional answers to the question, To what end painting in the 1980s?

Painting [is] a transcendental, high art, a major art, and an art of universal as opposed to topical significance....
　　Only painting [is] genuinely liberal, in the sense of free....
　　[Painting is] an expressive human activity ... our only hope for preserving high art....
　　[Painting] is the product exclusively of the individual imagination rather than a mirror of the ephemeral external world of objective reality....
　　Illusion ... is the essence of painting....

Today, the essence of painting is being redefined not as a narrow, arid and reductive anti-illusionism, but as a rich, varied capacity to birth new images into an old world. . . .

[Painting's] capacity [is] to materialize an image . . . behind the proverbial looking-glass of consciousness, where the depth of the imagination knows no bounds. . . .

Not innovation, but originality, individuality and synthesis are the marks of quality in art today, as they always have been. . . .

Art is labor, physical human labor, the labor of birth, reflected in the many images that appear as in a process of emergence, as if taking form before us. . . .

The liberating potential of art is . . . a catharsis of the imagination. . . .

These paintings are clearly the works of rational adult humans, not a monkey, not a child, or a lunatic. . . .

[The tradition of painting is] an inner world of stored images ranging from Altamira to Pollock.

For Rose, then, painting is a high art, a universal art, a liberal art, an art through which we can achieve transcendence and catharsis. Painting has an essence, and that essence is illusionism, the capacity to render images conjured up by the boundless human imagination. Painting is a great unbroken tradition that encompasses the entire known history of man. Painting is, above all, human.

All of this stands in direct opposition to the art of the previous two decades, for which I am using Daniel Buren's work as the example, that sought to contest the myths of high art, to declare art, like all other forms of endeavor, to be contingent upon the material, historical world. Moreover, this art attempted to discredit the myth of man and the humanist conventions growing out of that myth. For, indeed, these *are* the supports of the dominant bourgeois culture. They are the very hallmarks of bourgeois ideology.

But if the art of the 1960s and the 1970s contested the myth of man with an open assault on the artist as unique creator, there was another phenomenon that had initiated that assault in the visual arts at the founding moment of modernism, a phenomenon from which painting has been in retreat since the mid-nineteenth century. That phenomenon is, of course, photography.

＊

You know exactly what I think of photography. I would like to see it make people despise painting until something else will make photography unbearable.

 Marcel Duchamp, in a letter to Alfred Stieglitz

"From today painting is dead": it is now nearly a century and a half since Paul Delaroche is said to have pronounced that sentence in the face of the overwhelming evidence of Daguerre's invention. But even though the death warrant has been periodically reissued throughout the era of modernism, no one seems to have been entirely willing to execute it; life on death row lingered to longevity. But during the 1960s, painting's terminal condition finally seemed impossible to ignore. The symptoms were everywhere: in the work of painters themselves, all of whom seemed to be reiterating Ad Reinhardt's claim that he was "just making the last paintings anyone could make" or allowing their paintings to be contaminated with such alien elements as photographic images; in minimal sculpture, which provided a definitive rupture with painting's unavoidable ties to a centuries-old idealism; in all those other mediums to which artists turned as, one after another, they abandoned painting. The dimension that had always resisted even painting's most dazzling feats of illusionism – time – how became the dimension in which artists staged their activities, as they embraced film, video, and performance. And, after waiting out the entire era of modernism, photography reappeared, finally to claim its inheritance. The appetite for photography in the past decade has been insatiable. Artists, critics, dealers, curators, and scholars have defected from their former pursuits in droves to take up this enemy of painting. Photography may have been *invented* in 1839, but it was only *discovered* in the 1970s.

But "What's All This about Photography?"[7] Now this question is asked again, and in the very terms employed by Lamartine, also nearly a century and a half ago: "But wherein does its human conception lie?"[8] Lamartine's argument is rehearsed this time by Richard Hennessy, one of Rose's American painters of the 1980s, and published in *Artforum*, the very journal that had so faithfully and lucidly chronicled those radical developments of the 1960s and the 1970s that had signaled painting's demise, but which more recently has given testimony that painting is born again. Hennessy against photography is characteristic of this new revivalist spirit:

The role of intention and its poetry of human freedom is infrequently discussed in relation to art, yet the more a given art is capable of making intention felt, the greater are its chances of being a fine, and not a minor or applied, art. Consider the paintbrush. How many bristles or hairs does it have? Sometimes 20 or less, sometimes 500, a thousand – more. When a brush loaded with pigment touches the surface, it can leave not just a single mark, but the marks of the bristles of which it is composed. The "Yes, I desire this" of the stroke is supported by the choir of bristles – "Yes, *we* desire this." The whole question of touch is rife with spiritual associations.[9]

Imagine the magnitude of that choir, bristling so with desire as to produce a deafening roar of hallelujahs, in the particular case of Robert Ryman's *Delta* series, paintings that employed

a very wide brush, 12 inches. I got it specially – I went to a brush manufacturer and they had this very big brush. I wanted to pull the paint across this quite large surface, 9 feet square, with this big brush. I had a few failures at the beginning. Finally, I got the consistency right and I knew what I was doing and how hard to push the brush and pull it and what was going to happen when I did. That's kind of the way to begin. I didn't have anything else in mind, except to make a painting.[10]

Juxtaposed against Hennessy's panegyric, Ryman's words sound prosaic indeed. There is in his language, as in his paintings, a strict adherence to the matter at hand. His conception of painting is reduced to the stark physical components of painting-as-object. The systematic, single-minded, persistent attempt to rid painting once and for all of its idealist trappings lends Ryman's work its special place during the 1960s as, again, "just the last paintings anyone can make." And this is, as well, their very condition of possibility. Ryman's paintings, like Buren's, make visible the most literal of painting's *material* conventions: its supporting surface, its stretcher, its frame, the wall on which it hangs. But, more significantly, his paintings, unlike Buren's, make visible the mechanical activity of applying the brush strokes, as they are manifestly lined up, one after the other, left to right, say, or top to bottom, until the surface is, simply, painted.

The revivalism of current painting, which Hennessy's text so perfectly articulates, depends, of course, on reinvesting those strokes with human presence, a metaphysics of the human touch. "Painting's quasi-miraculous mode of existence is produced . . . by its mode of facture. . . . *Through the hand:* this is the crucial point."[11] This faith in the healing powers of the hand, the facture that results from the laying on of hands, echoes throughout Rose's catalogue essay, which pays special homage to Hennessy's attack on photography. The unifying principle in the aesthetic of Rose's painters is that their work "defines itself in conscious opposition to photography and all forms of mechanical reproduction which seek to deprive the art work of its unique 'aura.'" For Rose, elimination of the human touch can only express "the self-hatred of artists. . . . Such a powerful wish to annihilate personal expression implies that the artist does not love his creation." What distinguishes painting from photography is this "visible record of the activity of the human hand, as it builds surfaces experienced as tactile."

To counter the euphoria over photography's reappearance, Hennessy finally directs our attention to Velázquez's *Las Meninas*, which he sees as a "description of the photographic process, in which we become the camera." We are to understand, although it is stated ever so subtly, that we pay homage to this particular painting for its celebrated facture. Hennessy tells us of Velázquez that "he looks at us, almost as if we might be his subjects" as "his hand, hovering between palette and canvas, holds" – what else? – "a brush." Hennessy describes this painting with the most dazzling of metaphors, tropes of which he and Rose are particularly fond, for they consider painting essentially a metaphorical medium. He says, for example, that it is "a gift we will never finish unwrapping," "a city without ramparts, a lover who needs no alibi," in which "the play of gazes, in front, behind, past and toward us, weaves a web about us, bathing us in murmuring consciousness. We are the guests of the mighty, the august, in rank and spirit. We stand at the center of their implied world, and are ourselves the center of attention. Velázquez has admitted us into his confidence."[12]

Stripped of its fatuous metaphors and its reverential tone, Hennessy's description of *Las Meninas* might suggest a rather more persuasive discussion of this painting, which composes the opening chapter of *The Order of Things*. As Michel Foucault describes it, this is indeed a painting in which the artist, on the one hand, and the spectator, on the other, have usurped the position of the subject, who is displaced to the vague reflection in the mirror on the rear wall of Velázquez's studio. For within the seventeenth century's theory of representation, these parallel usurpations and displacements were the very ground of representation's possibility.

It may be that, in this picture, as in all the representations of which it is, as it were, the manifest essence, the profound invisibility of what one sees is inseparable from the invisibility of the person seeing – despite all mirrors, reflections, imitations, and portraits. . . .
Perhaps there exists in this picture by Velázquez the representation, as it were, of Classical representation, and the definition of the space it opens up to us. And, indeed, representation undertakes to represent itself here in all its elements, with its images, the eyes to which it is offered, the faces it makes visible, the gestures that call it into being. But there, in the midst of this dispersion which it is simultaneously grouping together and spreading out before us, indicated compellingly from every side, is an essential void: the necessary disappearance of that which is its foundation – of the person it resembles and the person in whose eyes it is only a resemblance. This very subject – which is the same – has been elided. And representation, freed from the relation that was impeding it, can offer itself as representation in its pure form.[13]

What Foucault sees when he looks at this painting, then, is the way representation functioned in the classical period, a period that came to an end, in Foucault's archeological analysis of history, at the beginning of the nineteenth century, when our own age, the age of modernism, began. And, of course, if this era of history came to an end, so too did its means of understanding the world, of which *Las Meninas* is a particularly fine example.

For Hennessy, however, *Las Meninas* does not signal a *particular* historical period with its *particular* mode of knowledge. Instead, *Las Meninas* is, more than it is anything else, a great painting, governed not by history but by creative genius, which is ahistorical, eternal, like man himself. This position – that of an entrenched historicism – is the very one that Foucault is determined to overturn. From such a position, painting is understood to have an eternal essence, of which *Las Meninas* is one instance, the marks on the walls of Altamira another, the poured skeins of Jackson Pollock another. "From Altamira to Pollock" – the phrase encapsulates the argument that people have always had the impulse to create paintings; how, then, can it even be suggested that they could stop in, say, 1965?

But what is it that makes it possible to look at the paleolithic markings on the walls of a cave, a seventeenth-century court portrait, and an abstract expressionist canvas and say that they are all *the same thing*? that they all belong to the same category of knowledge? How did this historicism of art get put into place?

*

There was a time when, with few exceptions, works of art remained generally in the same location for which they were made. However, now a great change has occurred that, in general as well as specifically, will have important consequences for art. Perhaps there is more cause than ever before to realize that Italy as it existed until recently was a great art entity. Were it possible to give a general survey, it could then be demonstrated what the world has now lost when so many parts have been torn from this immense and ancient totality. What has been destroyed by the removal of these parts will remain forever a secret. Only after some years will it be possible to have a conception of that new art entity which is being formed in Paris.

Johann Wolfgang von Goethe, introduction to the *Propyläen*

The new art entity being formed in Paris (literally, of course, the Louvre), which Goethe foresaw as early as 1798, was the art entity we now call modernism, if by modernism we mean not merely a period style but an entire

epistemology of art. Goethe foresaw that art would be seen in a way that was radically different from his own way of understanding it, which would in turn become, for us, a secret. The great art entity that was symbolized for Goethe by Italy, which we might call art in situ, or art before the invention of the art museum, simply no longer exists for us. And this is not only because art was stolen from the places for which it had been made and sequestered in art museums but also because for us the art entity is held in another kind of museum, the kind that André Malraux called *Imaginary*. That museum consists of all those works of art that can be submitted to mechanical reproduction and, thus, to the discursive practice that mechanical reproduction has made possible: art history. With art history, the art entity that Goethe called Italy is forever lost. That is to say – and this must be emphasized because from within an epistemological field, even as it begins to be eroded, it is always difficult to see its workings – that art as we think about it *only came into being* in the nineteenth century, with the birth of the museum and the discipline of art history, for these share the same time span as modernism (and, not insignificantly, photography). For us, then, art's natural end is in the museum, or, at the very least, in the imaginary museum, that idealist space that is art with a capital A. The idea of art as autonomous, as separate from everything else, as destined to take its place in *art* history, is a development of modernism. And it is an idea of art that contemporary painting upholds, destined as it, too, is to end up in the museum.

Within this conception of art, painting is understood ontologically: it has an origin and an essence. Its historical development can be plotted in one long, uninterrupted sweep from Altamira to Pollock and beyond, into the 1980s. Within this development, painting's essence does not change; only its outward manifestation – known to art historians as style – changes. Art history ultimately reduces painting to a succession of styles – personal styles, period styles, national styles. And, of course, these styles are unpredictable in their vicissitudes, governed as they are by the individual choices of painters expressing their "boundless imaginations."

A recent instance of such a stylistic shift, and its reception, exemplifies this art-historical view of painting and how it functions in support of the continued practice of painting. The shift occurs during the late 1970s in the work of Frank Stella. Although it could be said that this shift was presaged in every earlier stylistic change in Stella's work after the black paintings of 1959, Stella's move to the flamboyantly idiosyncratic constructed works of the past several years is by comparison a kind of quantum leap, and as such it has been taken as sanction for much of that recent painting that declares its individualism through the most ostentatious eccentricities of

shape, color, material, and image. Indeed, at the Whitney Museum Biennial exhibition of 1979, one of Stella's new extravaganzas, which was set up as the spectator's first encounter as the elevator doors opened on the museum's fourth floor, became an emblem for everything else that was displayed on that floor – a collection of paintings that were surely intended to be read as deeply personal expressions, but which looked like so many lessons dutifully learned from the master.

But apart from Stella's imitators, how can the phenomenon of his recent work be accounted for? If we remember that it was Stella's earliest paintings that signaled to his colleagues that the end of painting had finally come (I am thinking of such deserters of the ranks of painters as Dan Flavin, Donald Judd, Sol LeWitt, and Robert Morris), it seems fairly clear that Stella's own career is a prolonged agony over the incontestable implications of those works, as he has retreated further and further from them, repudiating them more vociferously with each new series. The late 1970s paintings are truly hysterical in their defiance of the black paintings; each one looks like a tantrum, shrieking and sputtering that the end of painting *has not come*. Moreover, it is no longer even *as paintings* that Stella's new works argue so tenaciously for the continued life of the medium. The irony of Stella's recent enterprise is that he is able to point at painting only from the distance of a peculiar hybrid object, an object that may well *represent* a painting but can hardly legitimately *be* a painting. This is not a wholly uninteresting enterprise, this defiance of the end of painting, but surely its only interest is in such a reading, for conceived as renewal, Stella's recent works are, as Gerhard Richter said of painting, pure idiocy.

Nevertheless, it is as renewal that they are understood. Here, for example, is Stella's friend Philip Leider, expressing the art-world majority opinion:

In these most recent works, Stella, throwing open the doors to much that had hitherto seemed to him forbidden – figure–ground dichotomies, composition, gestural paint-handling, etc. – has achieved for abstraction a renewed animation, life vitality, that has already about it something of the sheerly miraculous. One would have to be blind not to see it, catatonic not to feel it, perverse not to acknowledge it, spiritless not to admire it.[14]

Leider's insistence on our belief in miracles, echoing that of Hennessy and Rose, is perhaps symptomatic of the real contemporary condition of painting: only a miracle can prevent it from coming to an end. Stella's paintings are not miracles, but perhaps their sheer desperation is an expression of painting's need for a miracle to save it.

Leider anticipates my skepticism in his apology for Stella's recent work, assuming that, as usual, a major change of style will be met with resistance:

> **Every artist who hopes to attain a major change in style, within abstraction especially, must prepare himself for a period in which he will have to "compromise with his own achievements." During this period he can expect to lose friends and stop influencing youth. . . . It is a matter of having taken things as far as possible only to find oneself trapped in an outpost of art, with work threatening to come to a standstill, thin and uncreative. At such a point he must compromise with the logic of his own work in order to go on working at all – it is either that or remain prisoner of his own achievement forever, face those sterile repetitions that stare at us from the late works of Rothko, Still, Braque.[15]**

Opinions about the late works of Rothko, Still, and Braque aside, sterile repetitions may, under the present circumstances of art, have their own value. This is, of course, the premise of Daniel Buren's work, which has never, since he began his activities in 1965, evidenced a single stylistic change.

*

It is no longer a matter of criticizing works of art and their meaning, aesthetic, philosophical, or otherwise. It is no longer a matter even of knowing how to make a work of art, an object, a painting; how to become inserted in the history of art, nor even of asking oneself the question whether it is interesting or not, essential or ridiculous, to create a work of art, how, if you are or desire to be an artist (or if you challenge that word), to fit in with the game so as to play it with your own tools, and to the best of your ability. It is no longer a matter even of challenging the artistic system. Neither is it a matter of taking delight in one's interminable analysis. The ambition of this work is quite different. It aims at nothing less than abolishing the code that has until now made art what it is, in its production and in its institutions.

<div align="right">Daniel Buren, Reboundings</div>

Buren's work has been exhibited more extensively than that of any other painter in the past decade. And although it has been seen in galleries and museums, as well as in the streets, all over the developed world, perhaps by more people than have seen the work of any other contemporary artist, it has thus far remained invisible to all but a few. This paradox is testimony to the success of Buren's gambit, as well as to the seemingly unshakable faith in painting – which is to say, the code. When Buren decided in 1965 to

make only works in situ, always using 8.7-centimeter-wide vertical stripes, alternating colored with white or transparent, he obviously made a canny choice. For, just as he predicted, this format has not been assimilable to the codes of art, regardless of how elastic those codes have been in the past fifteen years. As we have seen, even such bizarre hybrids as Stella's recent constructions can easily be taken for paintings, though certainly they are not, and as such they can be understood to continue painting-as-usual.

In a climate in which Stella's hysterical constructions can so readily be seen as paintings, it is understandable that Buren's works cannot. It is therefore not surprising that Buren is widely regarded as a conceptual artist who is unconcerned with the visible (or what Marcel Duchamp called the retinal) aspects of painting. But Buren has always insisted specifically on the visibility of his work, the necessity for it to be *seen*. For he knows only too well that when his stripes are seen as painting, painting will be understood as the "pure idiocy" that it is. At the moment when Buren's work becomes visible, the code of painting will have been abolished and Buren's repetitions can stop: the end of painting will have been finally acknowledged.

NOTES

1. *Eight Contemporary Artists*, an exhibition of the work of Vito Acconci, Alighiero Boetti, Daniel Buren, Hanne Darboven, Jan Dibbets, Robert Hunter, Brice Marden, and Dorothea Rockburne, organized by Jennifer Licht at the Museum of Modern Art, New York, October 9, 1974–January 5, 1975.
2. Barbara Rose, "Twilight of the Superstars," *Partisan Review* 41, no. 4 (Winter 1974), p. 572.
3. Lawrence Alloway and John Coplans, "Talking with William Rubin: 'The Museum Concept Is Not Infinitely Expandable,'" *Artforum* 13, no. 2 (October 1974), p. 52.
4. Daniel Buren "Function of the Museum," *Artforum* 12, no. 1 (September 1973), p. 68.
5. Rose, "Twilight of the Superstars," p. 569.
6. Barbara Rose, *American Painting: The Eighties* (Buffalo: Thorney-Sidney Press, 1979), n.p. All following quotations from Barbara Rose are taken from her essay in this catalogue.
7. This question is the title of an essay by Richard Hennessy published in *Artforum* 17, no. 9 (May 1979), pp. 22–25.
8. Quoted in "Photography: A Special Issue" (editorial), *October*, no. 5 (Summer 1978), p. 3.
9. Hennessy, "What's All This," p. 22.

10. Robert Ryman, in Phyllis Tuchman, "An Interview with Robert Ryman," *Artforum* 9, no. 9 (May 1971), p. 49.

11. Hennessy, "What's All This," p. 23 (italics original).

12. Ibid., p. 25.

13. Michel Foucault, *The Order of Things* (New York: Pantheon, 1970), p. 16.

14. Philip Leider, *Stella since 1970* (Fort Worth: Fort Worth Art Museum, 1978), p. 98.

15. Ibid., pp. 96–97.

HAL FOSTER

SIGNS TAKEN FOR WONDERS

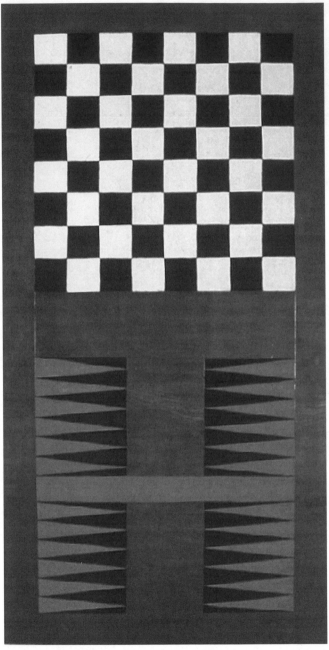

Sherrie Levine, *Lead Checks and Chevrons: 9*, 1988. Casein on lead, 40 × 20 inches. Collection of the Eli Broad Family Foundation, Santa Monica; photo courtesy Margo Leavin Gallery, Los Angeles.

What can we make of an artist like Jack Goldstein who, after performances, films and paintings that stressed spectacular effects, turns to "abstract" paintings – or, more precisely, to paintings of abstracted images or events (e.g., a star formation represented via a computer as a series of tiny spectra, a wisp of smoke specially photographed in a chamber, the rings of Saturn mediated by an electronic telescope, all painted on bright maroon, blue and green grounds)? What is the connection between his simulated works and his new abstract ones? What is the logic or dynamic of this turn?

Why, too, did James Welling pass from abstract photographs with representational effects (e.g., photos of aluminum foil or pastry dough on velvet that suggested Alpine landscapes) to "abstract" paintings – or, more precisely, to paintings of black dots on white grounds that seem randomly composed but are in fact based on computer graphics? What explains this passage?

How, also, did Sherrie Levine turn from inflected reproductions of modern master images (e.g., Edward Weston, Walker Evans, Kasimir Malevich, Egon Schiele), skeptical as these works seemed to be of the idea that any representation could be wholly original or symbolically total, to "abstract" paintings – or, more precisely, to paintings of generic abstract art (e.g., paintings of thin or broad vertical stripes, paintings on bare plywood with only the knothole plugs colored, checkerboard paintings)? What is the relationship between her serial repetitions and her new abstract ones?

And, why, a few years after the Op paintings of Ross Bleckner, have younger artists like Philip Taaffe and Peter Schuyff turned to this most outré form of abstract art: Schuyff to Op designs sometimes mixed with abstracted

Hal Foster, "Signs Taken for Wonders," *Art in America* 74, no. 6 (June 1986): 80–91, 139.

Surrealist motifs; Taaffe to Op sometimes paired with decorative pastiches of Barnett Newman paintings? What conditions these hybrid appropriations?

Finally, what are we to make of the work of Peter Halley, who paints rectilinear blocks and connective lines, which he respectively calls "cells" and "conduits," usually in Day-Glo arrangements on simulated stucco fields? Or of the work of Ashley Bickerton, who alternates between abstract paintings of pseudo-stone walls and standard design shapes and meticulous representations of quasi-sci-fi devices, structures and signs? Or of the work of Meyer Vaisman and Oliver Wasow, who, among other artists (e.g., Peter Nagy, Alan Belcher), seem obsessed with the abstractive effects of the reproductive techniques used to produce business logos and product displays? What prompts these "abstractions" and what (if anything) connects them?

*

I should say right away that I am concerned here with only one aspect of contemporary abstract art, one positioned at an ironic remove from its own putative tradition. The artists cited above are representative of this "new abstract painting," but any list makes three things clear at once: it is not new except sometimes in the sense of novel; it is not properly abstract except in the sense that it sometimes simulates or parodies abstract painting; and it is not monolithic – these artists are related by preconditions but diverse in practice.

The second point is the one of greatest possible misunderstanding. As suggested by the involvement of Goldstein and Levine, this new abstraction develops mostly out of appropriation art (i.e., art engaged in a sometimes critical, sometimes collusive reframing of high-artistic and mass-cultural representations). It is not at all derived, genealogically, from critical abstract painting – that of Stella, Ryman, Marden. The "irresponsibility" to this tradition is campy enough in the case of artists like Taaffe and Schuyff, who recycle the kitsch surrogate (Op) of this serious abstraction. With Goldstein and Levine, this irresponsibility, though no less evident, is more pointed.

For example, Goldstein makes his abstract paintings structurally as deep as early Stellas (4 to 12 inches thick) and often frames them with painted gold or silver bands; yet this stress on "objecthood" is beside any formalist point, and the metallic elements are formally gratuitous (the colors and chromatic schemes are precisely not "serious"). This gratuitousness is intentional: the stretchers and bands do not partake in any late-modernist reflection on the material presence of painting (Goldstein is only interested in mediated representations); rather, they serve as signs of such reflection. In effect,

Goldstein suggests that critical abstract painting à la Ryman has become all but reified in its conventions, that it is, in short, a readymade. This is generally the position of all these new abstractionists. The question is: do they receive abstract painting as so reified, or do they participate in its emptying out?

Manifestly generic, the abstract paintings of Sherrie Levine are even more demonstrative about this readymade status. On the one hand, her two series of stripe works on board belie the perceptual inquiry into its own conventions of serious abstraction like Marden's (her bright " '60s" colors are often optically rote, not at all the labored hues, evocative of the body in landscape, of early Marden). And, on the other hand, her series of plywood works with painted oval knots belies the aleatory freedom of Surrealist abstraction like Arp's (her ovals are mass-produced plugs machined into place, not at all chance elements, biomorphic forms or dream scripts). In short, her abstract paintings simulate modes of abstraction, as if to demonstrate that they are no longer critically reflexive or historically necessary forms with direct access to unconscious truths or a transcendental realm beyond the world – that they are simply *styles* among others.

This reduction to style, it should be noted, is most plain in the abstractions of the Neo-Opers; after all, Op was the first mass-cultural sign of modern abstract art in general, and, as Bleckner writes with just the right irony, "It is quintessentially twentieth century: technologically oriented, disruptive, 'about perception,' naive, superficial, and, by most accounts, a failure."[1] As such, despite (tongue-in-cheek?) claims by Taaffe of Newmanesque sublimity, its recycling now primarily reiterates this reduction, reification, "failure."

*

If this new abstract painting does not work within serious abstraction but rather comments on it at a remove, what conditions it? For some, who see this work mostly as a development of appropriation art, it appears as the next logical move in the match: to appropriate modern abstraction, to question its originary or sublime aspirations. Yet the nature of this move – back to painting, province of the immediate mark – contradicts this critique; and today the argument that painting can be used deconstructively as a form of camouflage for subversion of other beliefs reads somewhat dubiously. Besides, such an account of abstraction-as-appropriation only holds for some of this work, such as the recent paintings of David Diao after the famous 1915 installation of Malevich paintings – an appropriation which may serve to confirm the mythical status of the original even as it cuts it loose from its place in history.

For the most part, the new abstractionists do not appropriate modern abstraction so much as they *simulate* it. The paintings are simulacra rather than copies, and as such they function in a strategically different way ("the copy is an image endowed with resemblance, the simulacrum is an image without resemblance"; whereas the copy produces the model *as* original, the simulacrum "calls into question the very notions of the copy and of the model").[2] The Levines, for example, do not reframe any original painting so much as they vaguely recall this Kenneth Noland, that John McLaughlin or that Brice Marden; thus insinuated into the paternal order of modern abstraction, her abstract frauds or "false claimants" are potentially in a position to disrupt its institutional canon and confuse its historical logic. (The problem is that her simulacra might not be good enough – deceptive enough as abstract painting – to be thus insinuated into its order.)[3]

For others, who see this abstraction as neither an appropriation nor a simulation of abstract art, it is simply a swing of the pendulum. Equally bored with Neo-Expressionism and Neo-Pop, artists are drawn back to the other pole: geometric abstraction. Yet such a reading of art as a mere matter of stylistic *reaction*, governed by generation, measured by decade, circumscribed by oppositions (like representation/abstraction and facture/finish), is banal in the extreme; an ahistorical model, it cannot account adequately for any art, let alone for all this painting. (Indeed, some of this work seems to play, parasitically, parodistically, on this yin-yang history of modern art, and some of it, I will argue, potentially supersedes categories of representation and abstraction – and not by any decorative mixing of the two.)

Nevertheless, these artists, driven in part by compulsive repetition, cannot help but be affected by this cyclical logic of style – inevitably so, as it is tied up with one dynamic of the art market as well as one model of art history. The swing between set poles is well designed for the market/history system, for its provides a modicum of the new without threat of real change or loss of order.[4] The wagers of dealers and collectors, the categories of critics and curators, stand protected, as art alternates between familiar styles but within the prescribed exchange-form of the painting on exhibition. Unlike its predecessors in appropriation art which often underscored or contested this status, *all* of this abstract work complies with it.

However, stylistic oscillation alone is not enough to satisfy the market/history system: new forms must be expropriated (usually from popular or mass cultures) and obsolete modes retooled. In this continual retrieval of the outside and the outmoded (in a word, the outlandish), the cycle of set styles is elaborated into a sophisticated spiral that does much to describe recent art trends. Thus, though the new abstraction seems to oppose Neo-Expressionism, it opposes it only in terms of the market/history system: in

fact, the two share much the same dynamic. Just as Neo-Expressionists like Sandro Chia recently mined the once outré work of de Chirico and Chagall, so now Neo-Opers like Taaffe appropriate the outré work of Bridget Riley (made all the more risqué by juxtaposition with kitschy renditions of Barnett Newman). There may be some historical redemption in this recycling, some transvaluation of esthetic values, but finally the posture of the artist remains the dandyism of Dali rather than the radicalism of Duchamp, and the logic of the art follows the given dynamic of the market/history system more than any new modus operandi.[5]

∗

A readymade reduction of serious abstraction, a campy recycling of outré abstraction: much of this evinces a posthistorical attitude whereby art, stripped in the "museum without walls" of its material context and discursive entanglements, appears as a synchronous array of so many styles devices or signs to collect, pastiche or otherwise manipulate – with no one deemed more necessary, pertinent or advanced than the next. This attitude, which is pervasive today, can be called "conventionalism,"[6] according to which, for example, painting is produced as the *sign* of painting (rather than, as with Ryman or Marden, in historical involvement with its material practices). Now far from an authentic legitimation of the medium, much less an act of recovery through memory,[7] this duplication of painting literally abstracts it – empties its historical form of content, reduces its material practice to a set of conventions (which then somehow stand, out of time, for painting in general). Moreover, this conventionalism does not contest our mass-media economy of the sign so much as play into it, for this economy performs a similar operation on all cultural expressions, whereby the specific, ambivalent content of an expression (e.g., graffiti) is first abstracted as a general, equivalent style (graffiti art) and then circulated as so many commodity-signs (graffiti boutiques).

Now to Ross Bleckner, apparently, such a duplication of abstract painting first occurred with Op. "It attempted to construct a conceptual relationship to abstract painting," he states. "It was a dead movement from its very inception."[8] Yet, according to conventionalist logic, this demise is necessary: painting must die as a practice so that it might be reborn as a sign. And in this recycling, in which abstraction returns as its own simulation, there may well be (as Jean Baudrillard remarks about our age of simulacra in general) "no longer any God to recognize his own, nor any last judgment to separate true from false, the real from its artificial resurrection, since everything is already dead and risen in advance."[9]

Such is the posthistorical attitude that informs this abstract painting and much postmodern culture, an attitude which, if not resisted or, better, thought through, can lock artists into an indifferent pastiche or, as with some abstractionists, into a passive pessimism (which is not really leavened by irony). Thus the melancholy of Bleckner, for whom Op is an "appropriate metaphor" of a history which reduces out experience, memory, judgment; thus, too, the defeatism of Taaffe, who cites from Jean Anouilh's *Antigone*: "In a tragedy, nothing is in doubt. . . . There isn't any hope. You're trapped."[10]

✳

There is, of course, more at stake in this new work than an ironic position-ing of modern abstraction, a new inflection of art market/art history laws, or another symptom of posthistorical perspectivism. Though the different artists I have in mind here (Goldstein, Welling, Halley, Bickerton, Vais-man, Wasow and others) also develop out of appropriation art, they have less to do with modern abstraction than do artists like Levine, for they are involved in the *representation* of another sort of abstraction: the abstrac-tion of technological modes of control of nature (Goldstein), of scientific paradigms of (dis)order (Welling), of late-capitalist social space (Halley), of cybernetic languages (Bickerton), of commodity and image production (Vaisman, Wasow).

Vaisman and Wasow do not appropriate media or art images so much as they simulate the abstraction that objects, images and events undergo when they are transformed into commodity-signs. (Thus, for example, the grounds of many Vaisman paintings look like exotic fabric but are in fact photostat simulations of burlap.) In the postnatural works of these two artists only a slight residue of any image remains, as representational content (use value) is subsumed under abstract "packaging" (exchange form). The viewer-consumer is seduced by this abstraction, invested in this mediation – in these works and in the media world at large. And Vaisman suggests this integration when he includes, along with abstract signs and color fields, images of the biological and the biographical (e.g., colored penis symbols on dirty white circles in *Polyester Set*, his own fingerprint blown up on a blue-yellow, four-square ground in *Under My Thumb*).

To Goldstein, this opposition between biological individual and tech-nological society is all but moot, so intensive have its forms of mediation become. His motifs are not abstracted from the world but are generated as abstract (by computers, astral photography, etc.). Whether a snowflake un-der a microscope (its crystalline structure become a blurry splay of whitish

lines on a black ground) or a constellation through a telescope (its complex formation registered as so many colored blips on a maroon ground), these objects or events do not exist "out there," in the world, in a way that can be represented perspectivally, nor are they produced "in here," in the subject, in a way that can be evoked abstractly; rather, they are effects of technical apparatuses which do not mediate reality and perception so much as transform them utterly. In short, these paintings have more to do with new modes of information than with either classical representation or modern abstraction.

Many of the same concerns govern the work of Halley and Bickerton. Halley assumes a drastic Baudrillardian perspective, according to which our new dynamic of electronic information and mass media has made of social space a total system of cybernetic networks, at all levels of which is repeated one model: "cells" connected by "conduits" (thus, according to Halley, the cell-and-conduit system of the computer, of the office with its electronic lines, of the city with its transportation network, etc.). It is this abstract field, this putative "formalism of the cell and the conduit,"[11] that Halley depicts with color-coded rectangles and "Cartesian" lines, painted iconically on partially stuccoed grounds.

Apart from his tautological "Wall Wall" paintings (colored reliefs of pseudo-stone walls) and generic "Abstract Paintings for People" (Day-Glo arrays of simple design shapes), Bickerton also produces paintings involved in the abstraction of contemporary social exchange. On these boxy works are painted "technoscientific" images – part device, part structure, part sign – arranged so as to spell out different phonemes (GUH, GOH, UEH, UGH). These images suggest, on the one hand, a recomposition of alphabetic language into a new signal system or "postindustrial" esperanto and, on the other, an implosion of pre- and postliterate cultures.

Finally, Welling is also concerned with the abstraction of new scientific languages – in particular, fractal geometry, a mode of description of natural phenomena that cannot be reduced to (Euclidean) models or forms. Welling borrows his dot motifs from computer graphics generated to objectify such fractals as lunar craters and galaetic formations.[12] Thus, though his paintings appear totally abstract and randomly composed, they are in fact methodical representations: abstraction and randomness are inherent in the model used. Welling's is perhaps the most logical (least opportunistic) work of the group, for it develops out of his abstract photography and addresses both principal concerns of this new art. Like the Levines, his paintings can operate as abstract-art simulacra (quasi surrealist, automatist or Opish); and like the work of the other abstractionists, they evoke the abstraction of contemporary languages – only *not* in an illustrational way.

✳

In one way or another, most of these artists seek to picture abstractive tendencies in late-capitalist life: in science, technology, telecommunications, image and commodity production. That they represent such tendencies, which seem to defy representation, and that they do so in often beautiful paintings, which may reconcile us to them, is problematic. Today, Fredric Jameson has argued, the old "futurist icons" of modernity (e.g., the automobile, the airplane) are largely subsumed by new emblematic commodities (e.g., the computer), which "are all sources of reproduction rather than 'production,' and are no longer sculptural solids in space."[13] As complex processes rather than discrete objects, they cannot, Jameson asserts, be readily represented (or abstracted), at least not in the manner of modernist forms. This raises the question of the "representability" of late capitalism as a whole, a system apparently global in its reach, everywhere and nowhere at once.[14] It also raises the stake of the art at hand, for in the attempt to represent this system or its processes, artists like Halley and Bickerton may also simplify them, render them innocuous (à la newspaper illustrations of new weapons systems). So, too, in the attempt to simulate the abstractive effects of this system, artists like Goldstein and Vaisman may also mystify them, render them spectacular (in the manner of Shuttle photos whose sheer beauty cannot quite conceal the costly, deadly militarization of space). Here, then, the most vexed question of all about this work emerges: can it seriously engage issues of a technoscientific, postindustrial society in a medium, like painting, based in preindustrial craft?[15] Though concerned with systems of information, these artists still produce works of art in traditional mediums and formats; and though not oblivious to the contradiction here, they do not reflect on it in the paintings.

For example, can the everyday abstraction of objects and images into commodity-signs be simulated to any critical effect in painting, as the work of Vaisman suggests? Painting remains a necessary site of articulation for an artist like Sigmar Polke, involved as he is in the contradictory connections between mass culture and high art. But this is not entirely the case with Vaisman. Indeed, if the abstraction that concerns him is mostly a matter of mechanical reproduction and electronic information, surely film, video and computer work are more pertinent forms than painting for its critical exploration (as the work of an artist like Gretchen Bender demonstrates).

So, too, if we do inhabit a new social space of immanent flows and simulated effects, as Halley suggests, it is not at all clear that it can be painted, let alone represented, by a simple image of a cell and a conduit. His painted

image, its metaphoric functions, its iconic placement on a Cartesian grid – all of these elements constitute a mode of representation incommensurate with the hypothesis of a new social network of cybernetic interconnection. Such a network demands instead both a new mode of apprehension and a new strategy of intervention (such as the one suggested by certain Keith Sonnier works of the '70s that hooked directly and diagrammatically into radio, telephone and television systems).[16]

Given that these artists develop out of (post)conceptual appropriation art, they must, in order to return to painting, repress its (often dubious) critique of the original art work, its subject positioning, commodity status and exhibitional format. And with Bickerton this "strategic inversion of many of the deconstructive techniques of the past decade or two" becomes programmatic.[17] Thus, though he includes cryptic references in his work "to every station of its operational life" (e.g., jokes on its back for art movers, brackets on its sides to underscore its objecthood), these references turn the (post)conceptual analysis of the art object and its institutions into a closed Rousselian device, one that collapses autistically inward rather than (as with artists like Hans Haacke or Louise Lawler) proceeds discursively outward. It may be that, for Bickerton and others, such analysis is now a dead end. Yet, as with the reductive treatment of abstract painting in this new work, it is not clear whether these artists receive this critique as historically reified – as an "absurd, pompous, saturated and elaborate system of cul-de-sac meanings" – or whether they seek to render it so. In any case, the operation here is more nihilistic than dialectical.

✳

In its conventional logic, some of this painting regards the material practice and history of abstract art as so many conventions and signs, and some of it suspends the critique of the art object, of institutional construction of meaning and subjectivity, of discursive entanglements with other discourses and institutions. So the question remains: if this new work is neither modern abstract painting nor (post)conceptual appropriation art, what type of art is it?

One way to respond is to consider its ambiguous relationship to both representation and abstraction. This work partakes of both, but does not combine them as opposed styles. Instead, it suggests that they are connected in a way that qualifies the conventional reading of 20th-century art in terms of simple paradigm shifts between "representation" and "abstraction." For abstraction does not undo representation (any more than a Beckett or

Robbe-Grillet novel undoes narrative); rather, abstraction represses or sublates representation, and in this sublation representation is preserved even as it is cancelled.[18]

Representation is not preserved, however, in simulation, which is what most of this painting is. In fact, in a social history of paradigms, representation may be superseded not by abstraction but by simulation, crucial as this mode is to the serial production of media images and commodities in late-capitalist society.[19] For whereas abstraction may only *sublate* representation, simulation may *subvert* it, given that simulacra have representational effects but do not follow representational logic (i.e., they are not derived from referents in the world).[20]

To take an example of these different modes in art: far from a return to representation after Abstract Expressionism, Pop was in fact a turn to *simulation*, to the serial production of images without originals – a mode which must be distinguished from both representational and abstract paradigms.[21] This mode, announced by art in the '60s, was only used critically in art in the '70s and '80s – for example, in the serial simulations of artists like Cindy Sherman and Richard Prince whose Neo-Pop work is likewise less a return to representation than a critique of it by means of simulation. Now in this new abstract painting, simulation has penetrated the very art form that, with its insistence on immediacy and presence, resisted it most. Some of this work thus suggests a supersession (or at least a disruption) of both categories, representation *and* abstraction. For example, as serial abstract-art simulacra, the Levine paintings may confuse not only the historical logic of abstraction but also the conceptual order of representation – the hierarchy of originals, good copies and bad copies.

Yet the use of simulation in art remains tricky. Though this use may, on the one hand, transgress traditional forms of art and, on the other, connect the creation of art technically to the production of everyday images, it is hardly disruptive or critical of simulation as a mode. And this mode, though it may undercut representation or free us from its referential myths, is in no simple sense liberative. Along with the delirium of commodity-signs let loose into our world by serial production, the duplication of events by simulated images is an important form of social control, as important today as ideological representations. (Baudrillard: "Ideology only corresponds to a betrayal of reality by signs; simulation corresponds to a short-circuit of reality and its reduplication by signs.")[22] In fact, simulation, together with the old regime of disciplinary surveillance, constitutes a principal means of deterrence in our society (for how can one intervene politically in events when they are so often simulated or immediately replaced by pseudo-events?).

Like the critique of representation in appropriation art, then, the simulation of abstraction in this painting is a mixed enterprise, for finally both may be but ramifications of a much more practical and thorough "critique" and "simulation" – that of capital. "For finally it was capital which was the first to feed throughout its history on the destruction of every referential, of every human goal, which shattered every ideal distinction between true and false, good and evil, in order to establish a radical law of equivalence and exchange, the iron law of its power."[23] In short, more than this or any art, it is the abstractive processes of capital that erode representation and abstraction alike. And ultimately it may be these processes that are the real subject, and latent referent, of this new abstract painting.

NOTES

1. Ross Bleckner, "Failure, Theft, Love, Plague," in *Philip Taaffe*, New York, Pat Hearn Gallery, 1986, p. 5.
2. Gilles Deleuze, "Plato and the Simulacrum," trans. Rosalind Krauss, *October* 27 (Winter 1983), pp. 48, 47.
3. This is less the case with Charles Clough, who, like Gerhard Richter, simulates expressionist paintings by means of a collage of painting and photographed painting.
4. A good example of this system at work is the presentation, by Robert Pincus-Witten, of Julian Schnabel and David Salle as the new Rauschenberg and Johns; see his *Entries*, New York, Out of London Press, 1983.
5. "These paintings," Bleckner writes in the Taaffe catalogue, "are what happens . . . when 'the future is the obsolete in reverse'" (p. 11). Here the Robert Smithson epigram is turned into a tactical play on the planned obsolescence of the market, whereby products like Op, first discarded in disdain, can be later recouped as outré.
6. This term was suggested to me by Craig Owens. For more on conventionalism, see my *Recodings: Art, Spectacle, Cultural Politics*, Port Townsend, Wa., Bay Press, 1985; also see Jean Baudrillard, *For a Critique of the Political Economy of the Sign*, trans. Charles Levin, St. Louis, Telos Press, 1981.
7. This conventionalism was advocated in these terms by curator William Olander in his recent New Museum exhibition "The Art of Memory, The Loss of History."
8. Quoted in Jeanne Siegel, "Geometry Desurfacing," *Arts*, March 1986, p. 28.
9. Baudrillard, "The Precession of the Simulacra," trans. Paul Foss and Paul Patton, *Art & Text* 11 (September 1983), p. 8; also available in *Art After Modernism*, ed. Brian Wallis, New York/Boston, Godine/New Museum, 1984, and *Simulations*, New York, Semiotext(e), 1983.
10. *Philip Taaffe*, pp. 5, 12.
11. Peter Halley, "On Line," *LAICA Journal*, Fall 1985, p. 35. This "formalism of the cell and the conduit" is parodied in the Terry Gilliam film *Brazil*.
12. See Siegel, p. 32.

13. Fredric Jameson, "On Diva," *Social Text* 5 (1982), p. 118.

14. See Jameson, "Postmodernism, or The Cultural Logic of Late Capitalism," *New Left Review* 146 (July–August 1984). It is not that this system cannot be conceived, Jameson argues, only that it cannot be figured. (It can, however, be evoked, as it is in the Goldstein paintings that suggest the systematic mediation of *all* reality.) Jameson calls for a new esthetic of "cognitive mapping." This is considered problematic by some because of its apparent paradoxical reliance on old models of representation and the subject. Yet, Jameson makes clear, this esthetic must rethink these terms entirely. (An instance of this esthetic at work may be Martha Rosler's videotape *Global Taste*, which begins to map out the late-capitalist penetration of both First–World psyches and Third–World markets.)

15. The term "technoscientific," developed by Jean-François Lyotard, describes the inextricability of modern science and technology. The term "postindustrial," popularized by Daniel Bell, describes the shift away from production of goods to that of services. A problematic concept, it is refuted by Ernest Mandel in *Late Capitalism* (London, Verso, 1978), who argues that, far from postindustrial, "late capitalism . . . constitutes *generalized universal industrialization* for the first time in history" (p. 387). Inasmuch as some of these artists pose postindustrial models, they abet this ideology, which tends to dismiss the working class and class struggle in general as anachronistic.

16. See Sanford Kwinter, "Keith Sonnier: Tracing Flows," in *Territory and Technique*.

17. Ashley Bickerton, exhibition statement, Cable Gallery, New York, 1986. The next two quotations are also from this source.

18. For this argument regarding fiction, see Jameson, "Beyond the Cave: Modernism and Modes of Production," in *The Horizon of Literature*, ed. Paul Hernadi, The University of Nebraska Press, 1982, pp. 176–78.

19. In *Noise* (Minneapolis, University of Minnesota Press, 1985), Jacques Attali argues that representation is superseded by (serial) repetition. (Baudrillard makes a similar case in *For a Critique*: "That which was representation – redoubling the world in space – becomes repetition – in indefinable redoubling of the act in time" [p. 106].) Seriality and simulation are related in this new mode of production, which becomes integral to the production of art with Minimalism and Pop; see my "The Crux of Minimalism" [in *Individuals: A Selected History of Contemporary Art*, ed. Howard Singerman, Los Angeles Museum of Contemporary Art, 1986, pp. 162–83].

20. Representation "starts from the principle that the sign and the real are equivalent. . . . Conversely, simulation starts . . . from the sign as reversion and death sentence of every reference" (Baudrillard, "Precession," p. 8).

21. Just as Pop and Minimalism must be regarded together – as different responses to the same moment in the dialectic of modernism and mass culture – so this new abstract painting must be seen with its contemporary counterpart: the cute-commodity "readymades" of such artists as Jeff Koons and Haim Steinbach. There is evidence that all this work will be challenged by art that *develops* rather than inverts "the deconstructive techniques of the past decade or two."

22. Baudrillard, "Precession," p. 30.

23. Ibid., p. 28.

JEREMY GILBERT-ROLFE

THE CURRENT STATE OF
NONREPRESENTATION

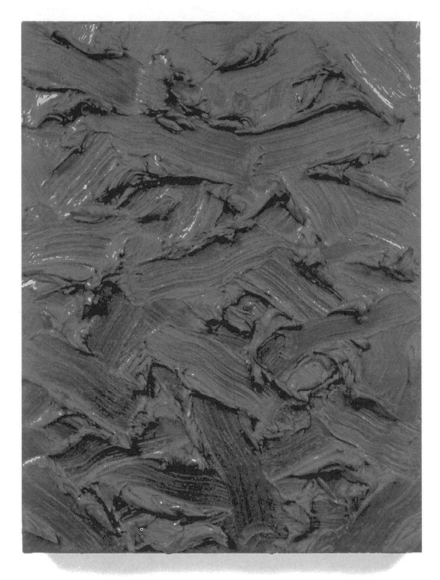

James Hayward, *Absolute 21 × 16 Pthalo Green y.-s.*, 1991. Oil and wax on canvas on board, 21 × 16 inches. Collection of Susan Curry Hayward, Moorpark, California.

Nonrepresentation is getting some attention again – hemlines go up, hemlines come down – but, for many, it continues to be as suspect an activity as it was in the early days of late modernism – the early years of this century – where it began. The same critique, a realist one, continues to be levelled against it: it is not socially responsible; it is historically irrelevant; there's nothing to look at – this last truer than those who utter it tend to realize, the task of nonrepresentation being, typically, one which involves seeing a thing which is, for once, about the presentation of no thing.

People are uncomfortable with such an activity because it destabilizes so much that is dear to them. Unlike Conceptual Art, which celebrates the triumph of the idea over the material – in the name of Materialism, of course, like all realisms – nonrepresentational art does not offer the security of historicism, of the notion of historical relevance as the final arbiter – a nonaesthetic one, therefore – of the work of art (or what, after art's alleged death, substitutes for it). Unlike representation more generally considered – that is to say, aside from the representationalism that is Conceptualism – nonrepresentation does not give one pictures of things which one may then relate to the (historically unified, i.e., bound together by the complementary concepts of Self and History) subjectivity which produced them. Nonrepresentation is then deprived of, and deprives the viewer of, the security to be found in appreciating *interpretation*, of the pleasures of distortion, of levelling things out, of incongruity.

Instead, nonrepresentation deals with the possibility of presenting nothing. Literally the possibility of the unthinkable, inasmuch as we think in

Jeremy Gilbert-Rolfe, "The Current State of Nonrepresentation," *Visions* 3, no. 2 (Spring 1989): 4–7.

words which stand for concepts which are themselves founded in, or give birth to an awareness of, things. It is not altogether surprising that such an activity should come to be the one most eloquent in its articulation of precisely a particular kind of thingness, that of the art object, because it is in the denial of that object's object*ness* that representation is founded – it's meant to stand for something which isn't here (it's an image of something); it's not important in itself; it's the idea that counts (it is a pale representation, or evocation, of an idea). Nonrepresentation begins with what other kinds of visual art seek to leave behind or, more exactly, to hold firmly in check or under control (of an historicism, of a subjectivity conventionally defined): the object itself, the so-called vehicle for expression, or support for the idea. I have suggested elsewhere that nonrepresentation brings to one's attention possibilities for thinking which are not accessible to representation, and these have to do with nonrepresentation's implicit dependence on completeness as something – an experience or a concept – available to it as it is not to other kinds of visual art.[1] If one is not representing anything, then there is nothing to crop. All representation is a partiality, a cropping of some sort, the diminution and reordering of the image in the interests of a point of view. The nonrepresentational work cannot but be complete. Unlike the representational work and the realist or conceptual work above all, it isn't a slice of anything in any but the ultimate sense – it's the product of human imagination – or the most banal – by being made it becomes a part of art considered as a whole, and to that extent it becomes a fragment by default.

Otherwise, it is an object which is complete by definition, and it is thus that it is subject to an endless deferral in the Derridean sense. It defers to other objects, both art objects and those to which we do not attach the high value we reserve for the eloquently useless, in being like them but not representing them, in differing from them and with them. Robert Ryman talks about wanting to present painting naked, painting differing from all other things as a particular kind of body. Painting deferring to all other types of art the task of *picturing*, of representing the truths of psychological anxiety or historical sensitivity – or, of course, vice versa.

One is pleased to see that despite its unpopularity nonrepresentation is becoming fashionable again. Fashion has very little to do with people liking things. It has to do with getting bored and dissatisfied, with wanting to posit a significant difference with regard to what has gone before. Deadened by a decade of sanctimonious positivism, of Sherrie Levine "seeing through" originality, which is to say claiming power over it through an historicist mannerism, or the comparable power plays of Jeff Koons with regard to

beauty or of Hans Haacke with regard to the institution – in all cases knowledge as power in the crudest sense, we hang it on the wall and we own a truth, we are no longer intimidated by originality or beauty, nor are we accomplices in the collusion between the museum and the corporation, because *we know about it* – people are beginning to wonder whether the extremely neat eliminations of nonrepresentation performed by the critical community and their artist friends over the past decade or so might not have left something out.

This has meant a return to certain questions last raised in the nineteen-sixties. For art students, who almost immediately become young artists, a return provoked by the very reasonable suspicion that their teachers, who by and large achieved their reputations in the nineteen-seventies, were hiding something from them. And one would add to that Viktor Shklovsky's point about art not being a matter of fathers and sons so much as of uncles and nephews, and that one generation always finds itself in that which the immediately preceding generation regarded as peripheral. For art dealers, the possibility of airing out various graying personages from whom one hadn't heard all that much of late, and of acknowledging their grandfather status with regard to what is happening now. A retrospective of Don Judd's work, shows of works that Robert Morris and others might have done, but didn't, back then: works from the sketchbook, as we politely say. For the art audience, a return to having to actually look at what's in the gallery. An American painter who recently had a show in West Germany made the point to me that the triumph of Conceptualism in the land of the New Economic Miracle and also of the Green Party, meant that one didn't really have to spend any time at the shows. One sort of looked in at the door and then thought about it later if one felt like it. That is not possible with nonrepresentation, one can't "get the idea" and then go home. The reemergence of nonrepresentation means the end of the rule of the quick read.

This causes problems and, in one sense, they are the material problems which define the current situation. The critical community has long since grown used to works which were little more than occasions for reiterating various sorts of social enthusiasm, and indeed that is what works of art by and large are. There is no difference of a substantial sort between say, a critic like Benjamin Buchloh, who hates nonrepresentation – who will for example dismiss Stella's works as "corporate brooches" without asking whether an artist like Haacke does anything more than ornament the piety which he and Buchloh share – and an enthusiast of the stuff like David Carrier. Both are agreed as to the discourse, which is the discourse of the historical and

therefore of the ahistorical, an historicist category. They merely disagree as to how it works. Thus it is that Carrier can go on about the virtues – exclusively and narrowly art historical, like the virtues Stella claims for himself – of the polite sixties nostalgia painting of Sean Scully or the Malevich-as-beach-towel paintings of Harvey Quaytman, confident that nonrepresentation is what he always thought it was.

It could not be. Its discourse would have to change as we change and the world changes, and it has. A great deal of the interesting nonrepresenta-tional work being made at the moment, although certainly not all, is being made by people in their thirties who have rediscovered nonrepresentation not least by way of internalizing much that has been adversely critical of it. Jasper Johns reasserted the conventionality of the painting's – and by extension the art work's – objectness in a way that, as I explained at some length in a now antique discussion of Brice Marden's painting, made it quite impossible to suppose that the problematic contained in the pictorial object was subsumable in the sort of essentialist identification of frontality with oneness, and therefore of a unity of inside with outside that would make possible a condition of pure expression, which characterized the sort of aesthetic that nonrepresentation invented for itself during the pioneer days of Abstract Expressionism and its rationalist disciple, Minimalism,[2] and which continues to provide discursive meat and drink for Buchloh/Carrier and the art establishment in general.

One might do better to think of the discourse of nonrepresentation nowadays as one of deconstructive deferral, where deconstruction is not to be confused with the positivist defamiliarization inherited from Russian Formalism and Brecht, and filtered through Duchamp's concept of the readymade, which characterizes the dominant academic tendency of the moment: and we live in a time when the academy and the art market are almost as one, conceptualist/realist historicism is an ideal companion for the marketplace, which is always historicist. Most contemporary art histo-rians are people who give lectures on things that dealers choose to show, and most conceptual artists are people who make art about that. In contrast, nonrepresentation as we have it at the moment defamiliarizes nothing – a statement which one may certainly take both ways. Moreover, as an arena of deferring and differing, it is certainly not one thing, but is rather a matter of several or many: of Roni Horn's redefinition of sculpture as one thing made up of two things which are identical but which cannot be seen simul-taneously, of presence as a presence complemented by a present absence;[3] of Mary Boochever and Moira Dryer making nonrepresentational art out of the very critique which was supposed to put it out of business – in the case

of Boochever, Richter's version of the critique, imbibed by osmosis while at art school in Munich, in the case of Dryer, Levine's, similarly inhaled while studying with the likes of Joseph Kosuth at New York's School of Visual Art;[4] of Peter Halley's transgression against nonrepresentation's prohibition against representation – a transgression also performed by Boochever and Dryer; of Nancy Haynes' and David Reed's and Ron Janowich's pursuit of movement and density as the conditions of discontinuity, an interest in which I am myself also implicated; of Christian Haub's and David Rowe's (and, again, Haynes') persistent deferral of the object to that most pressing problem – certainly one which to a greater or lesser degree unites all the painters named here – of all, the question of the space contained by the object by convention, which is to say by virtue of turning the mind's will to see space into a sign, and which becomes, as it does most emphatically for artists such as Haub or Rowe or Haynes, the problem of uniting the surface with that to which it automatically defers but cannot be, spatiality, space beyond, of this as that and as not that simultaneously – of a representation, not a representation of a thing but of a condition, and moreover a condition of spatiality only imaginable, i.e., conceivable only as an image of itself. As Hegel put it, one can only imagine things that aren't there. In nonrepresentation, they're only not there by being there, otherwise they aren't at all – not being things, they can't even be nowhere.

In the essay on nonrepresentation mentioned earlier I suggest that the realm or district of nonrepresentation is, because of its inherent completeness, one which is close to, or likely to think itself through, the discourse of the body rather than of history – the story of production and incompleteness, of lack manufacture, and Norman Bryson has pointed out, apropos of that essay, that in this respect my theory would be fundamentally anti-Lacanian. I make use of an anecdote gleaned from public television, where, in a program on Harlem's Cotton Club, I heard an old dancer talk about another dancer who had had a wooden leg. It sounds ridiculous, said the old man, but when the disabled dancer danced everything *made sense*. The sense that nonrepresentation makes is profoundly counterhistorical but in that by no means ahistorical. On the contrary it is an arena of absolute conventionality – like music – and as such an entirely historicized species of production, which is why and how it can be counterhistorical. It can be, and is, in other words, an entirely and automatically historicized presentation of that which the moralizing master discourse of history itself can only include through exclusion, by writing it off, deferring it: the invisible, that which can only exist as an image, which is only realizable as image, being rather than production. It is full of history,

but not reducible to it – it is indeed by definition non-reductive in every respect.

In a fairly recent essay on the work of James Hayward I suggested that one really only needs Derrideanism in the visual arts where nonrepresentation is concerned, that representation, particularly of the Sherrie Levine variety, is entirely served by earlier critical models, and I have said here what those are.[5] We don't need Derrida to understand contemporary historicism, we already have Duchamp and Brecht. We do need Derrida, it turns out, to theorize the relationship of nonrelationship, of deferral and difference, between surface and support, here and there, this and that and this *as* that, which is the discourse of nonrepresentation. One important difference between now and then, where "then" stands for an earlier moment in nonrepresentation's evolution, is that the mind which makes it and looks at it is no longer one which thinks of itself as entirely comfortable with the concept of an historically unified subject. Roland Barthes talks of needing to search for a way out of the western enclosure, that of the historically unified subject, an enclosure in which he sees his earlier work – for example, *Myth Today* – but perhaps not his later – post-*S/Z*, say – as firmly situated. Nonrepresentation conceived as a counter-historicism which pits against the historical all that is not reducible to the notion of historical meaning, that is, to meaning which explains objects and experiences only in terms of where they are leading and what forces originated them, would be part of such an endeavor as Barthes recommends.

In, as they say, practical terms, the reemergence of being within, and in part perhaps in response to, a context overburdened with historicist knowingness, with the consequent obligation to actually look which goes with those things that represent nothing, nonrepresentational art objects, means, once again, domination for New York. People such as James Hayward, who lives in near isolation, aside, most artists who make art like to see what other people who do a similar sort of thing are doing, and nonrepresentation neither reproduces well nor can one for the most part send it through the mail. In New York it is possible to see a lot of art without depending on the magazines, and then there is this question of the general fear of nonrepresentation with which I began. New York has always more or less tolerated abstraction, as we call it in our less precise yesterdays, which is true of more or less nowhere else – exceptions would be arcadias such as Seattle. In Europe it remains the case that nonrepresentationism stands for America which stands for Imperialism-Chauvinism-etc., so that interesting contributions to the discourse of nonrepresentation, such as some of the works of Günther Förg, are always rationalized – should one say marketed? – as

safely Beuysian rejections of any such thing. On the other hand, Richter himself has lately begun to insist that his pluralism is not a matter of the historicist's typical claim to mastery through anonymity – of levelling as self-display, and the self in question exquisite and superhuman: the leveller, historical consciousness as a passive-aggressive Charles Bronson – so things may be changing. In the meantime one must say that one finds an artist such as Boochever, whose work is implicitly indifferent to the orthodoxy while having learnt from it how not to do boring sixties abstraction, more convincing than her influences in this as in other regards. For the present Europe – I pass in silence over Britain, where nothing stirs save Hamish Fulton and where people still angrily discuss Clement Greenberg, as do moralists and historicists of all sorts in America, only nonrepresentational painters never mention Greenberg, they have outgrown him without need-ing to kill him – slumbers in the sound sleep of historical righteousness, so that even a painter like Helmut Federle, whose work is perhaps closest of all to someone like David Novros, in its sense of structure and of what the pictorial space is like, although one could also cite certain works of Stephen Westfall in this connection, has to be somehow a critique of precisely what it is, which is to say, to be precisely not what it is, when presented to the public.

And then there is L.A. As America's chief not–New York, slightly differ-ent, because of distance as opposed to relative proximity, to the not–New Yorkism of Chicago, L.A. seems to have always disliked nonrepresentational painting and sculpture, perhaps because that is what New York is famous for. It used to be the case that people in L.A. would make things that were nonrepresentational as long as they weren't made out of paint or anything like that. The preferred material was of course resin, the language of the surf board, and this tradition has found a post-Modern (*i.e.*, Levinian) version of itself in the career of Tim Ebner. Nowadays, Ebner aside, the situation in general is if anything even more extreme when it comes to fear of art as an alternative to making art. If it was the case, as I had occasion to remark on a panel in L.A. recently where the Great Realist Nancy Spero saw fit to an-imadvert about the exclusion of women artists from the establishment one hour and forty minutes before her retrospective was due to open at MOCA, that ten years or so ago the Beach Boys were in control in L.A., people who used resin and responded to things like the career of Robert Smithson by putting together assemblages of colored twigs, it is now the case that it is held firmly in the grip of the good boys (and, of course, nowadays, girls). There are interesting nonrepresentational artists in Los Angeles. Apart from James Hayward, and John McCracken when his work avoids being about

the way it's made, there are younger artists such as Fred Fehlau and Melissa Kretschmer and Liz Larner. But in the main, as I said at the aforementioned panel, the quintessential Los Angeles show would, at the moment, be one in which two artists, a man and a woman of course, and probably members of the faculty of a certain local art school where Duchampian academicism is taught as a kind of folk art, would chain together the doors of MOCA on the grounds that it contains objects which might inflict pleasure. Documentation for the show, which would be funded by the Lannan Foundation, would be exhibited at LACE. Afterwards it would travel to the Art Institute of Chicago and New York's New Museum. There is little room, in such a scheme, for art which is about no thing but which has to be looked at.

At the same time it is not yet clear what the mobility of the contemporary art world will do to nonrepresentation. Certainly the West has not yet opened itself up to those who assume a discourse of no interior, the painters of the Orient, a tradition without underpainting, to cite Bryson again. Certainly, too, no one knows what nonrepresentation is. Perhaps then one should hypothesize a decentered nonrepresentation, meaning different things in different places. A nonrepresentation peripheralized in one place and central in another, a multiplicity of conditions of production for the ultimate object of nonproduction, nonrepresentation which shifts as one moves about the globe. That sounds about right, and it sounds like it means that New York will continue to be the place where one actually gets to see much of it, whatever it is, at any one time.

NOTES

1. See my "Nonrepresentation in 1988: Meaning-Production Beyond the Scope of the Pious," *Arts Magazine*, vol. 62, no. 9, May 1988, pp. 30–39.
2. See my "Brice Marden's Painting," *Artforum*, October, 1974, also in Jeremy Gilbert-Rolfe, *Immanence and Contradiction*, New York, 1985, where it appears in unexpurgated form, undamaged by an editorial policy committed to a doctrinal faith in the death of painting.
3. For more on the implications – explicated by the work – of this deferring maneuver, a deconstructing of the conditions under which the object proposes the concept of unity, see my *Roni Horn*, catalogue essay, Galerie Lelong, New York, 1988.
4. For more on these artists see my "Beyond Absence," *Arts Magazine*, vol. 64, no. 2, October, 1988, pp. 52–59, which is a comparison and discussion of their work.
5. "Abstract Painting and the Historical Object: Considerations on New Paintings by James Hayward," *Arts Magazine*, vol. 61, no. 8, April 1987.

DONALD KUSPIT

THE ABSTRACT SELF-OBJECT

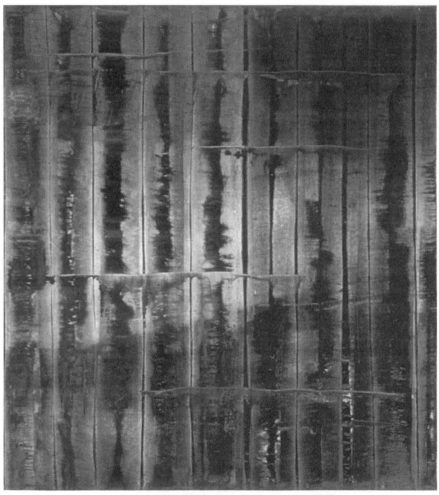

Gerhard Richter, 774-4 *Abstract Painting*, 1992. Oil on canvas, 78³/₄ × 70⁷/₈ inches. Collection of Linda Pace, San Antonio.

There are two questions to ask of the most serious practitioners of abstract art today, artists such as Helmut Federle, Imi Knoebel, and Gerhard Richter in Europe, and Robert Mangold, Brice Marden, and Robert Ryman in the United States:

1. What is the relation of their work to the tradition of abstraction? and
2. What is the significance in contemporary art?

Does their work give us a new sense of what it might mean – beyond simulation theory – to be "postmodernist"?

Abstract art was bifurcated in its development. On the one side, there was *organicist abstraction*, which maintained the idea that art was organic in essence. Organicist abstraction regarded art as the articulation of the indwelling naturalness of existence, a naturalness difficult to grasp and ultimately representable only in enigmatic – nonrepresentational – symbolic form. Naturalness was typically interpreted as spontaneity, and articulated gesturally. Kandinsky's abstract art, in its pioneering phase, was a basic expression of organicist abstraction. It was a defensive operation: its insistence upon the traditional conception of the organic character of art was in defiance of modern society, which sought to modernize art.

The modernization of art meant that, like society, it would be reorganized according to the rule of instrumental reason. It would be conceived as technical and formal in basis. Like society, art would reflect the understanding of nature afforded by pure science, the intellectual court

Donald Kuspit, "The Abstract Self-Object," *Abstract Painting of America and Europe* (Vienna, Austria: Galerie nacht St. Stephen, 1988), 41–52.

of last resort. Like nature, art was conceived as a series of interlocking mechanisms functionally related. For this mechanicism, it was less important to articulate the system of functional relations in organic terms than to acknowledge its formal character.

Organicist abstraction resisted this understanding of nature much as Goethe resisted Newton's mechanical understanding of color. Nature was force, not form; form was the shape of force. Form was transformation; it reflected the growth of force. Organicist abstraction resisted the effort to turn art into another instrument of reason, to bring it under the rule of reason. But it resisted the modernization of art with modern means, and so itself became another kind of modernization. Instead of representing external nature, it articulated internal nature – spontaneity – by direct gesture. It conceived of gesture at its energetic best as the occult form of natural spontaneity.

In contrast, mechanicist abstraction was a vigorous endorsement of formalist functionalism. Works of mechanicist abstract art did not attempt to create the illusion of organic force – the driving force of nature – in abstract form, but rather the illusion of a perfectly functioning formal system of abstract relationships. Works of mechanicist abstract art seemed to be constituted by a fixed number of interchangeable prosthetic parts systematically related according to rule. At the same time, mechanicist abstraction as such seemed infinitely extensible. It was like a computer system that could be expanded to carry out ever more numerous and more complex formal functions – to establish ever more qualitatively intricate relationships among an ever greater quantity of formal functions. To put this another way, mechanicist abstract art tended to become increasingly differentiated qualitatively and quantitatively, with no cut-off point, that is, with no one system of formal functional relationships regarded as absolutely optimal and terminal. The artist may limit himself to – specialize in – working with a limited number of formal functional relationships, but presumably that is a purely technical/practical matter. Malevich's geometrical mechanism is an eloquent early formulation of mechanicist abstraction.

The conflict between Kandinsky's organicism and Malevich's mechanicism – both equally sublime, ambitious, and absolutist in their claims, both claiming a monopoly on the inner necessity of art – is the driving force behind modernist abstraction. The question is whether this conflict is inherent and irreducible, and as such impossible to overcome, or whether it can be transcended. I submit that the challenge to abstract art today is to project a new synthesis of abstract art, a new unity of pupose: to heal the split in utopian aesthetic terms, in anticipation of its philosophical, and ultimately psychomoral, resolution in the lifeworld. Modernist abstraction

"realistically" articulated the modern world's bifurcation of organicist and mechanicist outlooks; postmodernist abstraction "idealistically" hypothesizes their resolution, rebalances their relationship. The question of this paper is how the abstract artists mentioned achieve this emblematic resolution.

The conflict between organicist and mechanicist abstraction has been understood conventionally as a conflict between aesthetic irrationality and rationality. Such a formulation has its difficulties, as well as its uses. The term "irrational" implies that organicist abstraction is a fetishization of growth as a sacred end in itself. At the same time, "irrational" seems to denigrate what it names. That is, it seems to imply that organic development is inevitably distorted – to the point where it seems absurd – in modern, mechanicist life. "Naturalness" becomes meaningless in a mechanicist world, which is why abstract art that idealizes naturalness or the organic seems irrational. Moreover, nature itself seems unnatural when it is treated rationally – "modernized." As simply another system of formal functional relationships, nature is not immune to mechanical manipulation. The organic can be "distorted," perhaps the ultimate import hinted at by the characterization of organicist abstraction as irrational.

The characterization of mechanicist abstraction as "rational" implies that it apotheosizes formal functional relationships in a closed system.[1] This mechanicist system – the grid epitomizes it – does not allow for feedback, that is, the semblance of openness. Mondrian's dynamic equilibrium is as close as mechanicist abstraction comes to creating an open system.[2] But the variables remain essentially unchanged in Mondrian's maturest paintings. In a sense, the pulsating character of Mondrian's 1940s New York paintings simply confirms the hermetic character of his system. The relationship between its parts necessarily intensifies, because the system is in effect a mechanicist reduction to and integration of artistic fundamentals (primary colors, the fundamental contrast of black and white, the fundamental geometrical shapes). Mondrian's system had to seem perfect to realize his final fling of innervating intensity. It makes no sense to speak of a new possibility of art in a mature Mondrian painting, only of art made absolutely actual – perfectly realized. From the perspective of a rationalist interpretation of mechanicist abstraction, "open system" – carrying with it the promise of the development of unexpected new kinds of art – is a contradiction in terms. Worst of all, it denies the perfection of the closed system, that is, the sense that it presents the first and last things of art in an absolutely cohesive and coherent way.

I will argue that the triumph of the postmodernist abstract artists discussed here is that their pictures are successful attempts to integrate, in different ways, organicist and mechanicist conceptions of abstraction. They

are overtly perfectionist, but covertly preoccupied with spontaneity. To put it another way, they want to make hermetic pictures, but they also want to make pictures that generate an empathic response – that link up with us in a vital, unconscious way. The result is a subtly open system of abstraction – a system that is manifestly closed, but latently open.

I will also argue that their pictures metaphorically address the psychological task of this age, which, as Heinz Kohut has said, is essentially narcissistic: the reintegration of the fragmented self.[3] The reconciliation of mechanicist abstraction and organicist abstraction is an aesthetic analogue for the reunification of the sundered parts of the self in a single, integral structure. At the same time, the dialectical result of the reconciliation reveals ongoing narcissistic difficulties. Optimally, the "grandiose self" (symbolized by mechanicist abstraction, whose systemism, hermeticism, and perfectionism represents the archaically perfect self) and the "omnipotent object" (symbolized by organicist abstraction, whose idealized spontaneity represents nature as limitlessly nurturant, the primitive omnipotent mother) integrate in a seamless way.[4] The consummate, postmodernist abstract work of art that results from the theoretically harmonious reconciliation of organicist abstraction and mechanicist abstraction can be understood as emblematic of such a narcissistically healthy self. But in practice the dialectic of the reconciliation is unbalanced, and remains narcissistically unresolved. Thus, on one level the postmodernist abstract work represents archaic integrity, but on another the narcissistic split in new form. It is complexly perfect, but also narcissistically tense. It does not solve the narcissistic problem, but perfects its articulation. The postmodernist abstract work is not one-sidedly artistic – naively fundamentalist, as though art could only be organicist or mechanicist, irrational or rational – but achieves a level of double entendre which remains narcissistically symptomatic.

The characterization of organicist abstraction as irrational and of mechanicist abstraction as rational has the advantage of dealing with abstraction in subjective terms, that is, in terms which bespeak the dialectical complexity of the self. The subjective formulation of the problem of abstraction directs attention to the urgent question haunting modern art from the start, and that abstraction – perhaps more than any other modern art – attempts to grapple with directly: can the "creativity" of the subject survive – retain any meaning – in the modern world? Creativity is associated with the idea of organic development – growth toward a goal, that is, maturation. More particularly, artistic creativity is associated with the idea of an art's growth toward maturity, metaphorically the artist's maturity. That is, a mature art is implicitly the sign of a mature self. Art is privileged and honored by intense attention,

because it seems to be the fullest statement of self-realization. The artist is presumably an exemplarily mature self – a truly realized human being.

This assumption has been brought into question in the modern world. It is increasingly hard to say what a mature modern art, or artist, would mean. Modern art is understood in terms of revolutionary breakthroughs, not in terms of mature realizations – unless the one is glibly understood as the other. "Revolutionary breakthrough" occurs to make a fresh start – to create a new youth for art. It once again seems fresh, and also immature – ripe with possibility but not truly ripe. Today, abstraction – whether organicist or mechanicist – is no longer a revolutionary breakthrough, a revolutionary art. Both organicist abstraction and mechanicist abstraction have become dogmatized and reified – which does not necessarily mean that they have become mature, have truly developed.

The question is, can abstraction become a mature art – can it become the vehicle for the mature self? Maturity occurs through the dialectical working through of contradictions. As has been noted, theoretically the postmodernist abstraction considered here dialectically works through the contradiction between organicist abstraction and mechanicist abstraction to create a mature, unified abstraction. Such aesthetic working through is emblematic of the self's working through of the contradiction between its belief in its own perfection and in that of the omnipotent object. Because it is aesthetic in form, the maturity of reconciliative unity that optimally results is a numinous "proposal": the general idea of unity of self it suggests remains a vision. Nonetheless, the working out of the details of a particular work's aesthetic unity issues in a temporary epiphany of unity of self. But however temporary, it is an illuminating articulation of artistic integrity, implying that the self's achievement of unity is also an "artistic" achievement.

It is worth noting that such abstraction is authentically postmodern, in contrast to the so-called simulated abstraction of neo-geometrical art (for example, the painting of Peter Halley and Philip Taaffe), which is inauthentically postmodern. Such neo-geometrical art implicitly assumes that the postmodern is a rupture in modernism, rather than a realization of its developmental possibilities – a completion of modernism, as it were. Above all, the simulated abstraction of neo-geometrical art regards postmodernism – and abstraction – as a kind of celebration of the disappearance of the subject. In contrast, for the abstract artists discussed here, the issue of postmodernism is the restoration of the self – its re-articulation, and maturation, under the conditions of absolute modernity. The question of postmodernism is how the self will endure and maintain strength in a situation in which modernity seems irreversible and ingrained, second nature.

It cannot be wished away, and so must in some sense be incorporated in the self without overwhelming it.

The issue of the possibility of an authentic postmodernist abstraction can be summarized in a series of questions. Did the revolutionary breakthrough of abstract art carry with it the promise of a mature abstract art, or was it meant to be an end in itself? Was it the only authentic abstract art because it was revolutionary – and to be revolutionary is to be more authentic than to be mature? Is revolutionary abstraction an unsurpassable ideal and thus a desirable end in itself, or a raw beginning? Is abstract art doomed to a tantalizing condition of eternal youth? Are contemporary abstract artists doomed to compulsively repeat the glorious moment of revolutionary breakthrough, as though it alone was worthwhile – the high point of abstract art? Are the only significant contemporary works of abstract art nostalgic recapitulations – cosmetically revolutionary, but otherwise reactionary – of the original abstract art? If abstract art remains a case of arrested development – however originally revolutionary – it cannot be regarded as "creative." As an end in itself, it becomes an obsolete reason for art – "aestheticist." Every revolutionary style becomes stylized – a historical code of art – or grows to maturity, which means that it becomes of use to the maturity of humanity. If abstract art has become aestheticist, it cannot be of service to the self in its efforts to endure the modern world, which is interested in the self only insofar as it can be an instrument of social "reason."

The issue, then, is to subvert the sense of instrumental reason and closed system, while retaining the appearance of coherence, equilibrium and the effect of end-in-itselfness that seems inseparable from abstract art – of the "purposive purposelessness" that Kant thought was essential to art, and that abstract art seems especially to exemplify. (The purposive purposelessness of abstract art suggests its role as the repository of the residue of the sacred and aristocratic sensibilities.) In a sense, the effort is to risk chaos without seeming to – to "crack" the system without abandoning it. The artists do this in different ways: Federle, Knoebel, Mangold rearticulate equilibrium as a seemingly empty possibility, always alluring but not really attainable. Marden, Richter, and Ryman create pictures that seem perfect, but are in a subtle state of entropic disintegration. It becomes impossible to conceive of them as stably cohesive, however ritualistically systemic they look. Insidiously, their perfectionism is a sign of their disintegration, the means by which they articulate entropy.

Federle's work has been understood in linguistic terms, but I think that is only partially their point. The asymmetry of the so-called New York Paintings (1980) calls attention to radical incompleteness as the implicit "theme"

of his works. By this I mean that there is an order that can never be realized, and that this never-to-be-realized-order – with the desperation implicit in it – is articulated through art, indeed, can only be discovered through art, which, perversely, is its apotheosis. There is a suggestion of the grid, with its relentless, all-consuming closure, but there is the sense that the distance to its infinity must traverse another infinity, that of off-balance and the never-to-be-balanced. There is an indelible desperation in Federle's pictures, which deceive one by using what have become the habitual terms of order and balance to articulate an impossible-to-order, impossible-to-balance. This insurmountable instability – its insurmountability itself – is the "subject" of his pictures.

In Mondrian, there was still the assumption that balance could be achieved, and that it was desirable. In Federle, there is an equally strong desire for balance, but it seems unrealizable. He articulates a seemingly untranscendable state of disequilibrium – what can be regarded as a "hypermodernistic" condition.[5] This is narcissistically useful to the fragmented or unbalanced self, as its curative mirror. In a drawing titled *Tod/Himmel. Haus/Welt. Sex/Unterwelt*, 1982, Federle positions a triangle below and a circle above a house, also flattened into a conventional pattern. The forms are almost entirely in the upper half of the picture, and on a diagonal, which goes through opposite corners of the house. The title immediately charges the universal forms with universal symbolic meaning, but the point is that the forms do not stably align. The sexual triangle of the underworld and the circular heaven of death do not balance one another. The juggling act is about to collapse, and this about-to-collapseness is the true point of the work. It is an allegorical depiction. One cannot help but recall Goethe's *Altar of Good Fortune*, 1776, with the sphere neatly balanced on the cube. In Federle, no such balance is possible: balance is forever impossible. One wonders if Federle is aware of the "three-body problem": in contrast to two bodies, three bodies develop complex orbit structures which are chaotic, that is, unbalanced in relationship to one another.

The juggling act is just that: a juggling act, rather than a stabilized balance. It is a narcissistic triumph to articulate non-balance without "going to pieces" (although the work is a group of pieces), that is, collapsing into what Kohut calls "prepsychological chaos."[6] That Federle can still identify the forms as "death" and "sex" indicates that he retains a "progressive" sense of psychopictorial organization, for all the regressive tendencies implicit in – and heavily disguised by – geometrical "reductionism." One cannot help thinking of Worringer's assertion that one turns to cosmic geometry to still anxiety; the triumph of Federle's art is that he uses cosmic geometry

to articulate anxiety – to give it full voice, indeed, to almost make it into a siren song.

If we compare Federle to Mangold, we see that the sense of uncanny disturbance is much less great in Mangold. The formally functioning elements are all subtly "off," if not as acutely as in Federle. The color sense and touch are quite different, contributing to this difference. Mangold mutes the hand, and uses colors that are far from muted. Federle maintains a subtly agitated hand, and almost grim – certainly brooding – color. Mangold still believes in the possibility of stable balance and clear cohesiveness – a coherence that will endure. The over-all effect is one of a balance that can be achieved with some difficulty, but without great strain. In Federle, the sense of strain is enormous, almost beyond endurance; the asymmetry is crushing. Mangold, in the last analysis, is delicate, if heroically so.

But this delicacy also suggests, as much as Federle's more assertive asymmetry, "negative narcissism" – unworkable narcissism. The fragments of form converge but do not coincide. All the colors are equally soft but subtly discrepant. In *Orange/Red/Green*, 1982, the cross is stable, but it is made of unstable parts. It seems more stable "theoretically" – as an "inevitable" form – than in fact. Mangold makes clear that reductionism is a kind of fatalism. Fatalism, with its regression to psychic fundamentals, implies a primitive recognition of the self's vulnerability. The recognition strengthens it, and the assertive articulation of fundamentals confirms the strength. It is a return to the bedrock on which the self rests. Similarly, reductionism, with its regression to artistic fundamentals, implies a primitive recognition of art's vulnerability in a world whose primary orientation is instrumental. Art is strengthened through the recognition, with its return to bedrock fundamentals, which becomes the "fundamental" form in which it will endure. Mangold's "realization" of the cross implies a primitive sense of perfection, but the formal inconclusiveness of the realization – all the forceful forms that function against it – suggest its contingency. The cross is in jeopardy, for all its inevitability, suggesting Mangold's profound ambivalence to it – suggesting narcissistic difficulties of balance. While not as profound as in Federle's case, they remain serious.

In Knoebel, the fragments of form are dispersed over the surface of the wall. The aura of disequilibrium created is extreme; it clearly reaches to the point of broken-apartness, active fragmentation. Knoebel's experience of disequilibrium is deeper than Federle's – more disintegrative. Federle, along with Mangold, maintains the cohesiveness of pictorial containment, as a token of narcissistic coherence affording the picture a minimum self-identity. In Knoebel, there is no direct cohesiveness, but rather the

cohesiveness generated by the affinity of the forms, in shape and color. The sense of random placement intrudes upon this "poetic" cohesiveness, upsetting the proposed equilibrium, if not so much as to obscure its possibility. It appears equally impossible and tantalizing.

Federle, Mangold, and Knoebel have taken mechanicist abstraction and added a more or less strong dosage of asymmetry – implicitly lack of cohesion – to it, putting mechanicist abstraction to a new subjective use. From Malevich through Mondrian the pursuit of rigorous equilibrium was the implicit or never easily realized goal. Now, in postmodernist abstraction, there is a Sisyphean sense of climbing towards the goal of equilibrium, but always falling short of it, and finally finding it too impossible, even subjectively absurd. Federle, Mangold, and Knoebel offer a rigorous disequilibrium, which affords a primitive recognition of our own inner disequilibrium, and reactivates our "theoretical" longing for equilibrium, restoring a primitive recognition of its inner necessity. Their paintings do not guarantee it, but inaugurate a therapeutic process. In none of these artists has disequilibrium hardened into a dogma, as equilibrium has in systemic abstraction. Disequilibrium remains a fluid process rather than a crystalline aesthetic, which is why it can empathically engage us.

In Marden, Richter, and Ryman we see the transformation – in different ways – of organicist abstraction into what looks inorganic but retains a sense of omnipotence, if an omnipotence no longer nurturant – a blind omnipotence, as it were. It is as though these artists have cultivated the perfectionism implicit in the grandiose self as the purest purposive purposelessness. This is perhaps most obvious in Richter, who offers us, in *Window*, 1985, among many other quasi-expressionist works, a kind of perfected but ingeniously devitalized gesture. It represents an absolute, borderless (all-encompassing), denaturalized grandiosity. It is aggressively exhibitionistic, as though driven, but perfectionist – subtly sterile and frozen. Where Federle, Knoebel, and Mangold attune us to our primitive disequilibrium, Richter's oppressive grandiosity attunes us to our primitive delusion of omnipotence. The omnipotence implied by his sterile perfectionism is an ingenious form of dissipation of selfhood.[7]

Richter's *Gray No. 349*, 1973, offers us another kind of perfected surface, also subtly sterile. It is even more intimate in effect than the quasi-expressionist surface, much more diffuse and undifferentiated. It looks grand and omnipotent, but it is unnourishing, and has none of the closure that would imply a true totalization of self – a true sense of limits. It is narcissistically absurd, as it were; in existing for its own sake, it can exist for nobody else's. Richter's all-over surface bespeaks the grandiosity of a self that cannot

begin to comprehend the separate existence of other selves, but dissolves them in itself. It is a discreetly insatiable surface, a quicksand in which the least sense of the other dissolves without a trace, or rather, survives as a trace of paint.

Ryman gives us similar, delicately agitated surfaces. In *Pilot*, 1978, the square format is historically familiar, as is the holistic surface. They are in contradiction: the one conventionally signals the systemic, the other the spontaneous. But Ryman's gestures are less spontaneous than random, and more static than dynamic in effect, for all their activity. As in Richter, absolute uniformity is avoided but strongly suggested. The same dry grandiosity is at work, inventing a peculiarly inorganic intensity. There is an air of mineral – rather than animal or vegetable – to this work, as there is in Marden, who, for all his surface differentiation, creates the same holistic nihilism. However, in Marden there is always the undercurrent of uncanny geometric control, pushing towards a final differentiation. It is the brilliant nihilism of grandiosity out of control yet longing for it.

Uncontrollable disequilibrium, uncontrollable grandiosity: these are the narcissistic conditions of the modern self. Oscillation between disequilibrium and perfectionism: this is the contradiction that pervades postmodernism in general, and postmodernist abstraction in particular. By articulating these extremes aesthetically, the postmodernist abstractionists activate them so that they can be overcome, or rather, show us how hard it is to overcome them.

NOTES

1. For a discussion of mechanicist abstraction from the perspective of systemism, see Lawrence Alloway, "Systemic Painting," in *Minimal Art*, ed. Gregory Battcock (New York: E. P. Dutton, 1968), pp. 37–60.
2. For the distinction between closed and open systems, see Ludwig von Bertalanffy, *General System Theory* (New York: George Braziller, 1968), pp. 39–41.
3. Heinz Kohut, *The Restoration of the Self* (New York: International Universities Press, 1977), p. 286.
4. For a discussion of the concepts of grandiose self and omnipotent object, see Heinz Kohut, *The Analysis of the Self* (New York: International Universities Press, 1971), pp. 26–27.
5. For a discussion of hypermodernism, see T. W. Adorno, *Aesthetic Theory* (London: Routledge and Kegan Paul, 1984), p. 22.
6. Heinz Kohut, *How Does Analysis Cure?* (Chicago: University of Chicago Press, 1984), p. 8.
7. Kohut, *The Analysis of the Self*, pp. 114–15.

DAVID PAGEL

ONCE REMOVED FROM WHAT?

Monique Prieto, *Miasma*, 1998. Acrylic on canvas, 96 × 72 inches. Collection of the Orange County Museum of Art; Museum Purchase with funds provided by Dr. and Mrs. John Kennady, in honor of his mother Leona Kennady and her father Abraham Rand; photo courtesy of Acme., Los Angeles.

The first question one might ask in surveying the diverse works that make up *Abstract Painting, Once Removed* is: Once removed from what?

As a Los Angeles-based critic – who's particularly sensitive to the ways in which New Yorkers talk about abstract paintings made out here as opposed to those made back there – I immediately answered this question geographically: "Abstract Painting, Once Removed from New York." Adding this prepositional phrase to the show's title accounts for the geographic distribution of the twenty-one artists in the exhibition, only four of whom live in the New York area (Polly Apfelbaum, Jim Hodges, Fabian Marcaccio, and Scott Richter). By featuring seven artists currently residing in Los Angeles (Kevin Appel, Uta Barth, Ingrid Calame, Fandra Chang, Sally Elesby, Monique Prieto, and Pae White), *Abstract Painting, Once Removed* is, to my knowledge, the first U.S. museum survey of contemporary abstraction in which artists who made their reputations in L.A. outnumber those who did so in New York. It is certainly the first show of its type in which as many artists reside in Texas (Mark D. Cole, Jeff Elrod, Tad Griffin, and Aaron Parazette) as in the environs of New York. The rest of the roster includes two painters from London (Glenn Brown and Richard Patterson), as well as one each from Edinburgh (Callum Innes), Tokyo (Takashi Murakami), Rio de Janeiro (Beatriz Milhazes), and Pennsylvania (Emil Lukas). It's significant (and refreshing) that none of the artists' works is called upon to represent its maker's national or cultural identity. Instead, viewers are invited to consider all of these works on equal footing with one another – at one remove, as it were, from the tendency of critics and

David Pagel, "Once Removed from What?," in Dana Friis-Hansen, *Abstract Painting, Once Removed* (Houston: Contemporary Arts Museum, 1998), 23–27. © Contemporary Arts Museum, Houston, Texas.

curators to treat art forms from other places as signs of their environments, rather than as multilayered objects that shape their surroundings as much as they're shaped by them.

Since Manhattan is no longer the undisputed center of art-making, and since most of the critics, curators, editors, and educators working there continue to act as if it still were, it seems sensible to conclude that today any ambitious painter, working anywhere in the world (including New York), must feel that he or she is painting at one remove – outside the loop (of what used to be called the dominant discourse). What's happening now in studios all over the world generally goes against the grain of what has taken place so far in the postwar era – or at least is at odds with what has been written about that era of art. What distinguishes this generation from previous ones is that its painters are perfectly content to be working at one remove. It's commonly felt that passing through New York is no longer a necessary stage in an artist's career. If Los Angeles stands as an example, staying out of New York may be more fruitful since it often gives a developing artist more room to experiment on his or her own, testing results and exploring possibilities that would be ruled out in a more traditional rule-bound context.

At the same time, it must be emphasized that establishing an antagonistic relationship with the mystique and reputation of New York is not an essential component of contemporary painting either. The most exciting painters working today neither seek the establishment's approval, nor go out of their way to reject protocols and assumptions, Instead, artists of this generation simply carry on with their work as if the old center of the art world didn't really matter. Spite drives none of the works in this exhibition. After all, making compelling paintings is not a zero-sum game, and what happens in Manhattan does not have to be addressed for artists to pursue their own projects. Consequently, it seems that many of the best paintings being made today inhabit something like a parallel universe – one that is remarkably similar to New York's often provincial art world but fundamentally different in every detail. One of the most startling characteristics of this universe is that works thriving in one locale are often invisible or incomprehensible in another. To take Los Angeles as an example again, no matter how ambitious or original a particular work from here may be, when shown in New York, it often barely registers as a blip on that city's critical radar screen. Usually, this says less about the art's merits than about New York's tightly focused (i.e., constrictive) frame of reference and the difficulty of breaking habits or seeing beyond established horizons.

Of course, contemporary painting is not only geographically removed from New York. It's also conceptually removed from many of the

self-conscious strategies that have dominated the past decade, when institutionally affiliated arts professionals filled the vacuum created by the crash of the overheated international art market at the end of the 1980s. It's important to distinguish what's going on in abstract painting today (as indicated by this exhibition) from the once prevalent Postmodern notion of art-in-quotation-marks. The primary purpose of the latter's predominantly abstract works was to make grand (tongue in cheek) propositions, and then by means of a sly wink, knowing nudge, or ironic twist, let insiders know that such goals were ridiculously overblown, even dangerously authoritarian. This insistence on making a mockery of Modernism, first by turning the history of American abstraction into a simplistic cliché, and then by attacking this straw target, goes hand-in-hand with the idea that form and content are separable and that artists' intentions are easily translated to objects. It cynically treats the contemporary world as an incidental footnote to a vaunted history from which artists and viewers have become irredeemably alienated. This passive-aggressive approach to artmaking often prevails where a surfeit of historical precedents is available, but current works have no vital connection or living relation to precedents – and have a hard time coming to terms with that fact.

Although paintings based on this Postmodern strategy appear to be operating at one remove, it would be a mistake to think that they share much with the works in this exhibition. Too eager to close the gap between the past and the present by claiming a position of centrality for themselves, their willingness to be once removed is an empty pretense, based less on maturity and willful humility than on juvenile self-aggrandizement. These defensive painterly surrogates merely act as if all of history were a sham in order to be seen, themselves, as "historically important." Linked so closely to earlier works, they never risk being seen as inconsequential, being misunderstood, or being not seen at all. In that light, it's useful to append the show's title with another prepositional phrase: "Abstract Painting, Once Removed from Postmodern Quotation." By taking a step back from such glib historicism, the painters in this exhibition find themselves in the thick of things once again. Strange as it may seem, putting some distance back into art brings it more intensely into the present, where the here-and-now has a chance to measure up to the long ago and faraway.

Finally, the question "Once removed from what?" must be answered in terms of expressive intentions. "Abstract Painting, Once Removed from Self-Expression" situates the works in this exhibition far from the old-fashioned yet still prevalent idea that abstract painting is the perfect vehicle by which "creative" individuals spill their guts and tell their personal, angst-laden

stories, whose unique pains and torments could not be conveyed by any other means. More than any other artform, abstract painting has been burdened with a history of misreadings, many of which put forth the hoary cliché that this art's primary purpose is to communicate one dysfunctional individual's interior life to another – as vividly, dramatically, and bombastically as possible. Rather than deriving a variety of social pleasures from a painting's forms and context, viewers beholden to this approach "read" paintings as authentic signs of another's psyche, which has been so traumatized by modern life that it cannot speak in less difficult more conventional, terms, but needs abstract painting to register its "uniqueness."

All of the works in *Abstract Painting, Once Removed* sidestep such sappy sentimentality. Preferring to pay more attention to the social spaces paintings actually occupy than to the psychological depths many viewers presume to read into their surfaces, they favor insistent superficiality. They cultivate a public that demands that art be regarded in terms of the effects it has on people who actually live in the world rather than merely read about it in books. With these works, speculation about particular gestures, flecks, and smears of paint never leads back to an originating consciousness. Instead, the activity of paying close attention to the peculiarities of each piece leads viewers beyond the shroud of privacy and into the world of shared social space, where arguments can be made openly and aggressively without compromises being made for personal "feelings." Throughout the show, cool detachment, intellectual rigor, and material veracity take precedence over urgent expressivity and inward-turning emotionalism. Paradoxically, keeping such overwrought theatrics at arm's length gives viewers more room to maneuver. It also accounts for the open-ended generosity of these restrained yet profoundly non-secretive works.

All three answers – removed from New York, removed from Postmodernism's smug historicism, and removed from self-expression – put a premium on distance. Contrary to expectations, distance in art is not the same as distance in life, where it provides a margin of safety, putting sufficient space between an object (or a person) and the rest of the world by creating a comfortable buffer zone. In contrast, *Abstract Painting, Once Removed* prioritizes the space between things in order to emphasize the *here* and *now* over the *there* and *then*. Whether measured spatially or temporally (i.e., geographically or historically), the distances implied by "once removed" are not vast, daunting, or impossible to traverse. In fact, they suggest only a slight degree of separation, one in which connections, echoes, similarities, and affinities play as important a role as do differences and distinctions. What distinguishes these works from their immediate predecessors is that

they do not derive the bulk of their power or forcefulness from negating or criticizing previous works, recent styles, or current social practices. With this generation of abstract artists, one-dimensional oppositions such as this fade far into the background. Apposition, rather than opposition, is their modus operandi.

Until very recently, if an artist was a woman who also made abstract work, it was assumed that she was being ironic and that her art offered a critical commentary on the obvious macho problems posed by Minimalism, Abstract Expressionism, and other unfriendly styles from which women have been traditionally excluded. Because abstraction looked content-free, and also appeared to be easy (if you didn't look very carefully), it was often treated as an empty vessel into which impatient, well-meaning artists could insert whatever content they chose. Whether politically motivated or personally driven, such narrative-oriented abstractions almost always began with recent art historical masterpieces (the most popular being works by Jackson Pollock and Richard Serra, followed closely by Carl Andre and Donald Judd) to which the next generation appended a variety of self-conscious revisions, which were often called feminist. "Correcting" the mistakes of their forebears' apparently misanthropic works, they softened these works' hard edges, ameliorated their authoritarian natures, and generally shifted their emphasis from heavy industry to body-scaled domesticity. Viewers were thus subjugated to tedious lectures by artists eager to transform the present into a time to do penance for the sins of the past. Religion and reeducation dovetailed as the possibility that art – and the present – might hold something different was squeezed out of the picture. (Today it appears that such academic exercises were insufficiently feminist, and it remains to be seen whether they gave feminisim such a bad name that young artists will have nothing to do with it, at least until they put some distance between this episode and their own work.)

Over the past four or five years, some of the best abstract painting in Los Angeles has been made by women. With remarkable consistency, these young painters do not begin with art enshrined in major museums but with works that have been critically dismissed and, after enjoying their fifteen minutes of fame, now are consigned to basement storage bins (or are still on display in regional museums whose acquisition budgets were cut long ago). Rather than starting with recent art history's triumphant success stories, such artists as Calame, Prieto, and White (along with New Yorker Apfelbaum) start with recent art history's biggest failures and defeats. They make 1960s Color Field painting look interesting again, transforming Formalist Abstraction, which had been written off as Modernism's biggest

dead end, into a fresh beginning. Filled with verve and vitality, the works by these women redeem a style of painting that was so far out of fashion that no one gave it serious consideration – at least not in public.

Calame's enamel-on-aluminum panels and monochromatic cartographies on vellum give Helen Frankenthaler's vacuous stain paintings an aggressive edginess in which the persistent amateurism of paint-by-number kits lurks not far in the background. Prieto's buoyant blobs of crisp color, stacked like odd architectural elements, highlight the gravity-defying lightness of Jules Olitski's early compositions by marrying their hovering forms to Tom Wesselmann's sexy Pop palette. And White's dazzling slabs of highly reflective Plexiglas infuse DeWain Valentine's giddy, candy-colored confections with diabolical intensity, transforming physically weighty (if conceptually lightweight) decorations into shimmering instances of blazing immateriality, whose hellishness is pointedly evoked by the double-edged title *The Inconsolable Wailing of the Damned*, 1994. For their part, Apfelbaum's installations of countless dots and splotches of color stained into elongated swatches of stretch velvet put Larry Poons' ellipses underfoot, where they function like paintings that have undergone molecular melt-downs. To step into one of these installations is to imagine that you're in a big printed picture whose Benday dots are on acid (which is a lot different from being on acid yourself).

Likewise, Appel's subtly subversive interiors travel back to David Hockney's intentionally distorted rooms and Southern California backyards only to take viewers into the future, where computer-generated fictions are at once seductive and suffocating, both strangely alien and hauntingly familiar. In a related manner, Barth, Chang, and Elesby scrutinize human perceptual processes by interrogating abstract painting's links, respectively, to photography, to prints (both silkscreen and digital), and to sculpture. By foregrounding what transpires between our eyes and our minds whenever we look at the world, these three artists open the exploration of perception that began with the Light and Space movement to even more untraditional materials and newly developed processes, persuasively demonstrating that *what* something is made of isn't nearly as interesting as *how* it works. As a group, all of the artists in *Abstract Painting, Once Removed* belong to what may be the first generation since the late 1960s for whom the label "formalist" is not an outright insult. Having been off limits for several generations, formal exploration has become once again a rich – and open-ended – area of inquiry. Perhaps the most exciting aspect of painting today is that it is equally indebted to Pop Art's exploitation of mechanical reproduction and High Modernism's focus on the embodied effects of aesthetics.

This is doubly curious because Pop Art began as a critique of museum art – in the name of more accessible commerical exchanges unsanctioned by highbrow institutions. It took about ten years (from the early 1960s to the early 1970s) for Pop to be transformed from a democratic indictment of elitism into an elitist critique of popular forms – all in the name of Marxist academics (whose tenure at prestigious institutions made their endorsements attractive to museums, which sought to distinguish their programs from the commercial world). Today, after both of these tendencies have run their course, the techniques and procedures of each run together in works that cannot be accounted for by either. For those who have been in power, this is undoubtedly bad news. But for those of us whose interests have not been served by the status quo, what could be better?

12

FRANCES COLPITT

SYSTEMS OF OPINION
Abstract Painting Since 1959

Peter Halley, *Intruder*, 1994. Acrylic, metallic and Day-Glo acrylic, and Roll-a-Tex on canvas, $88\frac{1}{2} \times 111$ inches. Courtesy of the artist.

ONE

"All genuine art is abstract," declared Susanne Langer in 1957.[1] This commonplace, modernist conceit accommodated the entire history of painting, from its prehistoric beginnings to the present, and assumed a creative process of *abstracting* that is literally indistinguishable from that of *representing*. Obscuring the fact that some paintings (at least all Western works of art until around 1910) show resemblances to things existing or imagined to exist (such as unicorns) and some paintings do not, the inclusiveness of this argument makes it fairly useless when it comes to understanding abstract painting as we now know it. Abstract painting was not arrived at by accident and, although it is less than a century old, its endurance suggests that it has the capacity to communicate in ways unavailable to mimetic painting. Rebutting the postmodern claim that "abstract painting is dead," Brice Marden affirmed, "Abstraction is new, it's in its infancy."[2] A similar sentiment was expressed by Robert Ryman. "Abstraction is a relatively recent approach to painting. I think abstract painting is just beginning. All possibilities are open to it in ways we can't imagine."[3] Proof of abstraction's viability is in the fact that it continues to be made and made meaningfully. Generations of painters have been devoted to the production of abstract paintings, which continue to be exhibited and to be the topic of discussion and debate, providing visual pleasure as well as intellectual challenges. Nevertheless, abstraction's viability does not lend itself to the construction of an unbroken genealogy. Because they do not share the same premise, paintings by Peter Halley in the 1980s, Frank Stella in the 1960s, and Piet Mondrian in the 1920s differ not only in appearance but in their potential for expressing what is possible to express, each marking a crucial moment in abstraction's history.

In his classic survey of 1936, *Cubism and Abstract Art*, Alfred Barr observed that "by a common and powerful impulse [European abstract artists]

153

were driven to abandon the imitation of natural appearances."[4] Earlier, even before modern nonrepresentational art existed, Wilhelm Worringer distinguished two "antithetic" modes of artistic volition that drove artists either to empathy and thus "naturalism" or to abstraction.[5] The oppositional definition of abstraction was rarely challenged by modernist critics. An exception was Clement Greenberg, who did "not feel that abstract painting, despite all the changes it has made in the language of painting, is so different from traditional, representational painting as to constitute a real historical break with it." Rather than as an alternative to mimetic art, "abstract painting has evolved out of the illustrative, representational painting of Renaissance tradition, and the filiation will remain visible to those who look hard enough."[6] Armed with complex theories of representation beyond the mimetic correspondence of an image to its real-world model, contemporary critics reject the oppositional relationship of abstraction and representation, although they may continue to define one in terms of the other. As Hal Foster sees it in "Signs Taken for Wonders" (Chapter 8), "Abstraction represses or sublates representation, and in this sublation representation is preserved even as it is cancelled."

Another reading considers it less an either/or option than a sliding scale, comparable to the elementary notion of the political spectrum. Painters could thus be hard-core abstractionists at one end of the spectrum, trompe l'oeil artists at the other, or moderates in the middle. In a televised interview, abstract expressionist Jane Freilicher said that she considered her paintings "figurative" but that next to those of a realist like Andrew Wyeth they look "abstract."[7] Outlining such a continuum theory in light of the statement that "all art is abstract," aesthetician Lucian Krukowski distinguished, as a matter of degrees, the universal, generalized qualities of abstraction from the particular qualities of realism. For example, Mondrian's paintings typify the abstractive process of generalization through their "destruction of 'particularity.'"[8] Working with these same terms, Langer held that generalization is the province of science, while specificity is the goal of art, although both operate abstractly by recognizing form or structure apart from specific things.[9]

Since the middle of the twentieth century, few artists and critics have situated their practice or articulation of abstraction in opposition to representation. In place of a "not" definition ("Abstract is what is *not* figurative, not narrative, not illusionist, not literary and so on"), John Rajchman writes of an abstraction that is affirmative, "an invention of other spaces with original sorts of mixture or assemblage ... which departs from classical illusionism [is actually prior to it], and eventually even from figure/ground

principles of composition." Exemplified by the paintings of Jackson Pollock, it expresses what can be expressed only abstractly. The traditional argument for generality, says Rajchman, derives from Plato's hierarchical process of abstraction in which higher general forms (Ideas) are identified in lower particular things. Following Gilles Deleuze, Rajchman proposes an alternative reading of abstraction – a "reverse Platonism" – which avoids such transcendental categorization and opens the space of abstraction to accommodate chaos and formlessness.[10]

Plato's famous definition of art as mimesis appears in Book X of *The Republic*, and while it is no longer considered a credible rationale for representation, its longevity (at least until the end of the Enlightenment) justifies even contemporary rebuttals and references to it. Using the example of a bed, Plato distinguishes painting and carpentry from reality or Ideas. A painting of a bed is only an imitation of a particular bed made by a carpenter, just as the carpenter's is an imitation of the idea of a bed, which is true and actual bedhood. The hierarchy is intended to condemn the painter as one who attempts to deceive and knows nothing of the real thing. The equation of painting and mimesis was common until the early nineteenth century, when G. W. F. Hegel irrevocably severed the link.[11] Stressing the spiritual nature of art, Hegel believed that the purpose of art is not the imitation of nature. "To take what already exists, just as it *is*, simply to make it over a second time as an exact *copy* – that we may at once dismiss as a superfluous labor. The result, at best, must fall far short of nature. Imitations are, after all, *one-sided* deceptions, i.e., appearances of reality addressed to one sense only, and therefore hardly more than parodies of what is genuinely living. Pleasure is no doubt to be found in the skill and industry required to produce strikingly realistic copies of nature, but it is pleasure that is soon enough chilled into boredom and repugnance."[12] As in religion and philosophy, art's content is the Idea, which is independent and self-determining, although, Hegel cautions, "the content of art must not be anything inherently abstract," because it would not convey concrete truth.[13]

At the time of Hegel, abstract art was nearly a century away. Once abstraction became a reality in the early twentieth century, the analysis of painting's relationship to mimesis was modified to accommodate abstraction as well as scientific advances, with which art historians and critics were especially enamored in the 1950s. E. H. Gombrich, for example, attributed the end of the debate over the role of mimesis to the complexities of vision discovered by psychology and optics.[14] Acknowledging the influence of physics as well as psychology, Leo Steinberg defined both abstraction and representation as analogues of experience. The experiences recorded in mimetic art are

visual, whereas in abstraction, they are beyond visualization, like the abstractions of contemporary science in which "we cannot picture what we are talking about."[15] Although such a theory is no longer mimetic, it makes abstraction a form of representation (Langer's "all art is abstract" becomes "all art is representational"): abstraction is a representation of whatever believable reality exists at the time.[16] Richard Wollheim similarly disavowed the difference between abstraction and representation by defining *abstract* painting as the nonfigurative (unrecognizable) *representation* of shapes and images.[17] More convincingly, Michael Fried unhooked figuration from representation by using the term nonfigurative to mean without figure/ground relationships and therefore without the representation of shapes. Fried's analysis differentiates Jackson Pollock's nonfigurative drip, which is neither a contour nor a boundary line, from Wassily Kandinsky's figurative mark, which has "the quality of an object . . . like a branch or a bolt of lightning."[18]

Nonrepresentational painting that depicts no shapes and especially no shapes in illusionistic space is simply more rigorously abstract than painting that includes representations of shapes.[19] This explains the inclusion of two chapters on monochromatic painting in this volume, since it is with monochromatic painting that the toughest questions about abstraction are posed. Much of what Wollheim, for example, would call abstract painting is, as Barnett Newman observed in 1945, "an ornamental art whereby the picture surface is broken up in geometrical fashion into a new kind of design-image."[20] In contrast, a nonfigurative abstract painting is seen "as a single visible skin, rather than, as in earlier geometric art, a container of diversified elements."[21] Some nonmonochromatic paintings prior to 1959 (instances of Russian avant-garde abstraction and Dutch de Stijl, for example) meet this criterion, as do many abstract paintings after 1959.

Terminological arguments in the literature on historical abstraction are manifold. Before Pollock introduced the possibility of nonfigurative abstraction, Barr argued for the retention of the general descriptor "abstract" in lieu of "nonobjective" or "nonfigurative," since "the image of a square [for example] is as much an 'object' or a 'figure' as the image of a face or landscape."[22] For Kasimir Malevich, "non-objective representation," expressing "the supremacy of pure feeling in creative art," replaced "the verisimilitude of the illusion" associated with "objective representation." Malevich's nonobjectivity results from the desire to picture (represent) pure, nonobjective feeling – feeling without an object – rather than merely the absence of depicted objects in a painting.[23] To emphatically differentiate the functions and meanings of the paintings at stake, Jeremy Gilbert-Rolfe prefers "nonrepresentation" to "abstraction," but for our more general

purposes, "abstract," as Briony Fer writes, "will have to do, because it is a current term in common use, with its own vicissitudes and history."[24]

A final distinction – not between abstract and representational paintings but between two types of abstraction – can account for the shift in thinking about abstract painting that occurred around 1959. Abstract painting can be treated as either a verb or a noun, a process or a product. Barr was the first to make the distinction, citing the traditional definition of "to abstract," which means "to draw out from." In this sense, Mondrian's plus and minus paintings are abstractions of a bird's-eye view of a pier and ocean. "But the noun *abstraction* is something already drawn out or away from – so much so that like a geometrical figure or an amorphous silhouette it may have no apparent relation to concrete reality," an example of which is Malevich's black square of 1915.[25] Despite their highly expressive content, however, Kandinsky's paintings, which Barr associates with the noun abstraction, reveal the inspiration of nature in the use of landscape space and organic forms and, as Fried and Rajchman argue, are clearly figurative.[26] With admittedly different sources and intentions, Kandinsky and Mondrian can now be seen to be involved with a *process*, an "abstracting from." Without a basis in observable reality, Malevich's suprematist paintings are also abstractions in this sense, derived from his participation in the opera *Victory Over the Sun* and, in particular, his design for the backdrop representing the eclipse (the half-black, half-white square) which metaphorically dispels illusion and "the falsity of the world of will and idea."[27] Because these three artists were involved in a radical conversion of painting to an art that was not mimetic and had no precedent, they had to move from representation to abstraction. This movement could occur only as a process, as a verb. For artists of Frank Stella's generation, however, the process was complete; abstraction (a noun) was viable, indeed more viable at the time than representational painting. Fer uses the terms "transcendental" and "structural" to distinguish the goals of modern European artists from those of American artists of the 1960s. Where Malevich's painting, for example, sought "a higher reality through the purity of its forms," '60s abstraction was inspired by "contemporary interests in structure and system." Fer's distinction also suggests that painters of the 1960s and beyond embraced abstraction as a received structure or idiom with ideological as well as formal implications.[28]

Pollock was the most influential artist for Stella's generation, but despite the elimination of figure/ground relationships in Pollock's paintings, his engagement with process and expression associates his work with early abstraction. The key figure at the crossroads is Ad Reinhardt, who "made the last of the first abstract paintings."[29] Summarizing the finality of his position,

he observed, "When somebody says, 'Well, where do you go from here or where do *you* go from here?' I say, 'Well, where do you want to go?' There's no place to go. . . ."[30] Motivated by the exhaustion of self-expression, his black paintings conclude the quest for the transcendental in a serial, nonrelational format that characterized abstraction until the 1990s. Dissatisfaction with expressionist painting was the impetus for what Lawrence Alloway termed "systemic painting," in which "the field and the module (with its serial potential as an extendable grid) have in common a level of organization that precludes breaking the system. . . . In all these works, the end state of the painting is known prior to completion (unlike the theory of Abstract Expressionism)." As a historical precedent, Alloway quotes Reinhardt in his catalogue essay for the 1966 *Systemic Painting* exhibition: "Everything, where to begin and where to end, should be worked out in the mind before hand."[31]

The history of early twentieth-century abstract painting, particularly in the form of exhibitions and catalogues, has been well rehearsed. Debates about who painted the first abstract painting are interesting and legitimate expressions of the desire to locate a point of origin for the beginning of a history,[32] yet the second manifestation of abstraction does not reveal a developmental, historical narrative.[33] "In fact," as Grégoire Müller observes in his 1970 essay (Chapter 5), "from an evolutive point of view, the history of painting stopped ten years ago . . . without anyone realizing it." Its resistance to the formulation of a history led David Carrier to propose a series of models of art history for abstract painting (none to his satisfaction), from autobiography to the contemporary theory that the history of art has reached an end. Acknowledging the effectiveness of Greenbergian formalism, an account of the progressive flattening-out of illusionistic space from the 1860s to the 1960s, Carrier contends that no plausible history of abstract painting has since emerged to replace it. All of the comprehensive histories of art available to Carrier are histories of the progress of representation; Giorgio Vasari's and Gombrich's more obviously so, while Heinrich Wölfflin's is defined as "the development of more difficult methods of presenting forms in space." Because theories of representation hold that abstraction lacks content, each example draws Carrier to the same conclusion: abstraction marks the end of the history of representation.[34]

For theories of representation, representations comprise the content of art; therefore, abstract art, as David Pagel remarks, appears to be "content-free." Paradoxically, certain reductive theories of formalism, such as Barr's "assumption that a work of art, a painting for example, is worth looking at because it presents a composition or organization of color, line, light and shade,"[35] also deny the role of content in abstract painting. For

failing to acknowledge that all art is shaped by experience and expression, Meyer Schapiro accused Barr of misinterpreting both abstract and representational art.[36] As Barnett Newman famously recalled, Schapiro himself distinguished between subject matter and "object matter" in painting. "It is the 'object matter' that most people want to see in a painting. That is what, for them, makes the painting seem full."[37] Consciously eliminating "object matter" from their paintings, the abstract expressionists were convinced that subject matter remained, since "there is no such thing as a good painting about nothing."[38] In their terminology, the subject matter of a work of art is what is generally referred to as content. Greenberg, who was often criticized for ignoring content in his formalist judgments, preferred the more traditional distinction of the two terms, "in the sense that every work of art must have content, but that subject matter is something the artist does or does not have in mind when he is actually at work."[39] "Quality, esthetic value originates in inspiration, vision, 'content,' " he later wrote, "not in 'form.' "[40]

Without representational images or narrative content, abstract painting was ideally suited to formalist art criticism. As a critical method, formalism aspires to objectivity by accounting for characteristics available to anyone's eyes. It is also an evaluative tool, eliciting from those who wield it pronouncements of quality based on compositional, spatial, and coloristic relationships, as well as historical significances. The pursuits of abstract painting and formalist criticism developed alongside one another and became so intertwined in the writings of Greenberg that, despite his protests, the artists he championed in the 1960s, including Morris Louis, Kenneth Noland, and Jules Olitski, were sometimes known as "formalists." Addressing the interdependence of abstract painting and formalism, Schapiro warned:

> The new styles accustomed painters to the vision of colors and shapes as disengaged from objects and created an immense confraternity of works of art, cutting across the barriers of time and place. They made it possible to enjoy the remotest arts, those in which the represented objects were no longer intelligible, even the drawings of children and madmen, and especially primitive arts with drastically distorted figures, which had been regarded as artless curios even by insistently aesthetic critics. . . . What was once considered monstrous, now became pure form and pure expression, the aesthetic evidence that in art feeling and thought are prior to the represented world. The art of the whole world was now available on a single unhistorical and universal plane as a panorama of the formalizing energies of man.[41]

The belief in formalism's universal vision derives in part from abstraction's earliest defenders. The goal of art, according to Mondrian, is the expression of "universal beauty," with the knowledge that "art is not made for

anybody and is, at the same time for everybody."[42] The very presumption of universalism, which characterized the first manifestation of abstract painting, would lead to the devaluation of abstraction in its later stages, as Saul Ostrow has observed. "The fact is that the critical discourse of modernism has been significantly affected by the '70s critiques that focused on its masculine and Western European disposition. It was this dismantling of the notion that these biases constituted a 'universalism' which resulted in the demotion of its prized product: abstract painting. The effect on the critical criteria upon which abstract painting was premised led to its dominant practices decaying."[43] Along with abstraction and universalism, formalism was concurrently discredited as a critical practice. In its place there developed, in Foster's words, "a desire to think in terms sensitive to difference (of others without opposition, of heterogeneity without hierarchy); a skepticism regarding autonomous 'spheres' of culture or separate 'fields' of experts; an imperative to go beyond formal filiations (of text to text) to trace social affiliations (the institutional 'density' of the text in the world)."[44]

One of formalism's justifications for ignoring worldly references in works of art was the essentialist nature of modern art. Most forcefully articulated by Greenberg ("The essence of Modernism lies, as I see it, in the use of characteristic methods of a discipline to criticize the discipline itself"),[45] essentialism has its roots in eighteenth-century discussions of the differences between the arts of sculpture, painting, and poetry by Johann Wincklemann and Gotthold Lessing, discussions which were formally codified by Hegel.[46] Although ultimately appealing to mind, according to Hegel, the individual arts address themselves to the senses to the extent that they may be classified into the visual, sonoral, and speaking arts.[47] As a teleological development of each art toward its essence, essentialism also entails reduction. In abstract painting this meant the elimination of literary or narrative subject matter or effects as well as the representation of objects.[48] "In the case of each of the universal art forms we have examined, there came a time," writes Hegel, "when art had fully revealed the essential content of the dominant world view of the age, when it had said all that it had in mind to say."[49] Taking his cue from Hegel, Arthur Danto claims that we have arrived at the end of art, "a somewhat dramatic way of declaring that the great master narratives which first defined traditional art, and then modernist art, have not only come to an end, but that contemporary art no longer allows itself to be represented by master narratives at all. Those master narratives inevitably excluded certain artistic traditions and practices 'outside the pale of history' – a phrase of Hegel's to which I more than once have recourse."[50]

Formalist art history and criticism were also deeply dependent upon Hegel's philosophy of art and its evolution. Wölfflin's concepts of style and the independence of art from culture were derived from Hegel and shaped by his mentor Jacob Burckhardt's belief that "as a whole the connection of art with general culture is only to be understood loosely and lightly. Art has its own life and history."[51] More directly influenced by Wölfflin than Hegel, Greenberg's essentialist art history is equally compatible with the latter's. "A fundamentally Hegelian conception of art history, in which styles are described as succeeding one another in accord with an internal dynamic or dialectic, rather than in response to social, economic, and political developments in society at large" defines Fried's method as well.[52] The critic's task, Fried explains, is to recognize "particular formal problems" grappled with or that "demand to be grappled with" by modernist painters. Fried analyzes the development of art in terms of "problem, solution, advance, logic, validity," an analysis that is highly reminiscent of the Hegelian dialectic, propelled by synthesis and rooted in logic.[53] Hegel's dialectic, through which history unfolds, is realized by, on the one hand, a "complete formalism of the method, that is, its independence from any concrete fact; and, on the other hand, its complete immersion in the concrete factuality of the world."[54] Just as history develops toward freedom, art develops toward perfection in Hegel's scheme. It progresses from the most material (architecture) to the least material (poetry) and advances through symbolic, classical, and romantic stages. Each stage is characterized by a dialectic relationship of spirit and sensuous matter, one or the other of which predominates in symbolic (matter) and romantic (spirit) ages. Only in classical art do they achieve a synthetic unity.[55] Although Wölfflin disputed the inevitability of Hegel's dialectic, he believed that the stylistic development from classic to baroque art could be observed in all periods of Western art.[56] Barr identified a comparable situation in postimpressionist painting, describing Paul Cézanne and Georges Seurat as classical and Paul Gauguin and the Fauves as romantic artists.[57] The duality of classical and romantic art was a prevailing assumption of much critical writing until the 1960s.

Barr's definitions of classical abstract art as "intellectual, structural, architectonic [and] geometrical" and romantic art as expressions of "the mystical, the spontaneous and the irrational" were based on the prevailing modernist distinction of geometric and gestural styles.[58] This can be traced to Wölfflin's contrast of linear and painterly styles and lurks in Worringer's concepts of the urge to abstraction, which produced geometric forms such as the Egyptian pyramids, and the urge to empathy, which resulted in the

organic naturalism of the Renaissance. The association of geometry with intellectual anonymity and gesture with emotion and self-expression is exemplified in the paintings and writings of Mondrian and Kandinsky, the former artist convinced of the objectivity and universality of his vision; the latter aspiring to direct expressions of "inner necessity." These stereotypes continued to be employed through the 1950s in critical assessments of action painting and color field painting. By the 1960s, however, they were no longer operable, notwithstanding Greenberg's Wölfflinian juxtaposition of post-painterly abstraction to the painterly abstraction of the 1950s.[59] Due in part to Pollock's development of a formally satisfying – as opposed to purely self-expressive – style of gesture painting, artists themselves lost faith in the incontrovertible dichotomy of geometry and gesture. Critics in the 1980s opened the two terms up to discussion again and in so doing, revealed their status as myth. The use of the grid – the ne plus ultra of geometry – was unveiled by Rosalind Krauss as a device for the projection of autonomy and disinterestedness in modern art, although each instance of it is actually one of representation (of itself and all other grids) and repetition (of the canvas surface on which it is inscribed).[60] Similarly, Benjamin H. D. Buchloh leveled a pointed critique of gesture at neoexpressionist painting in the 1980s. "Exalted brushwork and heavy impasto paint application, high contrast colors and dark contours are still perceived as 'painterly' and 'expressive' twenty years after Stella's, Ryman's, and Richter's works demonstrated that the painted sign is not transparent, but is a coded structure which cannot be an unmediated 'expression.' Through its repetition the physiognomy of this painterly gesture so 'full of spontaneity' becomes, in any case, an empty mechanics."[61] It is simply mistaken to assume that Marden's recent gestural paintings, for example, are any more expressive than his monochrome panels and diptychs of the 1960s and '70s, which, if anything, are profoundly romantic. Philip Taaffe's geometry cannot be reduced to anonymous intellectual statements any more than David Reed's arabesques can be reduced to emotive expressions. These oppositions, like that of abstraction and representation, are no longer useful methods of discrimination when it comes to contemporary painting.

In 1959, however, Jules Langsner accentuated the difference between romanticism and classicism in his catalogue essay (Chapter 1) for *Four Abstract Classicists* at the Los Angeles County Museum in order to differentiate the work of Karl Benjamin, Lorser Feitelson, Frederick Hammersley, and John McLaughlin from the better-known and dominant movement of abstract expressionism. Casting the abstract expressionists as romantics, Langsner accepts the widely held belief that their paintings are autobiographical

expressions, an assumption popularized by a superficial reading of Harold Rosenberg's "The American Action Painters."[62] A classicist is not "a narcissist in paint," nor does he have anything in common with the sterile tradition-alism of academic classicism, although the artists share with the traditions of ancient Greece, Nicolas Poussin, and Jacques-Louis David interests in clarity of form, unity, and order, while in Mondrian and Malevich they find precedents for the inscription of flat forms arranged in dynamic com-positions. The abstract classicists themselves, however, were not especially interested in style or composition and their works bear little relationship to those of classical Greece or the Renaissance. In fact, as John Coplans observed, Langsner's emphasis on the enduring principles of Wölfflinian classicism obscures the fact that this work is as "mysterious, ambiguous and subjective" as abstract expressionism.[63]

The origin of Langsner's terminology and the exhibition associated with it have been the subject of debate for decades. Curator Peter Selz claimed to have originated it for his gallery at Pomona College in Claremont, California, and suggested its title, before he relocated from Southern California to a position at the Museum of Modern Art in New York. Langsner, however, had already conceived of an exhibition of these four artists and was seeking a suitable venue when the director of the Los Angeles County Mu-seum arranged for it to be shown in San Francisco and Los Angeles.[64] The designation of abstract classicism was probably coined by Karl Benjamin in 1957 or 1958, and was commonly used at the time to refer to the work of the artists in question. Peter Plagens identifies an even earlier origin: a catalogue essay by James Byrne, then director of the Los Angeles museum, which clas-sified the paintings in a 1951 exhibition, for which Langsner was one of the jurors, as representational, near-abstract, and purely abstract. Within each of these categories were representatives of expressionistic, romantic, and classicist tendencies. Abstract classicism, Plagens contends, was the result of "simple cross-filing."[65]

The significance of Langsner's essay is beyond the quibbling over the genesis of the exhibition, its title, and its attempts to link contemporary painting to an ancient set of ideas. As Alloway observed, abstract painting of the '60s can be traced in part to the abstract classicists of 1959 without resorting to the commonality of classical absolutes.[66] Most '60s criticism also dispensed with Langsner's analogy to science, which was specific to defenses of abstraction in the 1950s. The most durable contribution of Langsner's essay is his invention of the term "hard-edged painting," on which Alloway's new title for the exhibition, *West Coast Hard-Edge*, was based when it traveled to London in 1960. Langsner had been dissuaded from calling his

exhibition "hard-edge" in the first place and subsequently titled its sequel *California Hard-Edge Painting* in 1964. Hard-edge painting, by definition, not only utilizes sharply delineated forms but relinquishes the illusion of space. Alloway refined the concept in his essay for *Systemic Painting* by distinguishing earlier geometric art from hard-edge painting, in which "the whole picture becomes the unit.... The result of this sparseness is that the spatial effect of figures on a field is avoided."[67] As such, the term was developed to apply to the paintings of Stella, Noland, Paul Feeley, David Novros, and Larry Poons, among others. Leaving behind the subtleties of its original references it now took on a decidedly "nonmetaphysical" meaning wholly unrelated, as Susan C. Larsen has remarked, to paintings such as McLaughlin's.[68]

Langsner's essay is one of the first in-depth analyses of abstract painting that is not framed as an apology. Most comparable essays written in the '50s and earlier structure their defense by juxtaposing abstraction to representational art, outlining the former's novel possibilities and its identification as the truly modern style. For Langsner, "The relative merits of figurative and nonfigurative art are not at issue here." His goal is to forge a cyclical continuity with the art of the past and thus naturalize the efforts of contemporary artists as a basis for the peaceful acquiescence to the convention of abstraction in the 1960s.

Greenberg still found it necessary in 1954 to defend abstract art from charges that it was less significant than representational art. He did so by maintaining that abstraction was a continuous development from representation; the difference was primarily a matter of space rather than the absence of recognizable images, since abstract paintings do not depict the kind of space occupied by our bodies and other things in the world.[69] In Greenberg's scheme, abstract paintings are not abstract in principle but result from the suppression of illusionistic space through the elimination of representational objects. In other words, it was the rejection of traditional space in the name of progressive flatness that drove painters to abstraction.[70] "Homeless representation," Greenberg's term for gestural abstract painting that utilized modeling and three-dimensional illusionism, accounts for the majority of abstract painting in the 1950s, including Willem de Kooning's, Philip Guston's, and Richard Diebenkorn's,[71] which can be seen as the very antithesis of flat, hard-edge painting. In the following decade, as Philip Leider points out, Stella made flat paintings "because he was crucially interested in making abstract pictures."

Abstract painting has always been haunted by the illusion of space, which, when present, does not exist – nor is it described – apart from

the experience of it. Early twentieth-century critics considered it an indispensable component of painting since "it is doubtful whether a purely flat surface, without suggestion of significant volume can arouse any profound emotion," according to Roger Fry.[72] While formalists believed that subject matter was irrelevant to appreciation, space never could be, as Clive Bell explained. "To appreciate a work of art we need bring with us nothing but a sense of form and color and a knowledge of three-dimensional space. That bit of knowledge, I admit, is essential to the appreciation of many great works, since many of the most moving forms ever created are in three dimensions. . . . Pictures which would be insignificant if we saw them as flat patterns are profoundly moving because, in fact, we see them as related planes. If the representation of three-dimensional space is to be called 'representation,' then I agree that there is one kind of representation which is not irrelevant."[73] Bell's remarks are echoed in Wollheim's observation that most abstract paintings involve an awareness of depth and are therefore not fully abstract.[74] Similarly, Worringer identified the source of pre-Renaissance abstraction in the "dread of space,"[75] reinforcing Greenberg's thesis that abstraction is the result of the elimination of illusionistic space. According to Greenberg, modernist painting converts illusionistic space into optical space "that can be traveled through, literally or figuratively, only with the eye."[76] Particularly relevant to Pollock's paintings in which webs of color float in an indeterminate but not believable space, Greenberg's notion of opticality forms the basis for Fried's analysis of abstract painting in the 1960s. His brilliant analysis of Pollock's liberation of line from the obligation to figuration is one of Fried's greatest contributions.[77] In the process of pulverizing figure/ground relationships, according to Fried, the raw canvas's function as ground is also done away with so that it is read as if it were not there. Ignoring the material presence of the streaks and pools of paint and the overall effect of scale on the viewer's body, Fried claims that Pollock's paintings appeal to "eyesight alone."[78] Both Greenberg and Fried have been criticized for their emphasis on opticality, which implies that the viewer is "floating in front of the work as pure optical ray."[79] Optical space is comparable to a transparent flatness, in which the picture plane is closed off only to tactile imagination. The space in this case, as Sheldon Nodelman would say (Chapter 6), is still "virtual."

Coincident with the transition into actual space is the acceptance of the idea of a painting as an object, achieved not through abstraction but through representation, specifically in the work of Jasper Johns. As Greenberg assessed it, Johns's flag paintings were the result of a process of dialectical conversion in which their total flatness (i.e., abstractness) suddenly brought

them to representation,[80] demonstrating the impossibility of complete two-dimensionality. As soon as they approach it, through the use of wholly two-dimensional imagery, such as flags, targets, or maps, they are converted into objects. Although Greenberg will not recognize it, this development has bodily as opposed to merely optical ramifications. For Steinberg, "these pictures no longer simulate vertical fields, but opaque flatbed horizontals. They no more depend on a head-to-toe correspondence with human posture than a newspaper does."[81] In contrast, Newman's paintings such as *Onement I* (1948) echo the upright and symmetrical orientation of the human body. "For what is the perception of bilateral symmetry, indeed," writes Yve-Alain Bois on Newman's work, "if it is not, as Maurice Merleau-Ponty has remarked, that which constitutes the perceiving subject as an erect human being, if it is not what solidifies for us the immediate equivalence between the awareness of our own body and the always-already-given orientation of the field of perception."[82]

In the manner that Hegel's work formed the basis for historical abstraction and formal criticism, Merleau-Ponty contributed more than any modern philosopher to theories of abstract painting in the 1960s and '70s. Dismissing the Hegelian "Spirit of the World" as an explanation of expressive style, Merleau-Ponty regrounds the idea of art's development in experience.[83] For Merleau-Ponty, all experience occurs in and through the perceiving body: "It is the expressive operation of the body, begun by the smallest perception, which is amplified into painting and art." The most significant aspect of Merleau-Ponty's phenomenology is its corporeal engagement with the perceptible world. Even abstract painting, he maintains, reflects an encounter with the world, the result of which may be an expression of "the allusive logic of the perceived world" in terms of refusal or negation. Since art is not a matter of copying, abstraction is not opposed to representation in Merleau-Ponty's aesthetics; both spring from the same desire to signify and say something.[84] Expression is not performed in isolation but represents the linkage of oneself and others, a linkage or synthesis that Merleau-Ponty identifies in terms of the Hegelian dialectic, but it is a dialectic now stripped of its transcendental implications.[85] Based on the fact that all experience, including the experience of works of art, is embodied experience, Merleau-Ponty offers an alternative to the distinction of the arts through their appeal to particular senses. One does not simply see with the eyes or hear with the ears but engages in a synthetic communion with the perceived object.[86] As Nodelman observes in his conclusion to "Painting in the Age of Actuality," the distinction of the arts based on a distinction of the senses was derived from

Hegel, articulated by Alois Riegl, and perpetuated by Greenberg's insistence on flatness as the essence of painting. Such a distinction is an obstacle to the experience of works of art "addressed to an integral consciousness as an act of meaning," but an obstacle that is overcome by acknowledging the synthetic nature of perception. Analyzed through categorization and opposition, historical abstract painting was finally reduced to pure opticality. The philosophical shift reflected in the writings of Merleau-Ponty mirrors the shift in abstract painting from its historical phase to its more recent one, in which abstraction is recognized as tactile, synthetic, and embodied in its appeal to the viewer.

TWO

Frank Stella's black paintings of 1959 introduce the second, late-modern phase of abstraction. While historical abstract painting was consistently contrasted to representational art, painters and their critics in the 1960s found it unnecessary to apologize for the departure from representation. As Stella explained, "I do not experience any special anxiety because I am trying to make abstract painting. I do not have a secret desire to put Donald Duck or naked women in my paintings, although I know they harbor a secret desire to be there."[87] By contrast, Reinhardt's manic prohibition of imagery ("no fooling-the-eye, no window-hole-in-the-wall, no illusions, no representations, no associations, no distortions...") and the rumor of Pollock's refutation of the purely abstract status of his classic 1947–50 drip paintings by unveiling the imagery in the 1951 figurative works sound suspiciously defensive.[88] Pollock's and de Kooning's paintings, according to Stella, were still "subjected to threats from the representational painting of the past," while "access to abstraction to anyone born after 1936 [the year of Stella's birth] is direct and unencumbered."[89] For Stella's generation, abstract painting was already a language and a tradition conscientiously inherited with the desire to say something that had not been said in the same way before. A key distinction lies in the fact that "meaning is conceived as external, not expressive of an 'inner self,'" notes Foster on Stella's significance for postmodernism.[90] As he explains in "Signs Taken for Wonders" (Chapter 8), the treatment of abstract painting as a readymade and the loss of faith in originality in the 1980s complete the process of reification. Stella's crucial role is also acknowledged by Douglas Crimp, who sees in Stella's earliest works "the end of painting" based on the fact that they convinced many artists in the 1960s of the futility of painting and led them to the

production of three-dimensional objects, photographs, installations, and videos. This is the evolution of the literalist option offered first by Pollock and subsequently by Stella that Philip Leider identifies in "Literalism and Abstraction" (Chapter 2). Concurrently, Greenberg's formalism, which was unsympathetic to Stella's paintings, also began to falter. Although Michael Fried had already moved away from Greenberg's insistence on opticality and reduction by the late 1960s, Benjamin Buchloh attributed Fried's retirement from contemporary criticism to the incompatibility of Greenberg's legacy and Stella's paintings.[91] Rather than bringing abstract painting (or abstraction or painting) to a close, Stella signaled a redefining rupture, after which it was simply impossible to make paintings with the formal or transcendental implications of Kandinsky's or Mondrian's. "They are *only* what they are," Mel Bochner observed of Stella's work, "which is a canvas of certain dimensions with some paint applied to it in parallel equiwidth and equidistant stripes which repeat to a logical conclusion the edge of the retaining shape. They are finite in their properties and not abstractions."[92]

Unlike abstract painters of the past, who were traditionally educated with a rigorous foundation in drawing, Stella could not draw.[93] The early paintings of Kandinsky and Mondrian (who was officially licensed to teach drawing in Dutch primary schools) reflect their facility as draftsmen. Pollock and de Kooning, Stella's immediate predecessors, relied heavily on drawing even in their most abstract work, although drawing was still primarily identified as a representational activity in the 1950s. Stella's confession to William Rubin that he "wasn't very good at making things come out representationally and [he] didn't want to put the kind of effort that it seemed to take into it," led Rubin to observe that "Stella is one of the first major painters in the modern tradition to have been formed virtually entirely through the practice of abstract art."[94]

Begun the year Stella graduated from Princeton University with a degree in history supplemented by courses in art, the black paintings are characterized by a willful suppression of expression or emotion. Rather than reflecting either the feelings of their maker or any commitment to idealist principles, they appear as concrete things-in-themselves. Although Stella believed that the devices of unusually thick stretcher bars and the elimination of illusionistic space made them *less* object-like, the reaction to these paintings was just the opposite and they influenced not only minimalist work in three dimensions but also the direction of painting – flat, monochromatic, and shaped – in the 1960s. "It is why every move he makes," Leider remarks, "is followed with such intense interest by other artists. . . . It is the source of his direct relevance to almost all the serious art that is being made today."

Nodelman credits Stella's paintings with initiating a "crisis" in painting that led to the acknowledgment of it as an "activity of painting in real space" by revealing "the picture as an object." Contributing to this was the use of symmetrical compositions that did not rely on traditional balance. Robert Coates's evocation of Mondrian in an early review of the black paintings (often cited by Stella as flattering but erroneous) overlooks Mondrian's use of relational composition based on opposition.[95] Derived from Pollock's equalization of compositional elements, Stella's composition affects the space in front of the painting by displacing relationships from within to without, to the space between the painting and the viewer.[96]

When works from a series such as the black paintings are displayed together, as John Coplans points out, the exhibition space and the intervals between the paintings are implicated: "The dialogue of Seriality is taking place in public; it is a gallery and not a studio art." This may indeed signify a shift from private to public forms of contemplation; however, as Donald Kuspit remarks elsewhere, "The gallery is conventionally understood as no more than a stand-in for the studio which incorporates the spectator, who is regarded as an extension of the artist and whose criticality is regarded as no more than a submissive objectification of the artist's intention. The spectator is thus no longer a threat, no longer truly critical – no longer a representative of the historical world outside the studio." It is the refusal of the "lifeworld" in the name of the "studio world" that Kuspit objects to in much abstract painting and formal criticism. Fried's insistence on the ethical nature of abstract painting represents, according to Kuspit, an attempt to claim moral authority for an art that, based on its alienation from the "lifeworld," cannot achieve it.[97]

Fried's case for the moral integrity of modernist painting is derived from its fecundity ("the ultimate criterion of the legitimacy of a putative advance in modernist painting is its fecundity"), a concept extrapolated from Merleau-Ponty's remarks on Hegel that locate the meaning of an ethical action in its fecundity for the future rather than in its efficiency in the present.[98] Transposed to a principle of art history participated in by paintings that offer potential for future works of art (such that Helen Frankenthaler's and Morris Louis's paintings illuminate the significances of abstract expressionism), fecundity brings with it moral implications from Hegel's formulation. As a form of radical self-criticism, the dialectical development of modernist painting also underlies its morality in that it is "founded upon as objective an understanding of one's present situation as one is able to achieve."[99] Fried, however, strays from Hegel as well as Greenberg in his rejection of the teleological implications of the

dialectic, which for Hegel and Greenberg are manifested in the form of reduction.[100]

Anthony Caro, Jules Olitski, Kenneth Noland, and Morris Louis were frequent subjects of Fried's criticism in the 1960s, but it was the work of his friend Stella that stimulated his most innovative ideas. The concept of deductive structure, from which he developed the opposition of modernist painting to literalism (his term for minimal art), first appeared in Fried's earliest writings on Stella.[101] Essentially, deductive structure is a compositional tactic that derives the internal configuration ("depicted shape") from the shape of the support ("literal shape"), and is a result of the dissolution of flatness into modernist painting's opticality in which tactility is displaced to the framing edge. Fried identifies the origin of deductive structure in Newman's vertical stripes or "zips," which echo the sides of the canvas, but it is most convincingly argued as a rationale for Stella's stripe paintings, especially the aluminum and copper series in which the painted bands follow the notched or right-angular shapes of the canvases.[102] After 1965, the relevance of literal shape, which remained compatible with the illusion of opticality, became even more emphatic in Fried's criticism. The conflict that other artists saw between literalism and illusionism, however, led them to a misguided allegiance to the purely literal (they were mistaken, in other words, about what was fecund in Stella's painting), according to Fried.[103] Shape as he saw it in Stella's work belonged to painting, whereas shape as it was used by the literalists was merely a property of objects. This is the basis for the critique of minimal art in his 1967 essay, "Art and Objecthood," in which literalism is seen to entail the non-art status of objects and the impurities of theatricality, with its emphatic (stage) presence and dependence on the spectator.[104] Despite its overall negative assessment, "Art and Objecthood" is widely accepted as the classic analysis of minimal art in the 1960s.

In his lengthy review of Stella's first retrospective exhibition organized by William Rubin for the Museum of Modern Art, Leider accepts Fried's terms without taking sides. Claiming that he does not use the word literalism as Fried does, that is to say, ignoring the theatrical and non-art consequences Fried deduces, Leider nevertheless acknowledges the impact of the "literal objectness" of Stella's paintings on Donald Judd and Carl Andre, in particular. Not only was the widespread move into three dimensions inspired by Stella's black, aluminum, and copper paintings, the repetitive pattern of stripes was a model of nonrelational composition. Judd's stacks of ten identical boxes attached to the wall and Andre's grids of square metal plates laid out on the floor reject the heretofore necessary conditions of

sculpture: anthropomorphism and balance. The antithesis of Leider's literalism is not modernist painting, which Fried assessed as "work [that] can stand comparison with the painting of the past whose quality is not in doubt,"[105] but abstraction. In contrast to Fried, Leider sees not only abstraction, or modernist painting, issuing from Pollock's work, but literalism – "he treated the picture as a thing" – as well.

Defenders of formalist-modernist painting found the literalist option intolerable. "Objectness was the thing to beat," or in Fried's words, it was "imperative that [modernist painting] defeat or suspend its own objecthood."[106] Minimal art, derived from the literalist attitude, was widely thought to have been based on a "misunderstanding" of the implications of Stella's paintings. Fried, Rubin, and Stella himself perpetuated this condescension, but Leider suggests that it was the art resulting from the (mis)understanding rather than the misunderstanding itself that Stella found problematic. As Leider explains, it is as if Stella could support the work of Noland and Caro but not, to the same extent, that of his friends Judd and Andre. The issue boils down to the questionable object-status of Stella's paintings, about which the artist made apparently contradictory statements in a single interview. "My painting is based on the fact that only what can be seen there *is* there," he said. "It really is an object. Any painting is an object and anyone who gets involved enough in this finally has to face up to the objectness of whatever it is that he's doing. He is making a thing." The deep stretcher bars, however, give his painting "just enough depth to hold it off the wall; you're conscious of this sort of shadow, just enough depth to emphasize the surface. In other words, it makes it more like a painting and less like an object, by stressing the surface."[107] Here, in fact, are the justifications for the literalist and abstract painting options that bifurcated the art of the 1960s. Alternative supports, such as Ryman's use of wax paper or Ed Moses's resin paintings of the early 1970s, and unstretched canvases, including Richard Tuttle's dyed cloths and works by the French Support-Surface group, were bids to emphasize the planar (i.e., abstract and nonillusionistic) rather than literalist potential of subsequent abstract painting.

In Stella's irregular polygon paintings of 1966, Leider identifies an important shift in the artist's concerns. Color, which was suppressed in Stella's previous work until it was *"needed,"* plays a definitive role in paintings that return to investigations of figure/ground and illusion while maintaining a tentative relationship to deductive structure. Working through these issues in the protractor paintings, Stella arrived at a "monumental decorative muralism," according to Leider. Not only is this a prophetic observation in light of Stella's work of the 1980s and '90s, particularly his colorful, large-scale

mural projects, it brings up an issue that had been avoided by most critics since Greenberg obliquely acknowledged the decorative potential of Henri Matisse's paintings by referring to them as "luxury paintings."[108] To suggest that part of Pollock's contribution was to decorativeness, the implicit fate of all bad to mediocre abstract painting, was simply unheard of in the 1960s and '70s.[109] Such a proposition, along with the wallpaper argument, which was typical of Pollock's early detractors, suggests a provocative reevaluation of the meaning of abstraction.

Leider's essay tracks the relationships between the various series of works produced by Stella since 1959. In "Serial Imagery" (Chapter 3), Coplans is interested in what he calls the serial macro-structure, the relationships between paintings in a single series. The micro-structure, or syntax, refers to the relationship of elements within an individual work. Coplans's examples using the number one and a comma (e.g., "1,1,1, 1,1, 1,1, 1, 1,1, . . .") demonstrate that while micro-structures may vary (and inevitably do vary in serial painting), the macro-structure remains consistent. Inverting Fried's notion of the deductive structure of Stella's individual paintings, Coplans writes that "in his second [aluminum] Series, as a final necessity brought about by the logic of the internal configuration, [he] began to notch out the shapes of his canvas; this idea was made possible by the reciprocity of the parts to the macro-structure, which in its topology lies outside the boundaries, or apart from the boundaries, of the framing edge." As such, the macro-structure links the works in the series and implicates the space of the gallery through the intervals between the paintings. Given the significance of the macro-structure, the "masterpiece concept" is abandoned. One suspects there are multiple factors besides seriality at work in such a revolutionary development in art history, and yet individual paintings in a series rarely rise above others in our estimation since the series as a whole, that is, the topology, is crucial to the meaning of the paintings. Most observers agree, for example, that Stella's series of black paintings comprises his best work without agreeing on the relative value, or even if there is one, of the individual canvases.

Written to accompany an exhibition at the Pasadena Art Museum in 1968, Coplans's essay is the most extensive analysis of seriality, a pervasive structural model for abstract painting of the '60s and beyond.[110] Although he was later to identify an 1860 set of photographs of Yosemite by Carleton Watkins as the first to use serial structure,[111] Coplans begins here with the paintings of Claude Monet, tracing parallel developments in mathematics, literature, and music. A central role is awarded to Josef Albers, who has yet to receive the recognition Coplans believes he deserves. Newman (whose work is not strictly serial) and Reinhardt, succeeded by Louis,

Noland, and Stella, were also instrumental in establishing seriality as a structure for the production of paintings in the 1960s. More than three decades since the original publication of Coplans's essay, serial structure remains viable, not only in the recent work of Stella, Marden, and Ryman, but for artists such as Peter Halley, Ross Bleckner, and California painter John M. Miller, who has utilized a structure of diagonal black or colored bars on raw canvas for more than twenty years. According to John Rajchman, seriality offers an alternative to the Platonic notion of abstraction as a form of generalization from particulars, which is characteristic of historical abstract painting.[112] The antihierarchical and nonlinear "lack of extension or progression," identified by Coplans, typifies the series used by contemporary abstract artists.

Reinhardt was a pivotal figure in the use of serial structure. His prescription, "The one work for a fine artist, the one painting, is the painting of the one-size canvas – the single scheme, one formal device, one color-monochrome," is rigorously serial, as are the five-foot-square black paintings he produced from 1960 to 1966.[113] Although Reinhardt was nearly a quarter of a century older than Stella, his works exerted little influence (other than, as Lucy Lippard has suggested, on Stella himself) until the mid-1960s, when the prevailing artistic climate established by minimalism was more conducive to an appreciation of his work.[114] By that time, color painting identified with the "formalist academy" – Lippard has in mind here Olitski's "extravaganzas," which she elsewhere describes as "visual Muzak"[115] – had begun to lose its grip on younger artists and critics who appreciated Reinhardt's rigor and "rejective" stance. Nevertheless, Reinhardt remained associated with the abstract expressionist generation, primarily on account of his idealism in the face of minimal art's emphatic materialism.[116] The literal quality of minimal art could never have been inspired by Reinhardt's mystical and elitist program. The museum, real or imaginary, which Daniel Buren calls a "vault" and Crimp defines as "that idealist space that is art with a capital A" in "The End of Painting" (Chapter 7), was for Reinhardt "a treasure house and tomb, not a counting house or amusement center." "This is the whole point of André Malraux's imaginary museum, the museum without walls. You have twenty-five thousand years of art and it's art and not anything else."[117] Reinhardt was also one of the last to pursue the polarity of classicism and romanticism, opting for the classical, which he identified as Apollonian, abstract, and universal, rather than the romantic and expressionistic.[118] The rejection of romanticism, according to Grégoire Müller, is based on Reinhardt's elimination of all concerns with space ("romantico-sentimental space") and life ("romantic psychological connotation") from his work.

Despite the fact that she identified herself as a romantic,[119] Lippard was drawn to Reinhardt's work because of her interest in "rejective art," a term she preferred to the negative-sounding concept of reduction.[120] As Greenberg had with his own analysis of reduction, she purports to be describing – rather than prescribing – the direction she observed in contemporary art that will eventually lead to the "dematerialization of art" in conceptualism.[121] Monochromatic painting, Lippard observes in Chapter 4, is one of the few remaining avenues open to rejective art in spite of the immanent conclusion with which it threatens itself. Within monochromatic painting, three directions are distinguished: the formalism of Reinhardt, Ryman, and Marden; the Dada-inspired emptiness of Robert Rauschenberg and Yves Klein; and shaped canvases that push toward sculptural issues in which the painting becomes a figure on the ground of the wall. It is the latter potential that Reinhardt's paintings avoid, according to Müller, by retaining a faint geometric composition that serves to keep the eye within the limits of the canvas. Pure monochrome, he insists, cannot prohibit the eye from gravitating to the edge of the painting (its literal shape) and proscribing it as an object. The margin of raw canvas marked by accumulated drips retained in Marden's paintings of the 1960s produces a similar effect by halting perception just prior to the edge. In "Marden, Novros, Rothko: Painting in the Age of Actuality" (Chapter 6), Nodelman also credits the margin with revealing the painting-nature of Marden's work since it causes the painted surface to appear like a sheet drawn over an object rather than identical with it.

Monochromatic painting elicits many questions about perception. Notoriously difficult to see because of the density of the dark pigment, Reinhardt's black paintings led Lippard to speculate that "the public eye is becoming more accustomed to forced contemplation" and that indeed "our perceptual faculties" have improved to the point that we actually see better than previous generations, since contemporary audiences, based on past experiences, are more attentive and optically discriminating than early ones. Issues of perception and the subject of light in Reinhardt's paintings lead both Lippard and Müller to Robert Irwin, rare acknowledgments of a West Coast contribution to the East Coast–centered dialogue of abstraction. Irwin's involvement with illusion, however, would henceforth exclude him from discussions of the materialistic direction of abstract painting. His convex dot paintings and illuminated disks of the 1960s create what Nodelman would call a "virtual" world, "seduc[ing] the viewer into the imaginative experience of objects, spaces, and qualities." Ryman, on the other hand, is acknowledged by Lippard and Müller for his achievement of totally flat surfaces, plain paintings that are neither objects nor illusions. Provoking

conflicting conclusions, the limitations of monochrome abstraction reveal either an extraordinary variety of possibilities to Lippard or the end of painting to Müller. Daniel Buren's role in the latter scenario was not inconsequential, as Crimp's 1981 "The End of Painting" (Chapter 7) also makes clear.

Despite their concerns with perception, neither Lippard nor Müller make reference to op art, another then-popular style of abstract painting. Although reviled by critics who found it disturbing to the point of causing nausea, optical art was the subject of a major exhibition, *The Responsive Eye*, at the Museum of Modern Art in 1965.[122] Curator William Seitz framed his exhibition of "perceptual abstraction" in scientific rather than Greenbergian terms, and included the work of Albers, Louis, Noland, Stella, Reinhardt, the four California abstract classicists, and many others from the United States, Europe, and South America.[123] The critical case against op art was based on the limitations of "pseudo-scientism," and its lack of substance and meaning. To differentiate the "ambiguity" of intellectually challenging abstraction from the "absurdity" of optical art, Lippard's critique of the movement offered a quote from Igor Stravinsky: "The notion of ambiguity must not be confused with that of absurdity. To declare that existence is absurd is to deny that it can ever be given a meaning; to say that it is ambiguous is to assert that its meaning is never fixed, that it must be constantly won."[124] Since meaning was a touchy subject in the 1960s, when many artists countered any interpretations of their works with statements such as Stella's "What you see is what you see,"[125] most critics found other reasons to reject op art. Op was revived in the 1980s, however, as Foster points out in "Signs Taken for Wonders" (Chapter 8), precisely because of its meaning, its deadened sensibility, and its lack of substance. Identifying a new content in op art, Halley equates its scientistic positivism with the Hula-Hoop, Cadillac tailfins, and Tang.[126]

As formalism gave way to (or was enhanced by) structuralism in the 1970s, critics began to make the case for abstraction's meaningfulness. In the 1960s, Nodelman had written of the inadequacies of theories that were concerned solely with the effects of art on the beholder, without a structural description of the work of art, which "consists in the full texture of all its relationships with the environment."[127] "Painting in the Age of Actuality" thus considers not only the spectator's interaction with the work, but the space in which that interaction takes place and the structural and contextual properties of the painting that inspires it. The shift he identifies in contemporary abstract painting is spatial: from painting in virtual space to painting in actual space. The concept of virtuality, which defines all images as virtual objects given to

vision, in contrast to tangible and practical actualities, is Susanne Langer's. "The space in which we live and act is not what is treated in art at all. The harmoniously organized space in a picture is not experiential space, known by sight and touch, by free motion and restraint, far and near sounds, voices lost or re-echoed. It is an entirely visual affair; for touch and hearing and muscular action it does not exist. . . . Like the space 'behind' the surface of a mirror, it is what the physicists call 'virtual space' – an intangible image. This virtual space is the primary illusion of all plastic art. Every element of design, every use of color and semblance of shape, serves to produce and support and develop the picture space that exists for vision alone."[128] As Nodelman sees it, all painting-space in works of art created since the Renaissance and until the time of Stella is virtual; presumably, this includes the optical space identified by Greenberg and Fried. Dispensing with the impossible simultaneity of pictorial forms sharing the same transcendent space and time, Marden, Novros, and Stella broach the actuality of real space. Nodelman's thesis is in direct conflict with Fried's, which claims that literal shape as it is used in Stella's paintings belongs to painting and as such is purely visual. For Nodelman, the structure of the painting thrusts itself outward, rather than inward as composition, into the space of the spectator, involving his or her body as distinct from the particular sense of vision. Asserting that "no sense exists in isolation," he identifies the nexus of sensory and cognitive faculties with the perceiving body. Understanding is thus linked to corporeal awareness, recalling Merleau-Ponty's comparison of binocular vision to the synthetic nature of perception. "It is not the epistemological subject who brings about the synthesis, but the body, when it escapes from dispersion, pulls itself together and tends by all means in its power towards one single goal of its activity, and when one single intention is formed in it through the phenomenon of synergy," writes Merleau-Ponty. "What is meant by saying that this intentionality is not a thought is that it does not come into being through the transparency of any consciousness, but takes for granted all the latent knowledge of itself that my body possesses." Moving from pure sensation to the *cogito*, Merleau-Ponty continues: "Now we may understand 'thought about seeing' as the consciousness we have of our constituting power. Whatever be the case with our empirical perceptions, which may be true or false, these perceptions are possible only if they are inhabited by a mind able to recognize, identify and sustain before us their intentional object."[129]

Nodelman's essay was written on the occasion of an exhibition at Rice University commemorating the Rothko chapel, which had been dedicated in 1971 at the University of St. Thomas in Houston. With parallel concerns

for site-specific painting, works by Marden and Novros were accompanied by four of Rothko's "alternate" paintings, excised by the artist from the chapel cycle. Novros's subtly sprayed shaped panels, which raised sculptural issues to critics such as Lippard, had given way in the '70s to a rectangular multi-paneled format. His paintings for the Houston exhibition were produced on large stretched canvases, which were installed in three contiguous rooms. As the visitor moved through the rooms from left to right, a subtle chromatic transition – from the first deep, cool hues through grisaille in the central room to fully intense color on the final wall – was apparent. The Houston cycle is related to Novros's continuing interest in fresco as a way of exploring the interrelationship of painting and architecture. Inspired by early Renaissance frescoes, Novros's "painting-in-place" emphatically avoids the so-called literalist option, although the activation of space in the Houston rooms led Nodelman to misleadingly identify them as environmental sculptures. Implicating the body's presence, Marden's *Seasons* also create a space for the spectator. Nodelman's essay maintains that the opaque surfaces and lower margins of drips in the original *Seasons* panels – before they were repainted without the margin – solicit from the observer an impossible entry through the margin into the virtual space of the canvas (even the *conception* of this possibility requires an immense leap of imagination!) and echo the corporeal presence of the spectator standing before them. With a front and a back himself, says Nodelman, the viewer must acknowledge the back of the painting as well, emphasizing a concern of Marden's figuring not only in his 1966 series known as the "back" paintings, but in the fact that many of his paintings forego the use of spacers between the stretcher bars and canvas, which results in visible impressions made by the bars during the painting process. This is especially evident in the *Seasons* and cues the spectator into the painting's possession of a back, a fact concealed by traditional illusionistic paintings.

Unlike Lippard, Nodelman does not limit his investigation to the surface of monochrome paintings. Such a limitation, combined with attention to perceptual effects, is characteristic of formal criticism and results in the description of monochrome surfaces as empty. Without images and compositional or coloristic relationships, monochrome paintings *are* empty of form and therefore, from a strictly formalist point of view, empty of meaning. The fear of such emptiness drove critics to their obsession with shape, as Joseph Masheck explained: "The latter-day modernist fixation with the framing edge was partly a symptom of desperation and partly an invocation of lasting values. The desperation was evidence of the anxiety that since the pictorial 'contents' of painting had been drained away, all that might

be left was an empty container exhibiting its own physical shape."[130] In Chapter 7, Crimp succinctly articulates this dilemma, which is the result of the viewer's expectations that paintings will simply "render up their meanings about themselves. And since they categorically refuse to do so, since they have, by design, no internal meaning, they simply disappear." Without resorting to the now-discredited appeal to feeling, how could the potential meaninglessness of monochrome painting be defused?

Several important attempts to secure meaning for monochrome painting have been offered. According to Marcia Hafif, meaning results from the activity of painting, which is not a process of self-expression so much as the creation of a visual language; thus the marks or strokes themselves carry meaning.[131] This studio rationale is particularly appealing to monochrome painters like James Hayward, who defines all painting as "mark-making." At the other extreme are critics such as Carter Ratcliff and W. J. T. Mitchell, who propose that the meaning of all abstract painting lies either in its history (Ratcliff) or in the theoretical discourse it provokes (Mitchell).[132] Buchloh is also willing to assign meaning to monochrome painting from the *outside*. Because works by Alexander Rodchenko and Yves Klein are "apparently" identical (Rodchenko's red, yellow, and blue and Klein's gold, pink, and International Klein Blue panels are Buchloh's pertinent examples), "the perception of an immanent meaning" in each is a futile exercise in connoisseurship. Buchloh looks instead for meaning in the works' reception.[133] All three of these positions are compatible with Arthur Danto's long-held belief in the relevance of artistic theory and context, which can illuminate in outwardly similar objects differences unavailable to the eye. With monochrome painting, he writes, "we have to think, however profound the resemblances between works, of their individual histories. We have to explain how they arrived in the world, and learn to read them in terms of the statements each makes and evaluate them in terms of that statement. . . . There could be a museum of monochrome works, . . . a gallery of red squares, each of them profoundly different from its fellows, but all of them looking exactly alike."[134] The problem with these theories is that monochrome paintings do not 'look exactly alike' (as Buchloh's example should make clear), and that by attending to extra-artistic qualities one is failing to really experience the paintings in question. This is why Nodelman's invocation of the spectator's body and especially Merleau-Ponty's evocation of corporeal experience, which can be extrapolated from his remarks on color, are so much more satisfying. "Before becoming an objective spectacle, quality [of color] is revealed by a type of behaviour which is directed toward it in its essence, and this is why my body has no sooner adopted the

attitude of blue than I am vouchsafed a quasi-presence of blue. We must therefore stop wondering how and why red signifies effort or violence, green restfulness and peace; we must rediscover how to live these colors as our body does, that is, as peace or violence in concrete form."[135] Monochrome painting impacts not only through the quality of its color, but through its expanse (scale) and texture (quality of surface) both of which contribute to the singular effect of spatial presence. The meanings of these works are not reducible to a single history or individual histories, but the result of a complicit engagement of viewer and painting.

As many critics have observed, monochrome painting has historically signaled the end of painting.[136] Reinhardt's claim to be making the last paintings anyone could make echoes Malevich's arrival at "the zero of form" in the black square and Rodchenko's declaration of "the end of painting" in the red, yellow, and blue canvases. Analogous to the death of God, the death of painting signals a crisis in belief. It is a strong subtext in Lippard's and Müller's discussions of the monochrome and an outright proclamation in Crimp's essay. From Paul Delaroche in the nineteenth century to Donald Judd in the late twentieth, artists and critics have confronted the issue over and over again only to observe that painting stubbornly perseveres.[137] Each case against it is formulated on different grounds and expresses varying cultural concerns. For the Russian avant-garde, the end of painting was synonymous with the end of representation. Similarly, Delaroche's prediction was based on mimesis, which photography could more easily achieve than painting. At the same time, photography was considered a liberating force for painters, freeing them from the task of representation. Since any definitive connection between painting and mimesis was long ago severed, what threatens painting now is mechanical reproduction, the devaluation of the hand, as Crimp suggests in Chapter 7.

Crimp's assessment of the situation in 1981 is framed as a deconstruction of the myth of painting as essentialist, humanist, and transcendent (qualities that may be attributed to historical abstraction but not, I would argue, to most significant abstract painting since 1959). His targets are the reactionary style of painting included in Barbara Rose's controversial *American Painting: The Eighties* and Stella's recent "extravaganzas." While Rose claimed that her artists offered an alternative to attempts by minimal and conceptual artists to discredit the "institution" (the museum as well as the activity and tradition of painting that it supports), Crimp counters with the critical practices of Buren, which are effective only *within* the institution, critiquing it – literally – from the inside. Posing as painting, Buren's striped cloths are "contingent upon the material, historical world," in contrast to Richard

Hennessey's handmade paintings that are motivated by an ahistorical idealism. This attitude allows Hennessey, in a 1979 essay cited by Crimp, to disengage Diego Velásquez's *Las Meninas* from its context, elevating it to a timeless metaphor. Such a reading was made possible, Crimp asserts, by the institutions of modernism: the museum and art history.

The concept of the death of painting is related to the death of modernism, a modernism defined as progressive and essentialist by Greenberg. Once the essence of painting is arrived at (flatness and the delimitation of flatness), no more progress is possible.[138] Despite their rigorously antimodernist stance, those who proclaim the death of painting, says Danto, have bought into the modernist narrative of progression in which artists such as Ryman represent "the end of the line."[139] Although Crimp is the object of Danto's critique, Crimp's case against painting is not developed in modernist terms with the exception of its *refutation* of painting's essence (which Rose identifies as illusion) on anti-idealist grounds. For Crimp, Ryman is the new Reinhardt, making the last paintings, but unlike Reinhardt's, Ryman's are purely materialist paintings divested of idealism. Tellingly juxtaposed to Hennessey's discovery of spirituality in the bristles of a paintbrush is Ryman's matter-of-fact description of his process. Ryman's mode is not only materialist but repetitive in the sense that he continues to paint white paintings, albeit with different mediums, tints, and supports. Stella comes in for much harsher criticism from Crimp because he has not pursued the implications of the black paintings, but chosen to change directions in his work, oblivious to the fact that progress is no longer possible and "in defiance of the end of painting." The irony of it, says Danto, is that just as Crimp was declaring the end of painting, there was a tremendous revival of painting, primarily in the form of neoexpressionism.[140] The irony was not, however, lost on critics, many of whom based their assaults on painting on its status as a commodity. A lingering Marxism combined with the anti-object asceticism of conceptual art made all painting suspect.

Danto is at pains to distinguish the death of painting from his own proclamation of the end of art. Developing Hegel's contention that "art, considered in its highest vocation, is and remains for us a thing of the past," Danto claims that the narrative of art history came to an end in the 1960s.[141] That is the moment, too, when Hegel appears to have outlasted his usefulness for most art historians and critics, the same moment that the Hegelian contradiction between thought and reality, according to Müller, is resolved in Reinhardt's paintings. As Lippard has written, the black paintings "restored the history of painting to the makers of paintings, slowing down the single line of 'progress' by proving and simultaneously dismissing the progressive

or evolutionary theory of art history. . . . [Reinhardt's paintings] thus made it possible for painters to paint within the tradition of painting, without having to surpass or bypass that tradition."[142] The passionate investment that painters had in painting was nowhere better exemplified than in the multitude of angry responses to an *Artforum* survey conducted in 1975, which proposed that "painting has ceased to be the dominant artistic medium at the moment."[143]

THREE

Despite the prevailing death-of-painting ideology, painters continued to make abstract paintings in the 1970s and '80s. Now, after emerging from the pluralist situation that leveled the modernist mainstream and also focused attention on art produced outside of New York, abstract painting did not follow any path or singlemindedly pursue any direction as it had with the monochrome or shaped canvas in the 1960s. With the important exception of artists identified with neo-geo, there were no theoretical constructs to which these new paintings held. As Barry Schwabsky, one of the primary defenders of '80s abstraction, observed, "The mistake lies in thinking of abstract art as something in particular, when it is interesting only insofar as it is *not* something in particular, but simply a way of manifesting the desire for painting in as naked a way as possible."[144] Statements such as "Suddenly last season, abstract paintings reappeared en masse in New York's galleries" were commonplace,[145] suggesting that abstraction was reified as style, oscillating in and out of fashion, and had lost its cachet as an avant-garde movement.

In the midst of abstraction's complacency, neo-geo coalesced as a well-defined movement with strong theoretical underpinnings. Despite the fact that its adherents included sculptors and painters, both representational and abstract, it was the abstract painting faction on which critics focused their sights.[146] Many of the artists themselves seem to have accepted the death of painting and so preceded to paint, not so much in the face of it as had Stella, Ryman, and Marden, but in despair. This despair led Kuspit to characterize the work as "secretly dead on arrival,"[147] while for Foster its complicity with the market reduced its products to sheer commodities. Neo-geo, in name as well as intent, was a response to neoexpressionism and, as many critics suspected, to its successful market strategy. Following a decade dominated by conceptual art's dematerialized projects, paintings were highly desirable acquisitions; and abstraction offered collectors a cool alternative to the reactionary figuration of neoexpressionism. By appropriating styles and motifs from artists such as Newman, Stella, Noland, and Bridget Riley, neo-geo

paintings were usually interpreted as a form of representational art since they took modernist abstraction as their subject. Despite their geometric compositions, lack of representation, and flat space, this type of abstract painting was intentionally rendered bereft of formalist import and presence by its emphasis on surface and design rather than the handmade mark, coloristic resonance, human scale, or literalist effect.

As a spokesman for his own work and neo-geo in general, Peter Halley insisted on the referential nature of these paintings. Ross Bleckner's appropriation of op art motifs is, for example, "a telling symbol for that terrible failure of positivism that has occurred in the postwar era."[48] Dismissing representation and abstraction as misguided attempts to uncover the real (misguided because reality is no longer recoverable), Halley based his own work on Jean Baudrillard's notion of the simulacrum. "The simulacrum is a place 'where the real is confused with the model'; it is a 'total universe of the norm,' a 'digital space,' a 'luminous field of the code.' In my work," Halley writes, "space is considered as just such a digital field in which are situated 'cells' with simulated stucco texture from which flow irradiated 'conduits.'"[49] Although his paintings are produced with the techniques and formats of earlier geometric art, he considered them to be critical responses to the idealist philosophies of Plato, Descartes, and Mies van der Rohe, an idealism he associates with geometry.[50] His role as artist and interpreter is not without precedent, but where the writings of artists such as Donald Judd and Robert Smithson were accorded legitimacy by critics who frequently relied on them to illuminate crucial objectives driving the work, Halley's expositions were just as frequently used against him to demonstrate that his paintings did not achieve his intentions. In Chapter 8, Foster reveals the inherent contradiction in Halley's attempt to say something meaningful about "cybernetic networks" through a Cartesian grid rendered in the preindustrial craft of painting. Unlike Crimp's Buren, who criticizes painting through the institution of painting itself, Halley cannot properly deconstruct the contemporary social situation in a language that is anterior and foreign to it. Precariously positioned at the cusp of the modern and postmodern, Halley is also subjected to charges of inauthenticity from Kuspit in "The Abstract Self-Object" (Chapter 10). By celebrating "the disappearance of the subject" rather than restoring the self through abstraction, Halley effects a rupture rather than a completion or continuity. Kuspit's argument in this case is as much with Halley as it is with postmodern theorists like Fredric Jameson, who is convinced that "that kind of individualism and personal identity is a thing of the past; that the old individual or individualist subject is 'dead'; and that one might even describe the

concept of the unique individual and the theoretical basis of individualism as ideological."[151]

What would it mean to accept Jameson's position and deny Halley the privilege of determining the meaning of his own work? In reading Michel Foucault's critique into the minimalist project, "even if the conscious intents of its creators were otherwise," and postmodernism into Stella, "when Stella himself articulates such a different set of concerns for his own work,"[152] Halley's own methodology permits us to consider his works as abstract paintings despite his assertion, "I don't think of myself as an abstract artist; rather I describe my paintings as diagrammatic."[153] In a decade dominated by representational art that aimed to expose the manipulative ideologies of media-generated imagery, Halley's interpretation may be merely strategic. As critiques by Foster, Kuspit, and others demonstrate, his paintings are not especially convincing as diagrams. It might be easier to argue for them as abstract paintings. They consist, after all, of frontally oriented planes of artificial colors and textures. Organized by a compelling, centralized geometry, they acknowledge gravity and the verticality of the spectator. Stylistically referencing the work of Stella and Noland, Halley's paintings participate in the dialogue of abstract painting. Their inspiration (what the artist had in mind, according to Greenberg's definition of subject matter)[154] does not necessarily undercut their abstract content. With the exception of Eleanor Heartney, who claimed that "without the artist's theoretical justifications, however, the works appear to be simply rather decorative paintings with a certain kinship to minimalism,"[155] few of Halley's critics can tolerate the potential abstractness of his paintings. Carrier, for example, summarizes the Baudrillardian nature of Halley's paintings: "A Rembrandt refers to what it depicts; a Halley refers only to its exchange value. This is why Baudrillard denies that there can be any abstract art. In the art market, all works are signs, objects that refer to their exchange value."[156] Halley's analogy of the development of abstraction and the progress of capital, "from the precious-metal coin (bearing the likeness of the sovereign), to paper money (bearing the symbols of the state), to the plastic credit card (bearing the logo of the corporation)," supports this interpretation.[157]

The structuralist orientation of Halley's generation, "fixated on rules, that is, on language," has it roots, he not surprisingly claims, in European Marxism.[158] His position seems to be closer to that of the Frankfurt School, which, according to Jeremy Gilbert-Rolfe, "sought to make social-critical method out of Marx," such that "the meaning of the work lives in its usefulness (its use value) as a laying bare of reality," rather than to Baudrillard's "world in which signs refer not (or rather not only) to reality but rather to

one another."[159] As Stephen Melville sees it, Marx forms the theoretical *opposition* to Martin Heidegger, whose philosophy led in part to the phenomenology of Merleau-Ponty and the poststructuralism of Jacques Derrida. In its turn, structuralism is a reading of phenomenology through the Saussurean model of language, while all three movements are evidence of a dissatisfaction with Hegel, according to Melville.[160] Among the complexities of philosophical filiations, one of the few certainties is Foucault's: "Whether through logic or epistemology, whether through Marx or Nietzsche, our entire epoch struggles to disengage itself from Hegel."[161] The evolution of anti-Hegelian French theory of the 1960s and '70s formed the basis for poststructuralist criticism of abstract painting in the 1980s.

The tension between phenomenology and structuralism was already apparent to Fried in the 1960s, based on his reading of Merleau-Ponty's "Indirect Language and the Voices of Silence."[162] In this essay, Merleau-Ponty, philosopher of the body, reflects on Ferdinand de Saussure's linguistics through which Merleau-Ponty constructs a phenomenology of language. Signifying words, like the creative gestures of painting – both always intending to mean something – are not predetermined units derived from a dictionary or language, but expressive operations of the body in which what is between or absent is as meaningful as the words or gestures themselves. Structuralism, like Greenbergian formalism, had little use for the body, which is crucial to Merleau-Ponty's phenomenology. Otherwise, structuralism and phenomenology are basically formalist disciplines, against which poststructuralism asserts "the 'structurality of structure,' the point of which is that there is, in effect, no 'point,' no origin, no end, no place outside discourse from which to fix, make determinate, and establish metaphysical boundaries for the play of linguistic signifiers," observes Frank Lentricchia. "Sometime in the early 1970s we awoke from the dogmatic slumber of our phenomenological sleep to find that a new presence had taken absolute hold over our avant-garde critical imagination: Jacques Derrida."[163]

An abstract painter as well as a critic, Jeremy Gilbert-Rolfe has frequently invoked Derrida to account for the meaning of nonrepresentational works of art, which bring "to one's attention possibilities for thinking which are not accessible to representation." In James Hayward's paintings, for example, Gilbert-Rolfe finds a deconstruction of the concept of the "subject" that parallels Derrida's critique of the phenomenological subject who speaks in order to convey meaning. Independent of the identity or presence of the author, Hayward's gestural abstractions are made meaningful through deferral and difference, rather than as concretized self-expression.[164] A related point was made by Merleau-Ponty's turn to Saussure and away from

André Malraux in "Indirect Language and the Voices of Silence." Rejecting Malraux's claim that the only subject of modern painting is the painter himself, Merleau-Ponty counters that expression only becomes significant *in others* as the artist turns toward the world to communicate.[165] Considering expression in dialectical form, Merleau-Ponty links the for-oneself (which Gilbert-Rolfe and Derrida do away with) and the for-others, treating painting as a language, albeit a silent one. Negotiating the difference between Merleau-Ponty and Derrida, Gilbert-Rolfe reestablishes the body's role: "Nonrepresentational art," he writes, "is some sort of medium through which the body thinks the world." It is not derived from the phenomenology of minimalism, but as presence *and* absence, "without recourse to a notion of the essential or, better, of the irreducible – or, better yet, of the center."[166]

Phenomenology, structuralism, and poststructuralism allow us to rethink the concept of expressionism, while presence, which was key to phenomenological readings of '60s abstraction, is undone by poststructuralist *différance*. Derrida's revision of phenomenology, as Vincent Descombes has pointed out, delivers it from "that which 'still holds it within the confines of a metaphysics,' the metaphysics of *presence*."[167] Maintaining that presence is fundamental to prior philosophies, from the self-presence of the Cartesian *cogito* to the presence of the object of perception, according to Jonathan Culler, Derrida claims that presence is not pure but an effect of its difference from absence. "What is supposedly present is already complex and differential, marked by difference, a product of differences."[168] Presence is of no use to the discourse of signifying, which takes works of art as signs "and as such are only present to the extent that they *re*present."[169] Nonrepresentational work, as Gilbert-Rolfe explains in Chapter 9, "is subject to an endless deferral in the Derridean sense. It defers to other objects, both art objects and those to which we do not attach the high value we reserve for the eloquently useless, in being like them but not representing them, in differing from them and with them."

Preferring the term "nonrepresentation" to "abstraction," Gilbert-Rolfe returns to the oppositional strategy of early apologists in order to stress Derridean difference and deferral. Throughout all of his writings on the subject, nonrepresentation is consistently differentiated from representation to elucidate what it is or what it is not. First, nonrepresentation is not reducible to historicism or psychologism, which evolve from the essential Hegelian concepts of history and the self.[170] Historicism, in which representation and alternative readings of abstraction such as Carrier's participate, explains works of art from the point of view of origins and influences, a position reminiscent of Fried's valorization of fecundity. In contrast to

Greenberg's total reliance on historical significances, for Gilbert-Rolfe non-representation is about history and counterhistorical; full of history without being reducible to it. Invoking the other half of the famous pair of abstract expressionist critics, Gilbert-Rolfe identifies Harold Rosenberg as the proponent of psychologism, which links works of art to the self that produced them. The rejection of psychologism is thus the first step in the redefinition of expressionism. Nonrepresentational works involve the "presentation," according to Gilbert-Rolfe, "of no thing," and yet they themselves possess a particular kind of thingness. Because a representational work presents some thing (an image), it denies its own thingness. Unlike '60s objecthood, this concept of thingness is not reliant on presence, although it is characterized by completeness; whereas representation, because it stands for something else, evinces a lack.

Facilitating the transition from representation, which assumes an independence of signifier (image) and signified (referent), to simulation, in which signifier and signified are not detachable but locked in circularity without reference to reality, Baudrillard was an important force in the 1980s. Gilbert-Rolfe has used his theories to undermine the assumptions of reality necessary to the success of leftist political art, which is ironically convinced of Baudrillard's explication of the political economy of the sign.[171] In Baudrillard's scheme, works of art are transformed into signs (signifying, for example, the prestige that accrues to the art collector), independent of their use value, through the marketplace in which they are exchanged for money (their economic exchange value). In the political economy, "everything is abstracted and reabsorbed into a world market and in the preeminent role of money as a general equivalent," with the potential to reconvert to use value, whereas in the political economy of the *sign*, economic exchange value converts into sign exchange value.[172] It is this very process, as Foster points out, that neo-geo painters are seeking to represent. Along with Jameson, Foster is suspicious of the representability of the "abstractive tendencies" of capitalism since the abstractive process itself erodes representation and abstraction alike. Superceding representation is not abstraction but simulation (or, as he suggests elsewhere, repetition).[173]

Ultimately, "Signs Taken for Wonders" does not endorse the work it discusses. Because it extends the project of appropriation through the critique of originality associated with modernism, in Foster's estimation only Sherrie Levine's work rises above the op art–inspired paintings of Bleckner and Philip Taaffe and especially the impotent (in the sense of failing to intervene in or transgress the status quo) simulacra of Halley. As is the case with Fried's "Art and Objecthood," a negative assessment can nevertheless

illuminate the significance of the work in question, as Foster's surely does. Just as Crimp differentiates Hennessey's work from Ryman's, Foster separates the younger neo-geo artists from Stella, Ryman, and Marden, whom he identifies as *critical* abstract painters. Throughout his writings, Foster is supportive of projects that operate as a form of critique rather than those that function in complicity with official culture. In his influential anthology of postmodern theory, he is specific: "A basic opposition exists between a postmodernism which seeks to deconstruct modernism and resist the status quo and a postmodernism which repudiates the former to celebrate the latter: a postmodernism of resistance and a postmodernism of reaction."[174] As a reactionary movement, neo-geo "provides a modicum of the new without threat of a real change or loss of order." It is only superficially opposed to the just-previous style of neoexpressionism and equally complicit with the market economy that demands novelty but is satisfied by alternating trends. Buchloh makes much the same point on behalf of neoexpressionism in the 1980s and the classicizing figure painting of Pablo Picasso and others in the 1920s, known as *le rappel à l'ordre*. In both cases, retrograde styles of figuration were resurrected to reinforce the status quo and "to display the wealth and power of the social group that has appropriated them."[175]

To Halley, Baudrillard suggests a model of simulation in which the real, and the representation of it, are no longer possible. Therefore, his paintings cannot be said to be either abstract or representational, but simulations of abstraction. Foster marshals Baudrillard in support of his critique of neo-geo's collusion with simulation, which (in television, for example) serves as an exercise of capital and a form of social control. "Such is the later stage of development of the social relation, our own," Baudrillard writes, "which is no longer one of persuasion (the classical age of propaganda, ideology, publicity, etc.) but one of dissuasion or deterrence: 'YOU are news, you are the social, the event is you, you are involved, you can use your own voice, etc.' "[176] The new abstract painting mirrors the process of capital, which transforms objects into commodity-signs, by accepting the reification of critical abstraction and reducing it to style. As "the very gem of reified art-historical thinking," writes Buchloh, "style then becomes the ideological equivalent of the commodity."[177] The pendulum-swing Foster acknowledges is thus driven by the economy of the art market.

At least, this is the scenario developed by many contemporary critics, those whom Carrier identifies as proposing a holistic (and essentially Marxist) interpretation of works of art that connects them to the society that produced them. Carrier is able to locate both Foster and Jameson at the end of an art historical tradition. "Here we return to Jameson's holism; the

history of art cannot be understood apart from the society in which it is created. The history of modernism is the story of such radical criticism of the existing order. When Foster asserts that some progressive works 'recall a repressed or marginal sign-system in such a way as to disturb or displace the given institutional history of an art or discipline,' he offers but a variation on a theme (circa 1965) of Michael Fried, who got from the political writings of Lukács and Merleau-Ponty the ideal of 'perpetual revolution – perpetual because bent on unceasing radical criticism of itself' – realized, however, not in politics but in modernist painting."[178] The alternation of styles in the 1980s, from the histrionic gestures of neoexpressionism to the dispassionate geometry of neo-geo, is but a microcosm of Wölfflin's cyclical and more formal scheme for the Renaissance and baroque. Kuspit also implicates himself in this art historical tradition by acknowledging that the "forceful paint and use of the figure [in neoexpressionism] were like red flags to the bull of Abstraction" and by criticizing Buchloh's attack on neoexpressionism as "a Marxist blitzkrieg." For Buchloh and for Foster, the dialectic of geometry and gesture represents a reactionary capitulation to the marketplace; for Kuspit, abstraction signals the artificiality of technological society while painterly figuration aspires to a kind of healthy, but ultimately not recoverable, naturalism.[179]

Kuspit's history of modern and postmodern art involves two paired concepts: in modernism, nature and abstraction; and within abstraction – the second half of the first pair – organicism and mechanicism. Symptomatic of the modern world, abstract painting responded to the dynamic of technology in the early twentieth century by relinquishing "the representation of nature and the 'natural' look of things in general."[180] In content and method, Kuspit's theory echoes Hegel's opposition of nature to history, in which nature entails "the harmless and unopposed simple growth of organic life," while history develops dialectically toward perfection through the faculty of reason.[181] Leaving aside figuration's affiliation with nature, Kuspit articulates a thesis/antithesis comprised of Kandinsky's organicism and Malevich's mechanicism. The thesis/antithesis remains unresolved in modernism, which Kuspit describes as both childlike and primitive. Observing that "virtually all the nonobjectivists went through what they called a neoprimitivist phase," he concludes, in a statement reminiscent of Wilhelm Worringer, that "the pushing of neoprimitivism away from the figure and toward pure shape arose as a solution to the quintessential problem of self-definition forced on the authentically, self-consciously Modern artist who experienced a radically untraditional, 'unnatural,' 'inorganic' world."[182] Postmodernism, he suggests in "The Abstract Self-Object" (Chapter 10), represents a potential

synthesis of organicism and mechanicism, a completion of the modernist project, rather than a poststructural critique of it. Metaphorically attaining adulthood, postmodern abstraction is proof that "maturity occurs through the dialectical working through of contradictions."

Kuspit's real contribution to the issues of contemporary abstract painting is the psychological analogy. Beyond the Rosenbergian psychologism dismissed by Gilbert-Rolfe, Kuspit identifies a cultural crisis, historically reflected in the confrontation with "the question of how to retain an unshakable integrity of being in a world that not only mechanizes and ruthlessly controls life, but also is so dynamic that it necessarily denies any being a sense of wholeness with the world."[183] Kuspit appropriates the goal of psychology articulated by Heinz Kohut, "the reintegration of the fragmented self," as the goal of art. Although reintegration is potentially achievable through the postmodern synthesis, it remains elusive. The six painters discussed in Chapter 10 are differentiated into two groups, each positioned nearer to one or another pole of the organicist/mechanicist dialectic. Always falling short of equilibrium, Helmut Federle, Imi Knoebel, and Robert Mangold approach mechanicism in their rationality and perfectionism. Their use of closed systems is contrasted to the use of open, organicist systems by Marden, Richter, and Ryman, which, in a complicated spin on the binarism of geometry and gesture, are described as "devitalized" and "less spontaneous than random." Kohut's concept of the psychological self-object, in which, for example, the patient's father is the "idealized self-object" and the mother is the "mirroring self-object," is transferred by Kuspit to the status of painting as it relates to the sensibility that produced it.[184] By defining the polarities of narcissism – grandiose perfection and nurturant omnipotence – postmodern abstract painters point the way toward recuperation if not total resolution of conflict. The resolution Kuspit anticipates will occur, significantly, in the "lifeworld," the repression of which he attributes to the formalism of the modernist studio world.[185] For Kuspit, recognition of "the world historical" is as basic to postmodernism as historicism was to Greenbergian modernism. In the postmodern era, as Foster also observes, art is no longer considered to be "its own issue, engendered from a special history . . . in the historicist terms (post hoc, ergo propter hoc) of influence and continuity."[186]

Exhibitions such as Abstract Paintings by Three European and Three American Artists in Vienna, Austria, for which Kuspit's catalogue essay was written, are important but rare attempts to examine abstract painting from an international perspective, since it is, as Gilbert-Rolfe suggests in Chapter 9, primarily considered an American phenomenon. Most

historicist proponents of European abstraction associate it with a Beuysian critique to safeguard it from the taint of formalism and to undercut the potential affiliations of an artist such as Federle with Novros. Gilbert-Rolfe also notes the precarious position of abstraction in Los Angeles, where he lives. Although there is a strong tradition of abstract painting in Southern California, it consists of a private history relevant to artists in Los Angeles, but unacknowledged by New York critics as anything other than provincial. Since Gilbert-Rolfe's essay first appeared in 1989, Los Angeles has had another moment of recognition by the establishment (particularly for performance-oriented artists such as Mike Kelley and for its high-profile art schools), although its artists have yet to participate in a truly public discourse. In the minds of many Americans, New York remains the "art capital of the world."

As David Pagel points out in "Once Removed from What?" (Chapter 11), things are beginning to change. It is now possible to describe as provincial the assumption that art made in New York is "natural" while art made elsewhere is not. Pursuant to this belief is the treatment of a work of art produced outside the center as a sign of its environment, "a sociological artifact: a piece of evidence that's interesting primarily because it provides insights into what life is like in the provinces, where things are different – sometimes 'exotic,' but more often merely curious (as in weird)."[187] In an article related to his catalogue essay for the exhibition, *Abstract Painting, Once Removed*, at the Contemporary Arts Museum in Houston, Pagel describes this attitude as a tribal mentality that fails to acknowledge the contingency of all cultural production and assumes that the tribe's practices are the only natural ones. In contrast, a more open-minded attitude results in "civilized sociability."[188] Rather than creating psychological depths as Kuspit suggests, paintings occupy "social spaces" as markers of our civilized sociability. Not entirely unrelated to the notion of "a new social space of immanent flows and simulated effects" that Foster identifies in Chapter 8, Pagel's ideas are influenced by Dave Hickey, for whom social space consists of "a complex process of socialization during which some [works of art] are empowered by an ongoing sequence of private, mercantile, journalistic, and institutional investments." This includes "the entire business of dreaming and drawing and talking and trading and buying and selling – the deep rituals of sitting around in a big room filled with disconcerting objects, chatting about them, [and] looking at them."[189] Based on many factors, including a pervasive pluralism continuing since the '70s, an art market much less robust than in the 1980s, and a reaction to the austere, politicized conceptual forms of the same period, abstract painting of the 1990s reflects

this newly democratic vision. Unlike neo-geo, the new abstraction does not appropriate or simulate earlier forms of abstract painting and thus, as Pagel tells us, make a mockery of modernism by viewing it as a simple-minded cliché. Its stance is neither negative nor critical and, for the most part, it is free of meaningful "messages."[190] In an endorsement that would have been unthinkable in poststructuralist criticism, Pagel claims that the artists he discusses indeed "favor insistent superficiality." Although this implies that their paintings are meaningless, Pagel links superficiality to the idiom of painting itself, "an art of surfaces above all else."[191] Because it is a form of message-making, Pagel practically dismisses the potentially feminist content of painting, which was first explored by women as a critique of the predominantly male orientation of abstraction. Presumably, Pagel has in mind artists such as Judy Chicago in the late 1960s or Sherrie Levine in the 1980s, who first appropriated paintings by male artists and subsequently developed a generic form of hard-edge abstraction as a critique of the patriarchal concept of originality. In contrast, Pagel notes, women painters in Los Angeles have no such axe to grind, although it is not clear whether he thinks that their work is feminist. Unlike the artists of Levine's generation, Los Angeles artists Ingrid Calame, Monique Prieto, and Pae White look to the unfashionable, and arguably more feminine, work of Helen Frankenthaler and Jules Olitski, which is rejuvenated and given new meaning. While Pagel limits his discussion of the feminist implications of abstract painting to women artists, the most compelling argument for a "'feminine' abstract painting" in the 1990s is Shirley Kaneda's. Qualifying feminine paintings, which include works by Mary Heilmann, Valerie Jaudon, Suzanne McClelland, and Philip Taaffe, are multivocal, sensuous, incomplete, and propositional, but not necessarily made by women.[192]

Not only do the artists included in *Abstract Painting, Once Removed* make 1960s color field painting interesting again, according to Pagel, they do not resist being labeled formalists. After thirty years, the affiliation with formalism is once again acceptable, given its disassociation from Greenberg's valorization of opticality and quality. Like Pagel, Lane Relyea has compared the paintings of these Los Angeles artists with the work of Louis, Noland, and Olitski. Differing from the earlier formalists, who eschewed relational composition, Calame, Prieto, and Kevin Appel "deal with the relation of parts rather than with open, whole fields."[193] Other contemporary painters, such as Kaneda, Fiona Rae, and David Reed, even entertain the illusion of space in otherwise abstract paintings. Like Bleckner, Halley, and Taaffe, they investigate figure/ground relationships, not seen in much serious abstraction after Pollock. Artists in the 1980s, however, claimed to be uninterested in

formal issues. "My work has a formal element to it, but it is not formalist," Taaffe declared. "I care how things relate compositionally of course, but I am more interested in physical, expressive, compulsive and psychological ingredients beyond formalism, a search for the ruthless thing. I am not interested in making a pretty object."[194] Halley also denied that the lines, squares, and colors in his paintings were intended to be formal. Associating geometry with video games and computer graphics, he attempted to convey the sense of "an entirely synthetic geometric world."[195] The synthetic quality of abstract painting in the 1990s is due in some cases to the actual use of a computer for sketching and making studies by artists such as Rae, Prieto, Aaron Parazette, and Jeff Elrod. Coincident with the renewed interest in formalism, the computer encourages compositional shifting and balancing of lines and shapes, by dragging, cutting, and pasting. The resulting relational compositions are particularly susceptible to formal analysis, although it is no longer used to justify qualitative judgments as it had been by Greenberg and Fried. As Saul Ostrow explained in 1997, " 'Formalism's' concern for self-referential structures and literalism continues to be necessary to maintain the viability of abstract art though it neither supplies objective standards nor determinant criteria. In part this is due to 'Formalism' also having diversified, in order to respond to the differing practices by which these artists seek to objectify their conflicting themes and practices."[196]

Pagel represents a new generation of critics who celebrate the visual by *looking at* works of art with an intensity unmatched since the 1960s. "Human eyes," Peter Schjeldahl wrote in the catalogue for *Abstract Painting, Once Removed*, "are hungry and demanding organs that want exercise commensurate with their ability to discern and discriminate – given an emotional reward that justifies the effort."[197] In Hickey's opinion, much poststructuralist criticism, which prioritized meaning over appearance, was "horrified by the image and scandalized by looking."[198] The highly conceptualized art of the 1970s and '80s addressed by such criticism led Danto to declare that "whatever art is, it is no longer something primarily to be looked at."[199] While the so-called return to formalism in the late 1990s is arguably a reaction against the emphasis on theory and the illustrative narratives of conceptually based art, the new abstraction has absorbed much of that art's emphatically graphic style, emphasis on meaningful content, and reference (to earlier styles, popular culture, or technology, for example) outside the frame.

The bodily dimension of abstract painting is acknowledged as well in the 1990s, inspired in part by the contemporaneous exploration of the body's role in sculpture, installation, and video. In a phenomenological vein recalling Merleau-Ponty, Pagel appreciates "the pleasures and satisfactions that

result when our senses are sharpened and our minds and bodies work in concert."[200] Relyea and others point to the evocation of bodily presences by the shapes in Prieto's paintings, to which the viewer responds corporeally. The current formalism is no longer one practiced by a disembodied eye. As the chapters in this book demonstrate, the transformation and evolution of the issues of contemporary abstract painting reflect the prevailing spirit of the times. In retrospect, the times themselves can be summarized by the major philosophical paradigms – the systems of opinion – that inform each period's critical trajectory.

NOTES

1. Sussanne K. Langer, *Problems of Art* (New York: Scribner's, 1957), 163. To be fair, Langer's point is to differentiate the abstractions of discursive thought (science and logic) from those of art, which are specific rather than general. See below, note 9.
2. Quoted in Lilly Wei, "Talking Abstract," *Art in America* 75, no. 7 (July 1987): 83.
3. Quoted in Nancy Grimes, "White Magic," *ARTnews* 85, no. 7 (Summer 1986): 87.
4. Alfred H. Barr, Jr., *Cubism and Abstract Art* (New York: Museum of Modern Art, 1936), 11.
5. Wilhelm Worringer, *Abstraction and Empathy*, trans. Michael Bullock (New York: International Universities Press, 1953), 4.
6. Clement Greenberg, "Abstract and Representational," in *The Collected Essays and Criticism: Affirmations and Refusals, 1950–1956*, ed. John O'Brian, vol. 3 (Chicago: University of Chicago Press, 1986), 192–93.
7. Jane Freilicher, interviewed on "Style with Elsa Klensch," Cable News Network (CNN), August 1, 1998.
8. Lucian Krukowski, "Hegel, 'Progress,' and the Avant-Garde," *Journal of Aesthetics and Art Criticism* 44, no. 3 (Spring 1986): 284–85.
9. Langer, *Problems of Art*, 163–80.
10. John Rajchman, "Another View of Abstraction," in *Abstraction*, ed. Andrew Benjamin (London: Academy Group, 1995), 16–18.
11. A crude version of Platonic mimesis survived, however, in conservative attacks on modern paintings as "distortions" of reality. An example is Huntington Hartford's characterization of Pablo Picasso's *Les Demoiselles d'Avignon* as "stamped with the trade mark of the twentieth-century artist, straight, mechanical lines, flat colors, and distortion (as opposed to the lines of life, the colors of nature, and the beauty of human proportion of previous centuries)." Huntington Hartford, *Art or Anarchy: How the Extremists and Exploiters Have Reduced the Fine Arts to Chaos and Commercialism* (Garden City, N.Y.: Doubleday, 1964), 152.
12. G. W. F. Hegel, *On the Arts: Selections from G. W. F. Hegel's Aesthetics or the Philosophy of Fine Art*, trans. Henry Paolucci (New York: Frederick Ungar, 1979), 4.

13. Ibid., 8.

14. E. H. Gombrich, *Art and Illusion: A Study in the Psychology of Pictorial Art and Illusion* (Princeton: Princeton University Press, 1961), 16.

15. J. W. N. Sullivan, quoted in Leo Steinberg, "The Eye Is Part of the Mind," in *Other Criteria: Confrontations with Twentieth-Century Art* (London: Oxford University Press, 1972), 305.

16. Ibid., 289–306. See a similar scientistic justification in Chapter 1, this volume.

17. In most abstract paintings, these shapes and images are apprehended in the illusion of space and are thus representational. Wollheim concedes that flat paintings, such as Barnett Newman's, are not representational. Richard Wollheim, *Painting as an Art* (Princeton: Princeton University Press, 1987), 62.

18. Michael Fried, "Three American Painters: Kenneth Noland, Jules Olitski, Frank Stella," in *Art and Objecthood: Essays and Reviews* (Chicago: University of Chicago Press, 1998), 224–25.

19. Cf. Clement Greenberg's concept of "homeless representation" discussed in this commentary. In a letter to Langsner, John McLaughlin wrote, "I believe that forms other than rectangles assume a kind of entity and in a sense become objects and are therefore misleading." John McLaughlin, "Draft for Letter to Jules Langsner," March 11, 1959, in Donald McCallum, "The John McLaughlin Papers in the Archives of American Art," in Maurice Tuchman, *5 Footnotes to a Modernist Art History* (Los Angeles: Los Angeles County Museum of Art, 1977), 89.

20. Barnett Newman, "The Plasmic Image," in *Selected Writings and Interviews*, ed. John P. O'Neill (Berkeley: University of California Press, 1990), 139.

21. John Coplans, "John McLaughlin, Hard Edge, and American Painting" *Artforum* 2, no. 7 (January 1964): 31. Coplans is paraphrasing Lawrence Alloway.

22. Barr, *Cubism and Abstract Art*, 11.

23. Kasimir Malevich, "Suprematism," in *Theories of Modern Art*, ed. Herschel B. Chipp (Berkeley: University of California Press: 1968), 341–43.

24. Briony Fer, *On Abstract Art* (New Haven: Yale University Press, 1997), 5.

25. Barr, *Cubism and Abstract Art*, 11. *Black Quadrilateral*, once dated 1913, is now widely assumed to have been painted in 1915.

26. Fried, "Three American Painters," 224–25; Rajchman, "Another View of Abstraction," 21. Kandinsky himself cautioned, "If we begin at once to break the bonds which bind us to nature, and devote ourselves purely to combination of pure color and abstract form, we shall produce works which are mere decoration, which are suited to neckties and carpets." Wassily Kandinsky, *Concerning the Spiritual in Art*, trans. M. T. H. Sadler (New York: Dover, 1977), 47.

27. Malevich, "Suprematism," 342.

28. Fer, *On Abstract Art*, 8–9, 170 n. 3.

29. Lucy R. Lippard, *Ad Reinhardt* (New York: Abrams, 1981), 191.

30. Ad Reinhardt, "Ad Reinhardt on His Art," *Studio International* 174, no. 895 (December 1967): 269.

31. Lawrence Alloway, "Systemic Painting," in *Minimal Art: A Critical Anthology*, ed. Gregory Battcock (New York: E. P. Dutton, 1968), 39–58.

32. Kandinsky once held the honor, but subsequent scholarship showed that his *First Abstract Watercolor* was painted in 1913 rather than 1910. The artist himself

believed *Picture with a Circle* (1911) to be "the first abstract picture in the world." See Jelena Hahl-Koch, *Kandinsky* (New York: Rizzoli, 1993), 183–84. František Kupka in Paris and Arthur Dove in the United States were experimenting with abstraction around the same time. See Peter Vergo, *Abstraction: Towards a New Art, Painting 1910–20* (London: Tate Gallery, 1980). A recent comprehensive survey is Mark Rosenthal, *Abstraction in the Twentieth Century: Total Risk, Freedom, Discipline* (New York: Guggenheim Museum, 1996).

33. Cf. Arthur C. Danto, *After the End of Art: Contemporary Art and the Pale of History* (Princeton: Princeton University Press, 1995).

34. David Carrier, "Abstract Painting and Its Discontents," in *The Aesthete in the City: The Philosophy and Practice of American Abstract Painting in the 1980s* (University Park: Pennsylvania State University Press, 1994), 35–49.

35. Barr, *Cubism and Abstract Art*, 13.

36. Meyer Schapiro, "Nature of Abstract Art," in *Modern Art: 19th and 20th Centuries* (New York: George Braziller, 1978), 196.

37. Barnett Newman, " 'Frontiers of Space' Interview with Dorothy Gees Seckler," in O'Neill, ed., *Selected Writings and Interviews*. 250. See the discussion of content in Yve-Alain Bois, "Introduction: Resisting Blackmail," in *Painting as Model* (Cambridge: MIT Press, 1990), xxiv–xxv.

38. Adolph Gottlieb and Mark Rothko, "Statement," in Chipp, ed., *Theories of Modern Art*, 545.

39. Using the example of poetry, Greenberg wrote, "The content of the poem is what it does to the reader, not what it communicates." Clement Greenberg, "Towards a Newer Laocoon," in *The Collected Essays and Criticism: Perceptions and Judgments, 1939–1944*, ed. John O'Brian, vol. 1 (Chicago: University of Chicago Press, 1986), 28, 33–34.

40. Clement Greenberg, "Necessity of 'Formalism,'" *Art International* 16, no. 8 (October 1972): 106.

41. Schapiro, "Nature of Abstract Art," 186.

42. Piet Mondrian, "Plastic Art and Pure Plastic Art," in Chipp, ed., *Theories of Modern Art*, 352.

43. Saul Ostrow, "More Parts to the Whole: Revised and Reformed," in *After the Fall: Aspects of Abstract Painting since 1970*, vol. 2 (Staten Island: Snug Harbor Cultural Center, 1997), 37.

44. Hal Foster, "Postmodernism: A Preface," in *The Anti-Aesthetic* (Seattle: Bay Press, 1983), xv.

45. Clement Greenberg, "Modernist Painting," in *The Collected Essays and Criticism: Modernism with a Vengeance*, ed. John O'Brian, vol. 4 (Chicago: University of Chicago Press, 1986), 85.

46. Johann Joachim Winckelmann, *History of Ancient Art*, trans. G. Henry Lodge (New York: Frederick Ungar, 1968); Gotthold Lessing, *Laocoön: An Essay on the Limits of Painting and Poetry*, trans. Edward Allen McCormick (Baltimore: Johns Hopkins University Press, 1962).

47. Hegel, *On the Arts*, 63.

48. Ironically, historical abstractionists turned away from literature yet embraced the model of music as the purest and most emotional art form. Kandinsky was primarily responsible for popularizing the musical analogy, although even

Greenberg recognized that music was appropriately nonmimetic as well as definitive in terms of its appeal to a particular sense (music is for the ear as painting is for the eye). Greenberg, "Toward a Newer Laocoon," 31–32. Mondrian identified with boogie-woogie based on its "construction through the continuous opposition of pure means – dynamic rhythm." Piet Mondrian, "Statement [1943]," in Chipp, ed., *Theories of Modern Art*, 364. Coplans cites Arnold Schoenberg's music as a model of serial structure. Other critics have likened the improvisational technique of jazz to Pollock's drip painting; Philip Glass's repetitive compositions to works by Stella and Sol LeWitt; and the monotonal poetics of Bob Dylan to the early paintings of Brice Marden.

The inspiration for the analogy with music can be found in Hegel. Not only does most music not depend on subject matter for its content, it is more "romantic," less material and more spiritual than painting on Hegel's scale of the progressively dematerialized arts. Although Hegel could not have predicted the alliance of abstract painting and music, music was considered an appropriate paradigm by artists such as Kandinsky because it was typically associated with the expression of feelings. The connection between emotional experience and music was established by time. For Hegel, "the temporal movement or vibrancy of musical sound is of the same order as the temporal vitality of the soul, and so the two can interpenetrate one another fully." Hegel, *On the Arts*, 129. Since Kandinsky's paintings are the result of the expression of feelings, the temporal nature of music made it a suitable aspiration. Despite the fact that the paintings themselves can never participate in the duration available to music, evidence of gesture and process conveys a "sequential experience" in a completed painting. Krukowski, "Hegel, 'Progress,' and the Avant-Garde," 287.

49. Hegel, *On the Arts*, 58.
50. Danto, *After the End of Art*, xiii.
51. Peter Murray, "Introduction," in Heinrich Wölfflin, *Renaissance and Baroque*, trans. Kathrin Simon (Ithaca: Cornell University Press, 1964), 2.
52. Fried, "Three American Painters," 216.
53. Ibid., 220, 262 n. 8.
54. Robert S. Hartman, "Introduction," in G. W. F. Hegel, *Reason in History: A General Introduction to the Philosophy of History*, trans. Robert S. Hartman (Indianapolis: Bobbs-Merrill, 1953), xii.
55. Hegel, *On the Arts*, passim.
56. Wölfflin, *Renaissance and Baroque*, 167 n. 3; Heinrich Wölfflin, *Principles of Art History: The Problem of the Development of Style in Later Art* (New York: Dover, 1950), 231–33.
57. Barr, *Cubism and Abstract Art*, 19. See Schapiro's critique in "Nature of Abstract Art," 188–89.
58. Barr, *Cubism and Abstract Art*, 19.
59. Clement Greenberg, "Post Painterly Abstraction," in O'Brian, ed., *The Collected Essays and Criticism: Modernism with a Vengeance*, 4: 192–97.
60. Rosalind Krauss, "Originality of the Avant-Garde," in *The Originality of the Avant-Garde and Other Modernist Myths* (Cambridge: MIT Press, 1985), 158–61.

61. Benjamin H. D. Buchloh, "Figures of Authority, Ciphers of Regression: Notes on the Return of Representation in European Painting," in *Art After Modernism: Rethinking Representation*, ed. Brian Wallis (New York: New Museum, 1984), 120.

62. Harold Rosenberg, "The American Action Painters," *The Tradition of the New* (Chicago: University of Chicago Press, 1960), 23–39. In a footnote, Rosenberg advised: "Action Painting has to do with self-creation or self-definition or self-transcendence; but this dissociates it from self-expression, which assumes the acceptance of the ego as it is, with its wound and its magic. Action Painting is not 'personal,' though its subject matter is the artist's individual possibilities."

63. Coplans, "John McLaughlin," 31.

64. Peter Selz, "Setting the Record Straight," *Journal: The Los Angeles Institute of Contemporary Art* 5 (April–May 1975): 11; June Harwood, "Four Abstract Classicists," *Journal: The Los Angeles Institute of Contemporary Art* 5 (April–May 1975): 13. Langsner's essay says that the artists call "themselves Abstract Classicists."

65. Peter Plagens, "The Soft Touch of Hard Edge," *Journal: The Los Angeles Institute of Contemporary Art* 5 (April–May 1975): 17.

66. Alloway, "Systemic Painting," 52. One of the last catalogue essays to pursue the classical implications of contemporary abstract art is Ben Heller, *Toward a New Abstraction* (New York: Jewish Museum, 1963), 8.

67. Alloway, "Systemic Painting," 45.

68. Susan C. Larsen, "John McLaughlin: A Rare Sensibility," in *John McLaughlin: Western Modernism/Eastern Thought* (Laguna Beach: Laguna Art Museum, 1996), 25.

69. Greenberg, "Abstract and Representational," 3: 186–93.

70. Greenberg, "Modernist Painting," 4: 87–88.

71. Clement Greenberg, "After Abstract Expressionism" in O'Brian, ed., *The Collected Essays and Criticism: Modernism with a Vengeance*, 4: 124–25.

72. Roger Fry, "Art as Form," in *Readings in Aesthetics*, ed. John Hospers (New York: Free Press, 1969), 113.

73. Clive Bell, "Significant Form," in ibid., 92.

74. Wollheim, *Painting as an Art*, 62.

75. Worringer, *Abstraction and Empathy*, 15.

76. Greenberg, "Modernist Painting," 4: 90.

77. See above, n. 18.

78. Fried, "Three American Painters," 224.

79. Rosalind Krauss, "Theories of Art After Minimalism and Pop," in *Discussions in Contemporary Culture*, ed. Hal Foster, vol. 1 (Seattle: Bay Press, 1987), 61. See also Rosalind E. Krauss, *The Optical Unconscious* (Cambridge: MIT Press, 1993), 246–48. Opticality, as Fried has since pointed out, was no longer part of Greenberg's vocabulary after 1962, nor his own by 1967. "I was already," he explained, "interested in Merleau-Ponty, philosopher of the body." See Michael Fried, "An Introduction to My Criticism," in *Art and Objecthood: Essays and Reviews*, 21–22; and Michael Fried, "Theories of Art After Minimalism and Pop: Discussion," in Foster, ed., *Discussions in Contemporary Culture*, 71–72.

80. Greenberg, "After Abstract Expressionism," 4: 127. See Donald Kuspit, *Clement Greenberg: Art Critic* (Madison: University of Wisconsin Press, 1979), 22.

81. Leo Steinberg, "Other Criteria," in *Other Criteria: Confrontations with Twentieth-Century Art*, 84.

82. Yve-Alain Bois, "Perceiving Newman," in *Painting as Model*, 194–95.

83. Maurice Merleau-Ponty, "Indirect Language and the Voices of Silence," in *Signs*, trans. Richard C. McCleary (Chicago: Northwestern University Press, 1964), 66.

84. Ibid., 56–57.

85. Ibid., 73.

86. See especially Maurice Merleau-Ponty, *Phenomenology of Perception*, trans. Colin Smith (London: Routledge and Kegan Paul, 1962), 212–14.

87. Frank Stella, *Working Space* (Cambridge: Harvard University Press, 1986), 131.

88. Ad Reinhardt, *Art as Art: The Selected Writings of Ad Reinhardt*, ed. Barbara Rose (New York: Viking, 1975), 50; Lee Krasner, quoted in B. H. Friedman, *Jackson Pollock: Energy Made Visible* (New York: McGraw-Hill, 1972), 182. For a recent affirmation of Pollock's camouflaged figuration, see Pepe Karmel, "Pollock at Work: The Films and Photographs of Hans Namuth," in Kirk Varnadoe with Pepe Karmel, *Jackson Pollock* (New York: Museum of Modern Art, 1998), 87–137.

89. Stella, *Working Space*, 158, 164.

90. Hal Foster, "Re: Post," in Wallis, ed., *Art After Modernism: Rethinking Representation*, 195.

91. Benjamin H. D. Buchloh, "Theories of Art After Minimalism and Pop: Periodizing Critics," in Foster, ed., *Discussions in Contemporary Culture*, 65.

92. M[el] Bochner, "Systemic," *Arts Magazine* 41, no. 1 (November 1966): 40.

93. According to printer Kenneth Tyler of Gemini G.E.L. print studio in Los Angeles, "Frank told me he couldn't draw and why should he make prints if he couldn't draw?" Quoted in Sidney Guberman, *Frank Stella: An Illustrated Biography* (New York: Rizzoli, 1995), 105.

94. William Rubin, *Frank Stella* (New York: Museum of Modern Art, 1970), 8. Asked if he had ever "studied the technique of representational art," Stella recalled painting a neoimpressionistic still life while a student at Phillips Academy in Andover, Massachusetts. "From then on, I just did whatever I wanted. I didn't have to do any more representational art." Frank Stella, interviewed by Terry Gross, National Public Radio (NPR), November 16, 2000.

95. Robert Coates, "The Art Galleries," *New Yorker* 35, no. 46 (January 2, 1960): 61.

96. Cf. Allan Kaprow, "The Legacy of Pollock," *ARTnews* 57, no. 6 (October 1958): 24–26, 55–57.

97. Donald B. Kuspit, "Authoritarian Aesthetics and the Elusive Alternative," *Journal of Aesthetics and Art Criticism* 41, no. 3 (Spring 1983), 275–76.

98. Fried, "Three American Painters," 219; Fried, "An Introduction to My Criticism," 56 n. 11. Fried later acknowledged that such determinations about current work are precarious from the perspective of the present. See ibid., 19.

99. Fried, "Three American Painters," 218.

100. See Michael Fried, "Shape as Form: Frank Stella's Irregular Polygons," in *Art and Objecthood: Essays and Reviews*, 99, n. 11; Michael Fried, "Art and Objecthood," in ibid., 168–69, n. 6. These are critiques of Greenbergian reduction and essentialism in which Fried collapses essence into quality, thus allowing for the "perpetual revolution" of modernist painting. Fried, "Three American Painters," 218.

101. See, esp., Fried, "Shape as Form," 77–99; Fried, "Three American Painters," 213–65.

102. Fried does not intend to imply a causal relationship in which the shaped canvas precedes the stripes since he acknowledges that the stripes determine the character of the shape. See my discussion of the critiques of deductive structure in Frances Colpitt, *Minimal Art: The Critical Perspective* (Seattle: University of Washington Press, 1993), 50–54.

103. Fried, "Shape as Form," 88.

104. Fried, "Art and Objecthood," 148–72.

105. Ibid., 169, n. 6.

106. Ibid., 151. For the concept of formalist-modernism, see Michael Fried, *Manet's Modernism; or, The Face of Painting in the 1860s* (Chicago: University of Chicago Press, 1996), 407–10.

107. Bruce Glaser, ed., "Questions to Stella and Judd," in Battcock, ed., *Minimal Art: A Critical Anthology*, 158, 162. The interview, as originally published in *ARTnews* 65, no. 5 (September 1966) and reprinted in Battcock, was heavily edited by Lucy R. Lippard and excludes contributions by the fourth participant, Dan Flavin. Recent scholarship has shown that Stella was defending himself against attacks by Flavin, admitting that his painting is an object although he was trying to make it less of one. See Caroline A. Jones, *Machine in the Studio: Constructing the Postwar American Artist* (Chicago: University of Chicago Press, 1996), 169; and James Meyer, *Minimalism* (London: Phaidon Press, 2000), 197–201.

108. Clement Greenberg, "Review of an Exhibition of School of Paris Painters," in *The Collected Essays and Criticism: Arrogant Purpose, 1945–1949*, ed. John O'Brian, vol. 2 (Chicago: University of Chicago Press, 1986), 89.

109. Not until Timothy J. Clark, "Jackson Pollock's Abstraction," in *Reconstructing Modernism: Art in New York, Paris, and Montreal 1945–1964*, ed. Serge Guilbaut (Cambridge: MIT Press, 1990), 172–243, is the issue raised again with some consequence.

110. See Alloway, "Systemic Painting," 37–60; Mel Bochner, "Serial Art, Systems, Solipsism," in Battcock, ed., *Minimal Art: A Critical Anthology*, 92–102; and John Chandler, "Tony Smith and Sol LeWitt: Mutations and Permutations," *Art International* 12, no. 7 (September 1968): 16–19.

111. John Coplans, "C. E. Watkins at Yosemite," *Art in America* 66, no. 6 (November–December 1978): 100–108. Like Coplans's recognition of "the underlying control-systems central to an advanced, 'free enterprise,' technological society," Foster points out that seriality was inconceivable before industrial production in the nineteenth century. Hal Foster, "The Crux of Minimalism," in *Individuals: A Selected History of Contemporary Art*, ed. Howard Singerman (Los Angeles: Museum of Contemporary Art, 1986), 179.

112. John Rajchman, "Another View of Abstraction," 18.

113. Reinhardt, *Art as Art*, 56.

114. Lippard, *Ad Reinhardt*, 192.

115. Lucy R. Lippard, "Excerpts: Olitski, Criticism and Rejective Art, Stella," in *Changing: Essays in Art Criticism* (New York: E. P. Dutton, 1971), 201.

116. Lippard, *Ad Reinhardt*, 122.

117. Reinhardt, *Art as Art*, 54, 19.

118. Ibid., 132.

119. Lippard, *Ad Reinhardt*, 191.

120. Lucy R. Lippard, *Ad Reinhardt: Paintings* (New York: Jewish Museum, 1966), 10. She also preferred the term "structurist" to minimalist.

121. Lucy R. Lippard and John Chandler, "The Dematerialization of Art," *Art International* 12, no. 2 (February 1968): 31–36.

122. See, e.g., Barbara Rose, "Beyond Vertigo: Optical Art at the Modern," *Artforum* 3, no. 7 (April 1965): 30–33.

123. William Seitz, *The Responsive Eye* (New York: Museum of Modern Art, 1965).

124. Lucy R. Lippard, "Perverse Perspectives," in *Changing: Essays in Art Criticism*, 167–83.

125. Glaser, "Questions to Stella and Judd," 158.

126. Peter Halley, "Ross Bleckner: Painting at the End of History," in *Collected Essays: 1981–87* (Zurich: Bruno Bischofberger Gallery, 1988), 48–49.

127. Sheldon Nodelman, "Structural Analysis in Art and Anthropology," in *Structuralism*, ed. Jacques Ehrmann (Garden City, N.Y.: Anchor Books, 1970), 81–83.

128. Susanne Langer, *Feeling and Form: A Theory of Art* (London: Routledge and Kegan Paul, 1953), 72.

129. Merleau-Ponty, *Phenomenology of Perception*, 232–33, 375.

130. Joseph Masheck, "Hard-Core Painting," *Artforum* 16, no. 8 (April 1978): 48.

131. Marcia Hafif, "Getting on with Painting," *Art in America* 69, no. 4 (April 1981): 133.

132. Carter Ratcliff, "Abstract Painting and the Idea of Modernity," in *Abstract Painting Redefined* (New York: Louis K. Meisel Gallery, 1985), 6; W. J. T. Mitchell, "*Ut Pictura Theoria*: Abstract Painting and Language," in *Picture Theory* (Chicago: University of Chicago Press, 1994), 213–39.

133. Benjamin H. D. Buchloh, "The Primary Colors for the Second Time: A Paradigm Repetition of the Neo-Avant-Garde," *October* 37 (Summer 1986), 45–46.

134. Danto, *After the End of Art*, 169–70.

135. Merleau-Ponty, *Phenomenology of Perception*, 211.

136. See Carter Ratcliff, "Mostly Monochrome," *Art in America* 69, no. 4 (April 1981): 111–39; Buchloh, "The Primary Colors for the Second Time," 41–52; Bois, "Painting: The Task of Mourning," 245–57.

137. Paul Delaroche, quoted in Chapter 7, this volume; Donald Judd, "Specific Objects," in *Complete Writings: 1959–1975* (Halifax: Nova Scotia College of Art and Design, 1975), 181–89. Based on Hubert Damisch's theory of games, Yve-Alain Bois is able to salvage painting by identifying it as a game (like chess or tennis) and modernist abstract painting as a particular match during which

the game is played. The match, which was from the beginning played for the end of painting, is over but the game continues. See Bois, "Painting: The Task of Mourning," 241–42.

138. Greenberg himself seems to have recognized the flaw in his system and devised what Fried calls "a second dynamic" to account for painting after abstract expressionism. Fried, "An Introduction to My Criticism," 38–39.

139. Danto, *After the End of Art*, 154. "Ryman has been a favorite 'contemporary' painter," according to Robert Storr, for the death-of-painting critics, despite the fact that his work is neither reductive nor essentialist. Robert Storr, *Robert Ryman* (London: Tate Gallery, 1993), 39. As Bois sees it, "In his art the feeling of an end is worked through in the most resolved way," as his paintings approach the industrial conditions of photography and the readymade. Bois, "Painting: The Task of Mourning," 232.

140. Danto, *After the End of Art*, 139–40.

141. Ibid., 30.

142. Lippard, *Ad Reinhardt*, 193.

143. "Painters Reply," *Artforum* 14, no. 1 (September 1975): 26–36. There was general agreement, however, on *Artforum*'s supposition that the debate between abstraction and representation was no longer relevant.

144. Barry Schwabsky, "Against Exhibitions of Abstract Art," in *After the Fall: Aspects of Abstract Painting since 1970*, 47.

145. Steven Henry Madoff, "The Return of Abstraction," *ARTnews* 85, no. 1 (January 1986): 80.

146. See Eleanor Heartney, *Critical Condition: American Culture at the Crossroads* (Cambridge: Cambridge University Press, 1997), 33. Sculptor Jeff Koons also received more than his share of hostile criticism.

147. Donald Kuspit, "Young Necrophiliacs, Old Narcissists: Art About the Death of Art," *Artscribe* 57 (April–May 1986), 31.

148. Halley, "Ross Bleckner," 48.

149. Peter Halley, "Notes on Abstraction," in *Collected Essays: 1981–87*, 192.

150. Peter Halley, "Statement," in ibid., 25.

151. Fredric Jameson, "Postmodernism and Consumer Society," in Foster, ed., *The Anti-Aesthetic*, 115.

152. Peter Halley, "The Crisis in Geometry" and "Frank Stella . . . and the Simulacrum," in *Collected Essays: 1981–87*, 81, 148–49.

153. Quoted in Lilly Wei, "Talking Abstract, Part Two," *Art in America* 75, no. 12 (December 1987): 120.

154. See above, n. 39.

155. Heartney, *Critical Condition*, 31.

156. David Carrier, "Baudrillard as Philosopher; or, The End of Abstract Painting?," in *The Aesthete in the City: The Philosophy and Practice of American Abstract Painting in the 1980s*, 100.

157. Halley, "Notes on Abstraction," 175–76.

158. Peter Halley, "Nature and Culture," in *Collected Essays: 1981–87*, 68.

159. Jeremy Gilbert-Rolfe, "Baudrillard's Aestheticism and the Art World's Politics," in *Beyond Piety: Critical Essays on the Visual Arts, 1986–1993* (Cambridge: Cambridge University Press, 1995), 168–69.

160. Stephen Melville, *Seams: Art as Philosophical Context*, ed. and introduction by Jeremy Gilbert-Rolfe (Amsterdam: G + B Arts International, 1996), passim.
161. Quoted in Vincent Descombes, *Modern French Philosophy*, trans. L. Scott-Fox and J. M. Harding (Cambridge: Cambridge University Press, 1980), 12.
162. Fried, "An Introduction to My Criticism," 29–30; Merleau-Ponty, "Indirect Language," 39–84.
163. Frank Lentricchia, *After the New Criticism* (Chicago: University of Chicago Press, 1980), 159–61.
164. Jeremy Gilbert-Rolfe, "James Hayward: Nonrepresentation Which Doesn't Represent," in *Beyond Piety: Critical Essays on the Visual Arts, 1986–1993*, 106–11.
165. Merleau-Ponty, "Indirect Language," 52.
166. Jeremy Gilbert-Rolfe, "Nonrepresentation in 1988: Meaning Production Beyond the Scope of the Pious," in *Beyond Piety: Critical Essays on the Visual Arts, 1986–1993*, 69–70.
167. Descombes, *Modern French Philosophy*, 141.
168. Jonathan Culler, *On Deconstruction: Theory and Criticism After Structuralism* (Ithaca: Cornell University Press, 1982), 92–96. See Jacques Derrida, *Writing and Difference*, trans. Alan Bass (Chicago: University of Chicago Press, 1978), 278–82.
169. Jeremy Gilbert-Rolfe, "Beyond Absence," in *Beyond Piety: Critical Essays on the Visual Arts, 1986–1993*, 151.
170. Gilbert-Rolfe, "James Hayward," 95–96.
171. See Gilbert-Rolfe, "Baudrillard's Aestheticism," 167–87.
172. Jean Baudrillard, *For a Critique of the Political Economy of the Sign*, trans. Charles Levin (St. Louis: Telos Press, 1981), 112–13.
173. Foster, "The Crux of Minimalism," 179.
174. Foster, "Postmodernism: A Preface," xi–xii.
175. Buchloh, "Figures of Authority," 120.
176. Jean Baudrillard, "Precession of Simulacra," in Wallis, ed., *Art After Modernism*, 273.
177. Buchloh, "Figures of Authority," 117.
178. Carrier, "Baudrillard as Philosopher," 105.
179. Donald B. Kuspit, "Flak from the 'Radicals': The American Case Against Current German Painting," in Wallis, ed., *Art After Modernism*, 137–41.
180. Donald Kuspit, "Back to the Future," *Artforum* 24, no. 1 (September 1985): 88.
181. Hegel, *Reason in History*, 68–69.
182. Kuspit, "Back to the Future," 88.
183. Ibid., 87.
184. See Heinz Kohut, *The Restoration of the Self* (New York: International Universities Press, 1977), 10.
185. Kuspit, "Authoritarian Aesthetics and the Elusive Alternative," 263–64.
186. Foster, "Re: Post," 190.
187. David Pagel, "Aperto Los Angeles," *Flash Art* 199 (March–April 1998): 75.
188. Ibid., 75.
189. Dave Hickey, *Air Guitar* (Los Angeles: Art issues. Press, 1997), 204, 63.
190. Pagel, "Aperto Los Angeles," 75.

191. Ibid., 75.

192. Shirley Kaneda, "Painting and Its Others," *Arts Magazine* 65, no. 10 (Summer 1991): 58–64.

193. Lane Relyea, "Virtually Formal," *Artforum* 37, no. 1 (September 1998): 129.

194. Quoted in Wei, "Talking Abstract, Part Two," 121.

195. Quoted in Jeanne Siegel, ed., *Art Talk: The Early 80s* (New York: Da Capo Press, 1988), 236.

196. Saul Ostrow, *Divergent Models* (Wiesbaden: Nassauischer Kunstverein Weisbaden, 1997), 10.

197. Peter Schjeldahl, "The Rise of Abstraction II," in *Abstract Painting, Once Removed*, by Dana Friis-Hansen (Houston: Contemporary Arts Museum, 1998), 37.

198. Hickey, *Air Guitar*, 71.

199. Danto, *After the End of Art*, 16.

200. David Pagel, "Looking into Seeing," in *Plane Structures* (Los Angeles: Otis Gallery, Otis College of Art and Design, 1994), 12.